FAREWELL THE TRANQUIL MIND

THE ART OF

Maxwell Gordon

FAREWELL THE TRANQUIL MIND:
The Art of Maxwell Gordon

Printed by GZD, Germany

Acknowledgments

The project this book represents was conceived and overseen by
Charles and Xenia Stephens. It would not have been possible without
the brilliant editorial direction of Lia Ronnen. Stephanie Gordon,
Louis and Karen Stephens, Lauren Jacobs, Ken Nielsen, and Penelope
Georgenes made generous contributions of their time, memories,
and above all their collections of Gordon's paintings, so as to bring
together the most comprehensive picture possible of Gordon's life
and work. Bret Stephens, of the *Wall Street Journal,* spent many hours
interviewing Gordon's friends and acquaintances and reviewing old
diaries and news clippings to write the biographical preface.
The paintings were expertly photographed by Nathan Sayers in New
York and Jose Luis Santacruz in Mexico City. The New York design
team at karlssonwilker, Inc., led by Nicole Jacek, Hjalti Karlsson,
and Jan Wilker, worked patiently and methodically to create a stylish
and appealing final product. Their contributions are gratefully
acknowledged.

About the contributors

Maxwell Gordon was born in Chicago in 1910, raised in Cleveland,
and began his career as a painter in New York City. A narrative artist
fascinated by myth, symbol, and allegory, he exhibited his early works
at the Museum of Modern Art, the Whitney, the Corcoran Gallery,
Brandeis University, and the Israel Museum. In 1962, he moved to
Mexico City, where he became known for work that mixed psycho-
logical themes with aspects of Mexican folklore and surrealism.
He later lived in Jerusalem before his death in New York in 1983.

Bret Stephens is a deputy editor and columnist at the *Wall Street
Journal.* He was raised in Mexico City and was formerly the editor-in-
chief of the *Jerusalem Post.*

FAREWELL THE TRANQUIL MIND
The Art of Maxwell Gordon

Introduction by Bret Stephens
Design by karlssonwilker, Inc.
Published by Birchwood Press

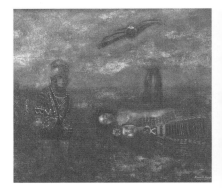

Fig 1

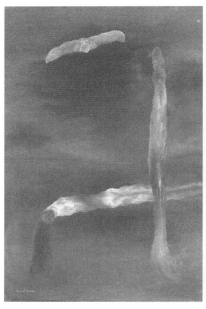

Fig 2

FAREWELL THE TRANQUIL MIND

The Art of Maxwell Gordon

So Giorgione started working. But he thought only of demonstrating his technique as a painter by representing various figures according to his own fancy. Indeed, there are no scenes to be found there with any order or representing the deeds of any distinguished person, of either the ancient or the modern world. And I for my part have never been able to understand his figures nor, for all my asking, have I ever found anyone who does. In these frescoes one sees, in various attitudes, a man in one place, a woman standing in another, one figure accompanied by the head of a lion, another by an angel in the guise of a cupid; and heaven knows what it all means.

—Giorgio Vasari, *The Lives of the Artists*

Don't bet on me. I'm an artist.

—Maxwell Gordon

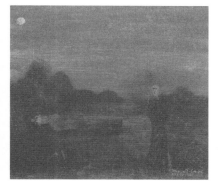

Fig 3

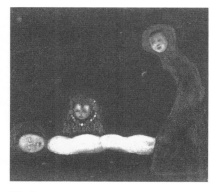

Fig 4

YOU WILL LIKELY have never heard of Maxwell Gordon, an American painter who died more than a quarter-century ago. Gordon, who spent the better part of his final years in Mexico, produced a large body of work mostly for a small circle of devoted friends. He was fascinated by symbol, allegory, myth, and memory at a time when abstract expressionism was in vogue. He gained modest professional recognition by the midpoint of his career, but there was never a definitive breakthrough. His paintings remain almost exclusively in private hands and, as far as I know, have not been publicly exhibited for many years.

Artists who die in obscurity must necessarily belong to one of two categories: the deservedly obscure and the undeservedly so, with the vast majority belonging to the former group. Nevertheless, examples of the latter—Vincent van Gogh, Herman Melville, and William Blake spring to mind—are reminders that contemporaneous judgments can sometimes be badly in need of revision. And while they are themselves now largely forgotten, the world owes a special debt to Van Gogh's sister-in-law Johanna Gesina van Gogh-Bonger, who revived his memory by publishing his correspondence with his brother (her husband) Theo; and to Raymond Weaver, whose 1921 biography put a long-dead Melville back on the literary map; and to Alexander Gilchrist, whose 1863 biography did the same for an also long-dead Blake.

This book, too, is a rescue attempt in the land of oblivion—Orpheus in search of his Eurydice. For Gordon this is particularly appropriate, since so many of his paintings seem to depict similar attempts. Consider four works from 1962: *Discovery* (Fig 1), *Vigilia* (Fig 2), and the untitled paintings (Figs 3 and 4). In each of these, mysterious personages keep watch over a

dormant figure, their expressions less suggestive of mourning than of some combination of expectation, protectiveness, wonder, and uncertainty. A question overhangs the paintings: Is it still not time to awake from this very long slumber? Any parent who has watched over a sleeping child, and every child who has watched over an ailing parent, has surely wondered about the answer.

MAX BERNARD GORDINSKY was born September 4, 1910, in Chicago, Illinois, to a Jewish family that traced its roots to Ukraine. Six years later his family moved to the small town of Chardon, Ohio, about 20 miles east of Cleveland. The Gordinskys were not dirt-poor: Gordon's daughter, Stephanie, remembers childhood visits to her grandparents' home, set on several acres of land. But they were very much working class: Gordon's father made his living as a stonecutter.

At 16, Gordon left home to study at a Cleveland polytechnic and then at the Cleveland Art School (later renamed the Cleveland Institute of Art). But he dropped out after a year to cross the country on freight trains. "I went bumming, looking for life," he told a journalist many decades later. "More happened in one day living like that than happened in one year living at home."

Eventually he returned to Cleveland, took a studio, and worked on canvases, textile designs, and woodcuts. An early inspiration was Hokusai, whose notion of an artist's vocation would serve Gordon as a lifelong inspiration: "If [as] a would-be draftsman you fail to poise above you such mystic harmony," admonished the Japanese master, "leave art, leave it to the few who, cursed from birth, are condemned to such Sisyphus tasks." He would sound a similar theme in a letter to Stephanie, then and now a stage actress, written from Jerusalem just a year before his death: "I'm happy you've been in rehearsal…. I know the theatre is a tough place to earn a regular living, as are all the arts. It's like a miracle…. I can never bet when I will sell my next painting."

Sometime around 1933, he was offered a scholarship to the National Academy of Design in New York. He turned it down ("I've always been against academic painting," he would later say) but came to New York anyway, where, according to Stephanie, he attended the Art Students League, probably under Thomas Hart Benton and alongside Jackson Pollock. He also made a meager living as an artists' model and—what would later become his steady profession for almost 30 years—a commercial lithographer. Not long afterwards, he met jewelry designer Edith Charmatz at a party in the Village. They decided to get married just three weeks later.

A letter to his granddaughter Lauren describes what came next:

> *1934—depth of Great Depression—I got a job with 'PATHE NEWS' one of the biggest 'news' film studios. We had the famous rooster that was the emblem of the place…and believe it or not, I was the youngest one in the studio (24 yrs old). It went out of business like all businesses did at that time. It was not 'cartoon' animation. We made serious work for different agencies.*

We got married—Steph was born—when she was about 3–6 months old—because Edith's mother interfered with our life so much—I decided and Edith agreed we would go to LA. I bought 2 coach tickets on train—4 days, 3 nites. On the train I bribed conductor to get a berth for Edith and Steph and I sat up.

In L.A. I got a job with a Poster House. I was fired as a troublemaker when I walked out and all men walked out with me. They were making us work like horses for $15 a week—I was highest paid, $20 a week. Then no work, some freelance work. Then when I saw Steph's baby food disappearing I decided to go back to N.Y.C. That's when one of the Hollywood animation studios called me up. But we had sold our furniture to second hand man etc. and hocked Edith's ring to buy tickets back.

The New York to which the Gordon family returned was no less economically hard-pressed. But for lithographers, it was a memorable era. In 1935, the Roosevelt administration established the Graphic Arts Division of the WPA's Federal Arts Project. In its eight-year history, the program would publicly exhibit more than 10,000 prints, often with starkly political themes: the plight of the unemployed; the oppression of the working class; the struggle against fascism.

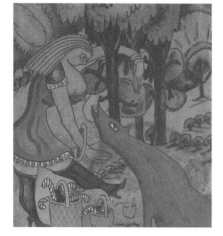

Fig 5

Gordon surely contributed to this burst of populist creative energy, though I was unable to locate any surviving prints. He also became an active member of the lithographer's union and, politically, very much a man of the left. How far left? Stephanie remembers her father as adamantly close-lipped on the subject, apparently on the view that if he told her nothing she would never have to lie about anything.

What we do have are some of Gordon's early paintings and ink drawings, most of them still lifes, portraits, and self-portraits, signed Max (or Maxwell) Gordon. The self-portraits show a slim, bespectacled, blue-eyed, redheaded young man, meditative in one pose, reflected and half-hidden in another. A still life of a low table on which lie a candlestick, a black hat, a prayer shawl, and a yarmulke with a yellow Star of David (a sign of the times, perhaps) is one of only a few of Gordon's paintings with an overtly Jewish theme. Gordon was himself an atheist.

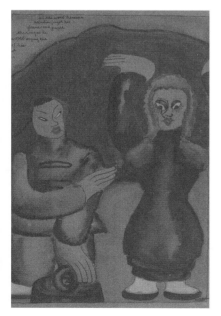

Fig 6

More accomplished are the small ink drawings (Figs 5 and 6), which are somewhat in the style of German expressionists Ludwig Kirchner and Otto Dix. Each is a scene of fable, seduction, and menace, a combination that typified much of Gordon's later work. The drawing of Little Red Riding Hood (Fig 5)—looking more like a prostitute than an innocent child, with the wolf in the role of a john—makes an interesting contrast to the somber, middle-aged, and demurely clothed *Little Red Riding Hood* he painted in the 1960s, in which the wolf seems less like a fairy-tale creature and more like the terrifying specter of an aging woman's social vulnerability and physical deterioration.

In 1943, a son was born: Mark (died 1995). Perhaps having him was an effort to save a bad marriage, or perhaps it was the beginning of the marriage's decline. Whatever the case, the marriage was not a good one. "I never saw

my parents kiss, never saw them touch each other," Stephanie recalls. Money was another issue. At one point, she says, her father declared to Edith: "I am an artist. I don't own property." They were separated in 1955, much to Stephanie's own relief, though for years Edith refused to agree to a divorce. It would later have fateful consequences for Gordon's career.

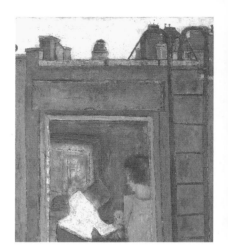

At the same time, Gordon's reputation as a painter began to grow, thanks initially to the efforts of the great Alma Reed. Reed, a journalist, had become a celebrity in Mexico in the 1920s, first by campaigning for the rights of Mexican migrant workers in the United States, and later for her love affair with the progressive (and ill-fated) Yucatán governor Felipe Carrillo Puerto, which is celebrated in the popular Mexican song "La Peregrina," or "The Pilgrim."

Fig 7

Gordon met Reed sometime in the early 1940s, when she was promoting the works of Mexican artists, particularly Jose Clemente Orozco. "I was a young artist and she offered to exhibit my works in a collective show," Gordon recalled in a 1975 interview. "It cost $12 to pay for the expenses of putting on the show and I stubbornly refused on principle alone. Finally, I gave in."

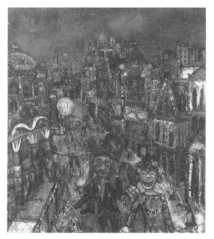

There followed exhibits of his works at the Rose Fried Gallery, famous for introducing American audiences to Mondrian and Rothko, and, between 1948 and 1962, five one-man shows at the Gallery of American Contemporary Arts (ACA) on 57th Street. Gordon's work also began to be exhibited (and collected) on a broader stage: at the Whitney, the MOMA, and the Brooklyn Museum in New York City; at the Corcoran Gallery and the Hirshhorn Museum in Washington D.C.; at the Cleveland Museum of Art and the Butler Art Institute in Ohio; at Brandeis University in Massachusetts and the University of Illinois; and at the Ein Harod Museum in northern Israel and the Israel Museum in Jerusalem.

Fig 8

A leaflet from Gordon's 1948 ACA show notes that his work "is constantly seen in every important national show," and adds that "his studio is now in the Bowery where, from this constantly changing scene of New York, he has created with definite imaginative feeling some of the paintings in this show." Stephanie has a vivid memory of that studio: "It was across the street from the infamous Men's Shelter. There was an airless studio with a fetid bathroom. A small, skinny Gypsy lived across the hall. She kept chickens and goats in the place. It was frightening and intriguing."

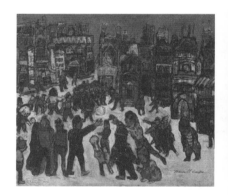

Fig 9

Many of Gordon's paintings seem to have been observed from his window. *Environment* (Fig 7), from 1948, is a tender scene of two parents tending to an infant child, framed by a door opening to a fire escape. *Parade* (Fig 8), *Snowball Fight* (Fig 9), and *Invasion* (Fig 10) show a great deal more of the whimsical imagination—as well as the thick and brooding colors—that would become the hallmarks of Gordon's future work. But they remain, identifiably, scenes of Manhattan living, cluttered, and energetic, and they earned him a label as a social realist, alongside the likes of Philip Evergood, Romare Bearden, Reginald Marsh, and Ben Shahn.

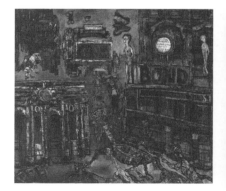

Yet the label never really fit. With few exceptions, Gordon's art rarely took an overtly political or even "social" turn. Instead, the paintings increasingly

Fig 10

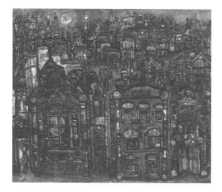

Fig 11

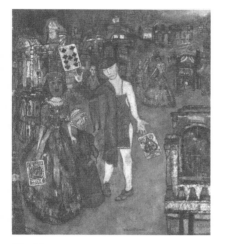

Fig 12

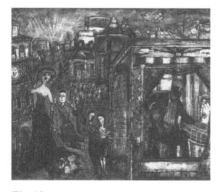

Fig 13

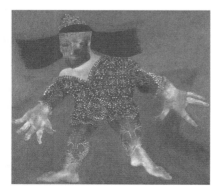

Fig 14

became allusive and allegorical, the landscapes and the characters other-worldly, as if he were attempting to rewrite Greek mythology. *Two Sides* (Fig 11), from the 1950s, seems doubly inspired by Breughel's *Christ Carrying the Cross* (1564)—particularly with its depiction of a crucified Christ who seems almost incidental to the large and busy scene—and Chagall's *The Dream* (1939). Masked figures also began to make regular appearances on Gordon's canvases, sometimes as carnival-goers (*The Jugglers,* Fig 12; *Evenin' Sun,* Fig 13); sometimes in not-quite-human form (*River Rest*); and sometimes, most powerfully, as suggestions of some deeper psychological truth (*Clown,* Fig 14).

"Maxwell Gordon's curious combinations of allegory, fantasy, genre painting and surrealism are in full evidence at the ACA Gallery," wrote *New York Times* art critic Dore Ashton in January 1959. "His most effective paintings are those in which the juxtaposition of the unlikely is overt. Such a painting is *River Rest* (Fig 15), in which cats as people, or people as cats, are mysteriously juxtaposed with an Etruscan Warrior. And they all seem to be floating somewhere very like the Hudson River."

Another review of the same exhibit offered this view: "While Gordon is too much the humanist to be the ordinary primitive, he is nonetheless faithful to his fantasies. Unlike Rousseau he works at a vision rather than a style. As a humanist he tends to be slightly didactic, but when he works directly with the fantastic (although he is capable of rather passable realism), he is able to transcend nostalgia. His pixies, angels, animals and people exhibit the tension of a dream life existing not in spite of reality, but as a psychological transformation of it."

Suffusing all this was a deepening sense of melancholy. Consider *Wounded Angel* (Fig 16): It is a work of almost unbearable sadness, a portrait of crippled ambition and defiled grace. "They were really spooky paintings," Stephanie remembers. "My brother and I couldn't stand to look at them."

The mood of the work seemed to track the mood of the artist. Stephanie speaks of Gordon as a gentle and attentive father, both before and after his divorce from Edith. But there was also a depressive and lonely streak, compounded by his unfulfilled ambitions and the strain of an impecunious existence. In 1960, Gordon was paying a monthly alimony of $90, or about $660 in 2009 dollars. It proved too much.

"Don't bet on me. I'm an artist," Gordon had once told his friend the poet and literary critic Leonard Wolf. In the fall of 1961, Gordon left for Mexico.

WHY DID GORDON decide on Mexico? Alma Reed, who had maintained a close connection to Mexico (she would die there in 1966), might have had a hand: It would help explain why, within weeks of his arrival, he was giving lectures about his work at the Mexican–North American Institute of Cultural Relations. Mexico was anyway an attractive destination for American artists, particularly those with limited budgets, radical politics, or both, and Gordon quickly fell in with the set. Ken Nielsen, an American who was living in Mexico at the time, remembers meeting Gordon in the company of Conlon Nancarrow, himself a political exile from the United States and among the most distinguished avant-garde composers of the 20th century.

Of his first impressions of the country, Gordon later told journalist Pat Alisau, "When I first came to Mexico, I asked myself what I can learn from it. I found something by reading of it in Bernal Diaz's writings"—referring to the great eyewitness account of Hernán Cortés's conquest of the Aztec Empire—"but I felt very attracted when I first saw those anonymous paintings done during colonial days. I liked the mystery, the unknown of those works and as a result I tried to paint in this spirit."

Yet Gordon never intended his sojourn in Mexico to be permanent. In 1962, he set off on a long trip, first across the American South, then through Italy, France, and England, and culminating in what was meant to be a triumphant return to New York with another one-man show at the ACA Gallery. It ended in disaster. On the exhibit's first night, the police impounded 24 of his paintings, which Edith collected as debt for Gordon's unpaid alimony. It was a blow from which he never recovered. Gordon was 52 and nearly penniless. But he had developed a mature and confident style, emotionally haunting and imitative of nothing else. He went back to Mexico as a virtual exile, convinced he could never return to the only city where he might establish a major reputation.

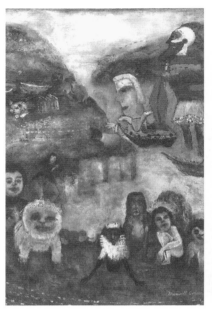

Fig 15

Years later, the wound remained raw, prompting Gordon to write a despairing letter to Edith, dated November 14, 1968:

> *Dear Edith,*
> *This letter may come as a surprise to you, but I must make the attempt to appeal to your generosity.*
>
> *I have now been in Mexico for about seven years, away from the city which was my home, without my family, and terribly lonesome most of the time.*
>
> *I have lived in Mexico all these years because of your judgment against me under our separation agreement, and my lack of money. I am sure that your rights in the agreement are unquestionable. But the only way I can earn money is through my paintings and if I tried to paint and exhibit in New York all my work could be taken by the sheriff, like the last time. I am financially incapable of paying even your old judgment against me, much less the arrears I may owe you since then.*
>
> *We were young when we first met and planned a life. Now, my bones are getting stiffer and I've had to see doctors about my blood pressure, liver and bad pains in my knees.*
>
> *We once loved each other and you were a devoted and faithful wife. I know you have made a success of your career and I have always had belief in your intelligence, talent, creativity and capacity to succeed in anything you try. Yet I also know what suffering you may have gone through. Since we have separated I have talked to divorced women and I am well aware how such a woman has it difficult. Yet a man alone suffers also.*
>
> *After all these years Mexico is still not my home town. Our children,*

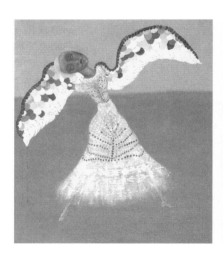

Fig 16

my past, and my memories are all of New York and I would like to be able to be there.

Would you consider making a new "Agreement" of some sort which would permit me to come back to New York? If you would be willing we could get together to talk personally or whatever you suggest.

Perhaps I should have written this kind of letter earlier but I probably was too proud to do it. But now I realize I can't continue to live on pride only.

I remember the parts of your personality that were soft and good hearted, and I hope that that part of you will now create some ideas for a solution which I know will have no practical gain for you but will take away the unhappiness I live under.

Please let me hear from you soon,

Max.

The letter must have meant something to Edith, since it survives. But it didn't mean so much that she actually agreed to a settlement—something that would come only after about a decade, during which Gordon thought himself effectively unable to leave Mexico. It would be years before he set foot in the United States again.

In the meantime, however, Gordon's life was not quite as bleak as the picture he painted in the letter. He quickly became a social fixture, popular with men, successful with women—the quintessential expatriate artist. "When we entered the museum of modern art [in Mexico City]," recalled his friend Nick Ingram, "the employees instantly recognized him as 'Maestro,' and would not allow us to pay to enter." The press also took notice: "The Maxwell Gordon opening at the Turok-Wasserman galleries on Wednesday night drew such a crowd that undoubtedly many of the visitors will be returning to see the paintings which were nearly invisible because of the crush," went a January 1964 account in the *Mexico City News.* "Obviously, Mr. Gordon, the globe-trotter, has gained many admirers in Mexico, for comments of first-nighters were warm and demands for prices brisk."

Gordon also became terrifically productive as an artist, the result of having no other professional responsibility except as a private painting instructor. "He was living in an apartment on Rio Hudson, in the Colonia Cuauhtemoc," recalls Louis Stephens, referring to a neighborhood in downtown Mexico City. "It was high-ceilinged and well-lit, though the light came from the west and not the north, as artists prefer. Instead, it was lit from the west, which meant that in the afternoon the sun would come pouring in."

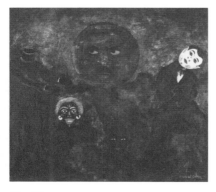

Fig 17

Louis, who studied with Gordon for eight years and would become his close friend, avid collector and personal champion, first met him in the late summer of 1965, at an exhibit of more than 50 of his works in the Palacio de Bellas Artes, the turn-of-the-century Beaux Arts building that is Mexico City's premier cultural space. The exhibit was something of an

Fig 18

event: A full-page spread in the *News* had photos of Gordon chatting with the U.S. embassy's cultural attaché, John Brown, and architect Harold Leeds of New York's Pratt Institute. Louis remembers being struck by the extraordinary quality of Gordon's paintings, a cut above anything he had seen in Mexico by recent painters. Also, by the force of his personality: "He was blunt, frank, to the point," says Louis. "He could get to the nitty-gritty in two seconds. He might have sometimes been cantankerous, but he was never devious. He was straight."

How much of Gordon's internal life can be seen in his art isn't easy to say, and perhaps it mistakes his purpose to ask. Still, he was not without thoughts on the subject. "The canvas is prepared for *all* of life," he wrote in one of his notebooks, describing his technique as a function of his philosophy. "The bumps are taken out—the receptive absorbency is taken care of for each of the 2 main phases to fit into. So, each painting has 2 main lives. The 1st life in full bloom. The 2nd life, thoughtful, retrospective, as it could be, as it might have been, as it becomes, as it *changes*."

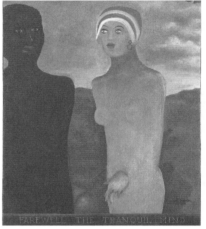

Fig 19

Less clear is whether Gordon had specific ideas of what his paintings were actually about. "Max did like to be interpreted," says Louis. "He'd say, 'I might tell one story [about a painting] and you might tell another.' But he'd also say, "You've got to *look* at the painting.'" When pressed, Gordon would sometimes describe his paintings as expressionist— critics called it "folk expressionism"—but he also insisted on the strictly visual experience of the work. "The paint," he would say, "has to do the talking."

So it did. Works such as *Extraños* (Fig 17) and *Another Search, Mexico* (Fig 18) are portraits of an atmosphere, more interesting for their tenebrous hues than for the mystery of the dimly seen faces and figures. In *Farewell the Tranquil Mind* (Fig 19), the drama of Othello and Desdemona becomes an opportunity to juxtapose black with coral, brown-green with cerulean blue. *Ring Around the Rosie* (Fig 20) takes inspiration from the moon landings to explore every possible shade of lunar gray. By contrast, paintings such as *The Champ* (Fig 21), *Death of a Warrior* (Fig 22), and *Leda and the Swan* (Fig 23) are romps of vivid color, their very garishness a counterpoint to the sadness of their themes.

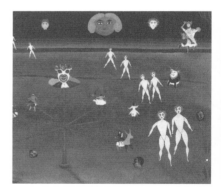

Fig 20

"Colors are important to me," he told Pat Alisau in one of their interviews. "You notice I have lots of black people in my paintings. I like the function of working with the black colors—their richness." Still, Gordon insisted that he remained attentive to the narrative aspects of his work. "I try to make a feeling of what I say," he added in the same interview. "It's poetic painting. For example, in one of my works, a man in a boat comes to a strange land, sees a man and woman embracing—her breasts sticking out. When he arrives, everything stops. That's the painting of the moment. It's the way I know how to say something."

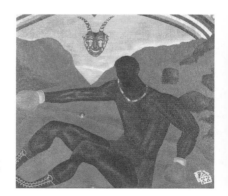

Fig 21

It was not the only way. Gordon was also careful, even obsessive, about the titles he gave his paintings, entertaining dozens of ideas before settling on one. For the *The Last Voyage* (Fig 23), he scribbled down 22 possible titles in his notebook, including "The Last of the Masks," "While the Angels Sing," "The Ship That Goes You Know Where," "Tidal Wave," "Maelstorm,"

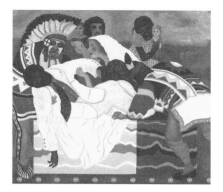

Fig 22

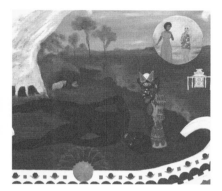

Fig 23

Fig 24

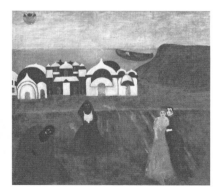

Fig 25

and "The Bier." Each reflects an aspect of an otherwise enigmatic painting. But his ultimate purpose wasn't to explain his works but instead to add to their mystery, giving free rein to the viewer's imagination.

Look, for instance, at *The Cessation and the Trial* (Fig 25). Without its title, the painting suggests a marriage, seemingly on the edges of some coastal African city. But the title adds another layer of imaginative possibilities. Just what has ceased and who is being tried? Why are the woman's breasts exposed? Is the man with the painted face her groom, her initiator into the ways of the country (or of sex), or something altogether more sinister? Are the three black figures bowing in respect, dancing in celebration, or taunting and tormenting a victim?

Dozens of Gordon's paintings lend themselves to similar kinds of questions, and the answers they evoke have a way of sounding hidden chords in the viewer's memory and subconscious. The effect is to disturb the tranquil mind—an effect heightened by Gordon's fascination with masks. Masks began to appear early in Gordon's work, often as central elements. But in Mexico, with its ancient and diverse mask-making traditions, masks became a second signature to his work. They served his purposes in various ways: as decorative motifs, as disguises, and as a kind of Greek chorus, observing the folly of the principal scene while reminding the viewer that he too, perhaps, is being observed.

Then, too, the masks could sometimes serve as alter egos, physical as well as emotional, when Gordon inserted himself into his paintings. It is almost certainly Gordon who is the masked painter in *The Painted Wedding* (Fig 26). It is probably Gordon, too—the broad red mustache is a giveaway—who is the masked figure in *The Performers* (Fig 27) just as it is likely that the other two figures are Stephanie and granddaughter Lauren. Gordon is also almost surely the bear in *The Son's Fantasy* (Fig 28), painted after a particularly difficult visit from his son Mark in Mexico.

There's a sentimentalism in these paintings (as there is in *Yesterday and Today* (Fig 29), a tribute to his parents) that in some ways renders them more approachable for the viewer. They betray Gordon's preoccupations with getting old—with the risk of becoming, in the case of *The Performers,* encrusted in somebody else's mythology. It's a preoccupation that grew only more acute the longer Gordon spent in his Mexican exile.

AND THEN, ON the eve of his 67th birthday, he settled his accounts with Edith for a mere $4,000. Suddenly he could go home again, reclaim his city, get a second shot at the recognition he was sure Edith had denied him 16 years earlier. He packed his bags, going first to see an old friend in San Francisco, and then on to New York, where he took a small apartment at the Chelsea Hotel.

Gordon's hopes could hardly have been higher. "Construct a show for success as art and money," Gordon had written earlier in one of his diaries. "Must be New York...Make 15 major paintings for N.Y. exhibit and sellout in major gallery." "In Mexico there are no fellow artists for inspiration." "With success can come happiness—freedom from Edith's legal position and a better relation with my children."

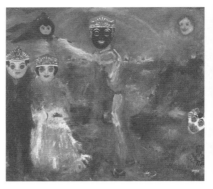

Fig 26

Yet again, the long-anticipated triumphal return quickly descended to trauma. Gordon had been away too long; the city had been transformed and made squalid; his old friends had moved on; his relationships with his children proved difficult. And there were new gods, not his, on the art scene. The ACA gallery, under new management, was not keen on another one-man show. A request to the director of the San Francisco Museum of Modern Art to display his paintings went nowhere. A long-distance love affair with a woman in Montreal didn't work out. Who or what else was there to turn to?

"Thanksgiving: One of the inhabitants of Chelsea hotel—a young woman— talks of making a dinner if she gets her own room," Gordon wrote a friend late in 1979. "She's living with a guy here she's not fond of. The police went investigating something here at Chelsea last night. The 'punk bands' stay here. Since I've been here 2 stabbings and a pool of blood in the hall, they don't know who from." (A year earlier, Sid Vicious of the Sex Pistols had stabbed his girlfriend Nancy Spungen to death in the same hotel.)

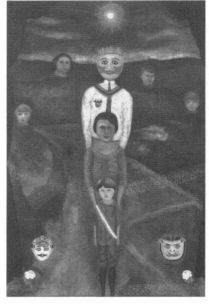

Fig 27

Gordon's stay in New York proved to be perhaps the unhappiest time in his life—so much so, Stephanie says, that he made a failed attempt at suicide. Within a year he was back in Mexico, in an on-again, off-again relationship with a Russian woman named Katya, in the company of his circle of friends and admirers. But he was restless, and he had an invitation from friends to visit Israel. He arrived there in August 1981, "a wanderer," as he wrote his daughter, "and very often alone."

Gordon settled in an apartment above Jerusalem's outdoor Mahane Yehuda market, the one place in Israel whose sights and smells could be mistaken for Mexico's. He traveled the country widely, ate his Sabbath meals at Arab restaurants in the Old City, hiked through the Judean desert, took in movies at the cinematheque, and made a stab at learning Hebrew.

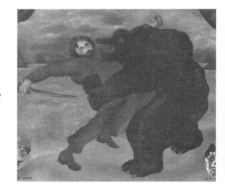

Fig 28

For a 71-year-old man moving to Israel was a gutsy thing to do, in line with Gordon's declared sense of himself as a latter-day Ulysses. But the country didn't take. "My neighborhood is like an old *shtetl* in Europe," he wrote Stephanie that fall. "Men in black, long hair...prayer shawls sticking out from undershirts. It would take a book to go into descriptions of fanatic Jews, moderate Jews, some non-religious Jews.... Food is horrible."

Again it was back to Mexico, this time by way of the south of France, Amsterdam, and Cornwall. By the following summer he would be dead. It was a case of cancer that had spread to his lungs, kidneys, and brain. He left for New York and checked in to Sloan-Kettering, where he learned his case was terminal. On a visit to see his father, Mark found him naked, on the floor, his intravenous drips all yanked out. Unlike the figures in so many of his paintings, he was not one to be easily reconciled with his own mortality.

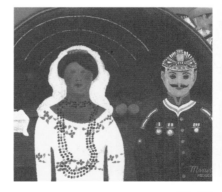

Fig 29

Stephanie recalls her last encounter with her father this way: "He didn't recognize me, because his brain tumor had returned, and he was staring at nothing, not seeing or hearing me. After sitting together for half an hour, I finally kissed him good-bye and walked down a very long corridor to the elevator. Standing there alone, I suddenly heard him yelling my name.

I ran back, and when he saw me he pointed to his closet and kept repeating, 'My slides, Stephie. Take my slides. Don't forget my slides.' I took a small brown zippered bag out. He nodded and turned away, staring again into space."

He died on June 23, 1983. His ashes are scattered in a rosebush in the village of Tepoztlan, an hour's drive south of Mexico City.

SOMEWHERE IN HIS notebooks, Gordon copied out these lines from T.S. Eliot's "The Hollow Men":

> *Between the conception*
> *And the creation*
> *Between the emotion*
> *And the response*
> *Falls the Shadow.*

It's as if the words were written for Gordon, both as an epitaph for his life and as an epigram for his work. Gordon was a painter—and a man—of journeys and exiles, of enigmatic arrivals and leave-takings, of quiet heart-breaks and tenderness amid desolation, of moments (and states) in between, of the nearly forgotten. It's for these reasons that he deserves to be ranked among the greatest and most original American painters of the 20th century. Leaf through the pages that follow, and see what stirs.

Bret Stephens
New York City
July 2009

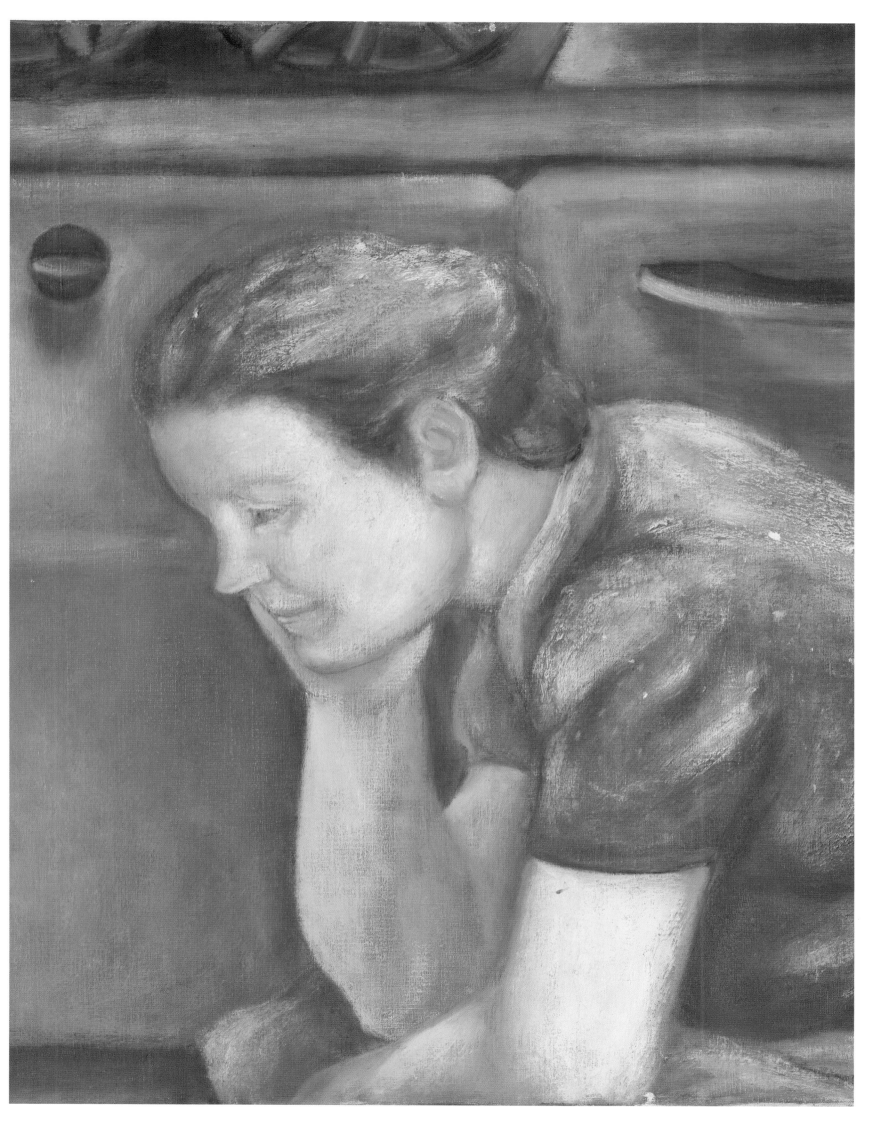

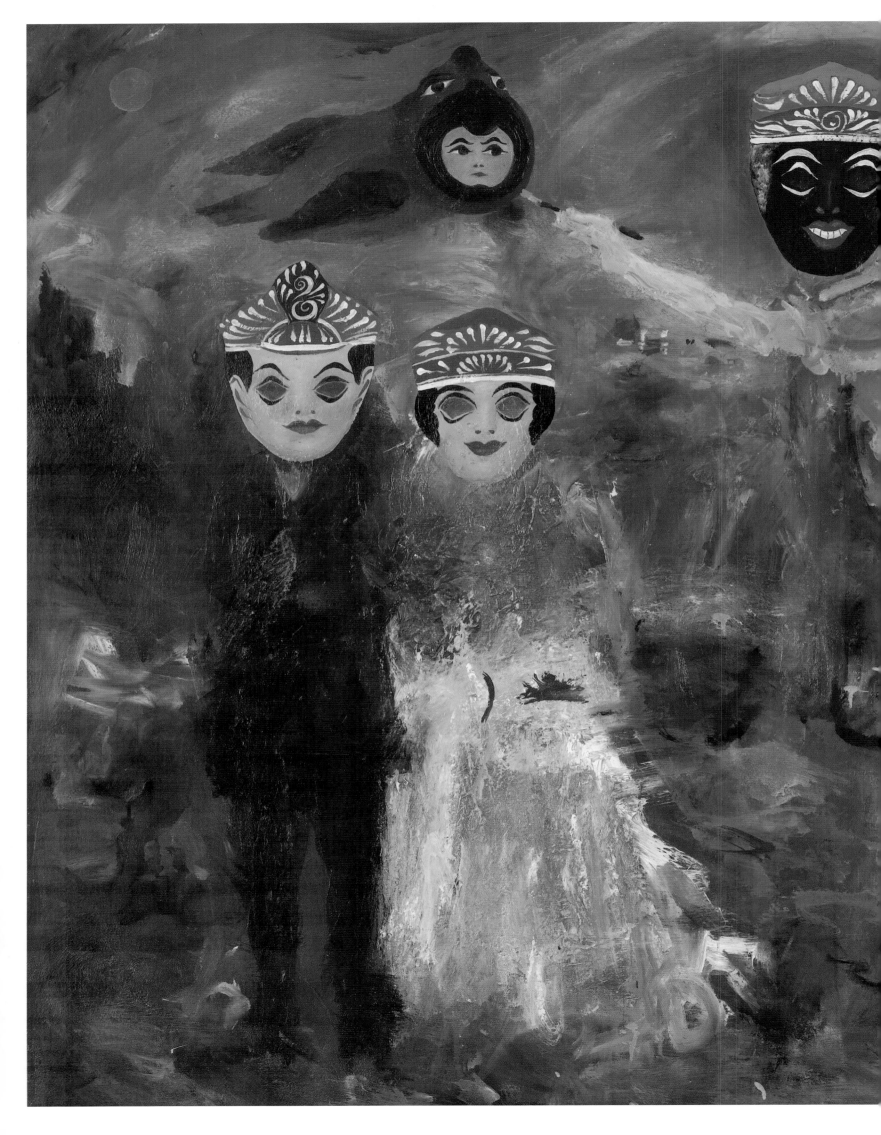

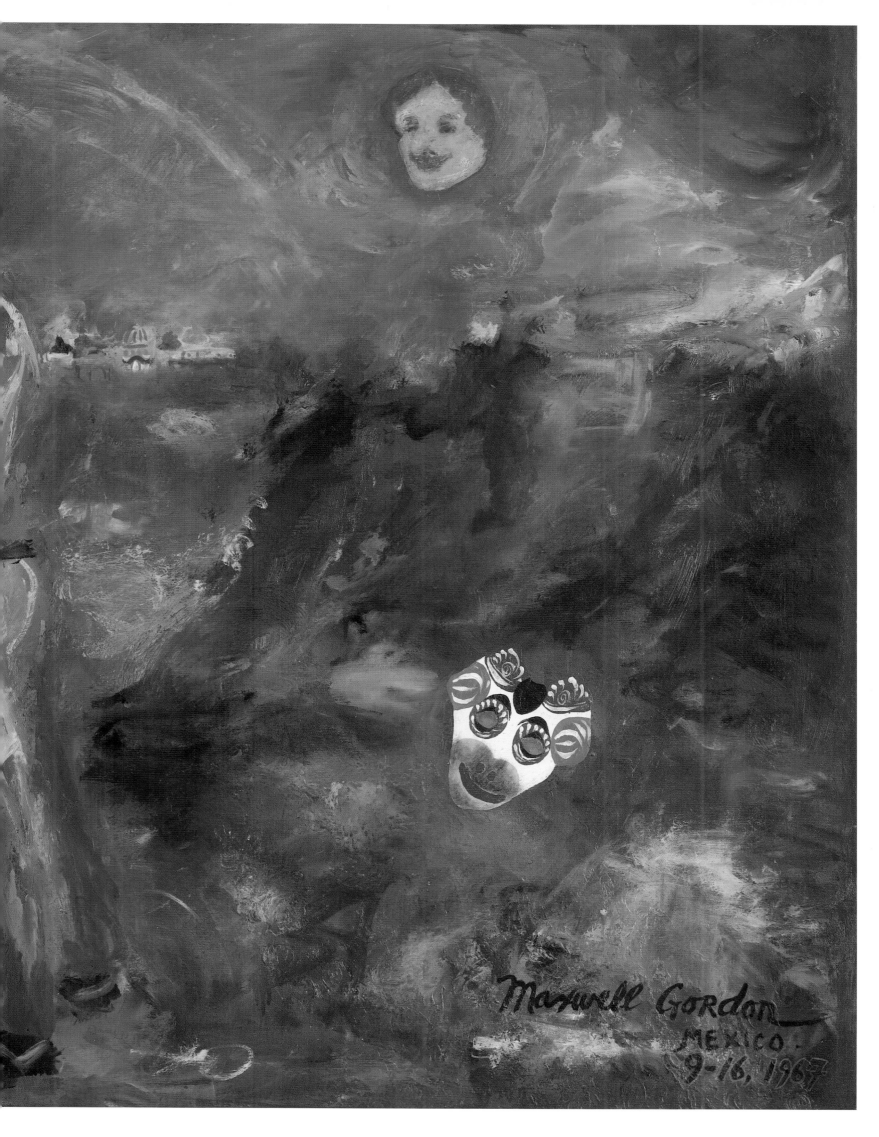

Maxwell Gordon
MEXICO.
9-16, 1967

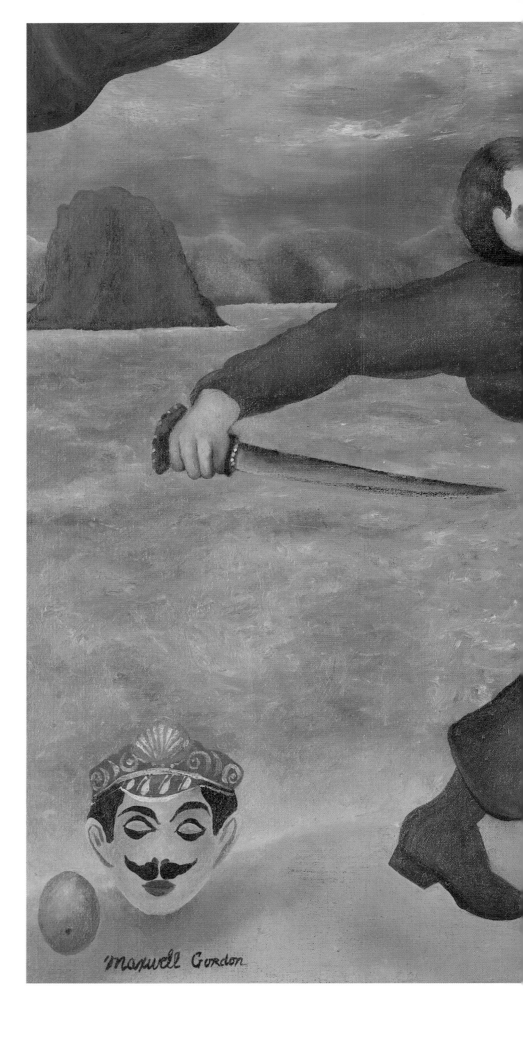

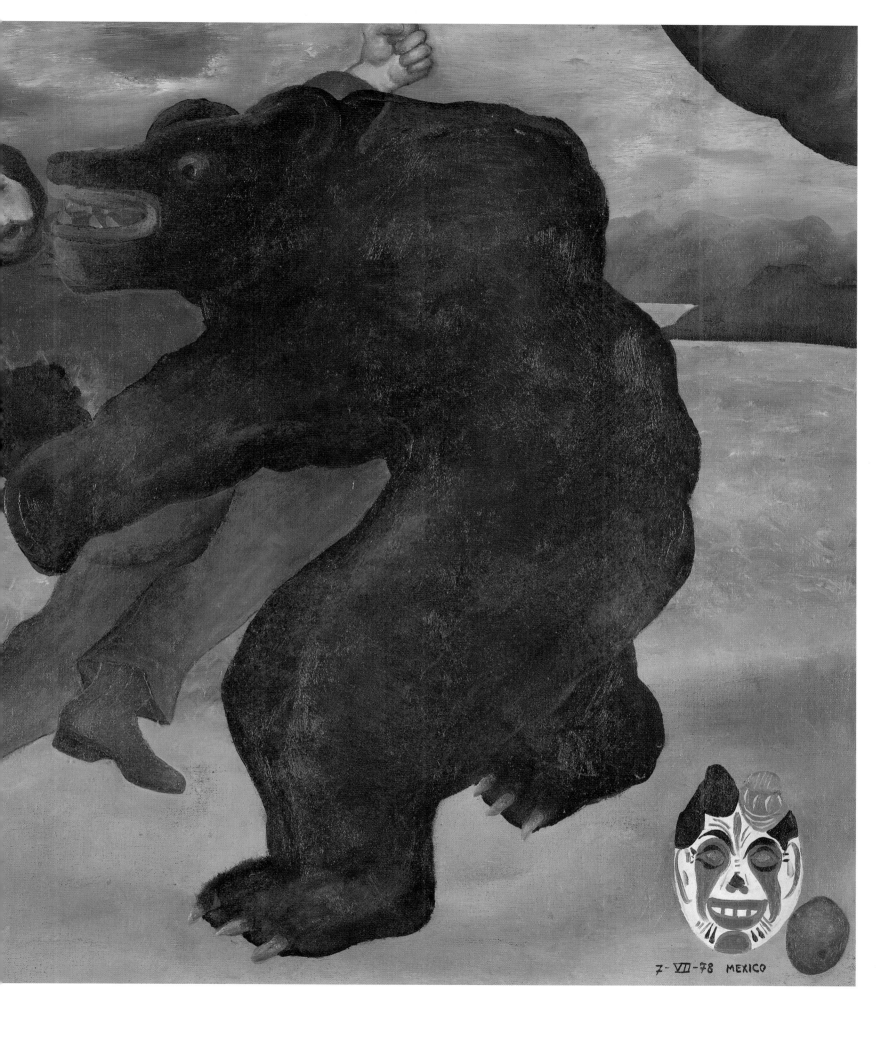

7-VII-78 MEXICO

> Strange Dames Dancing
in My Studio_[1964]
Oil on canvas

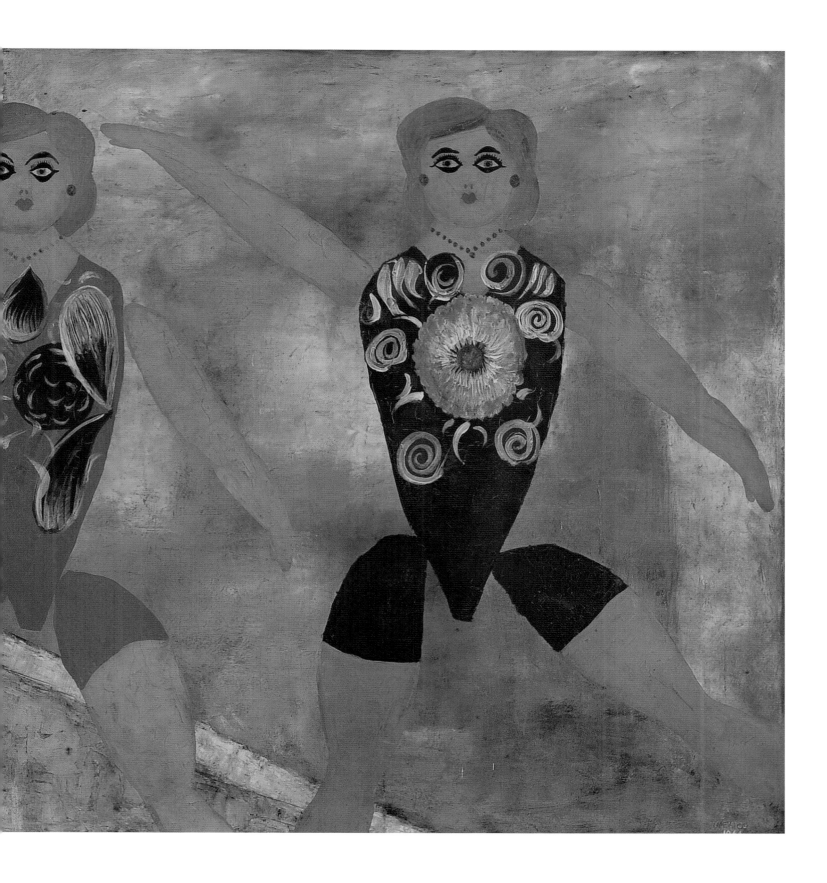

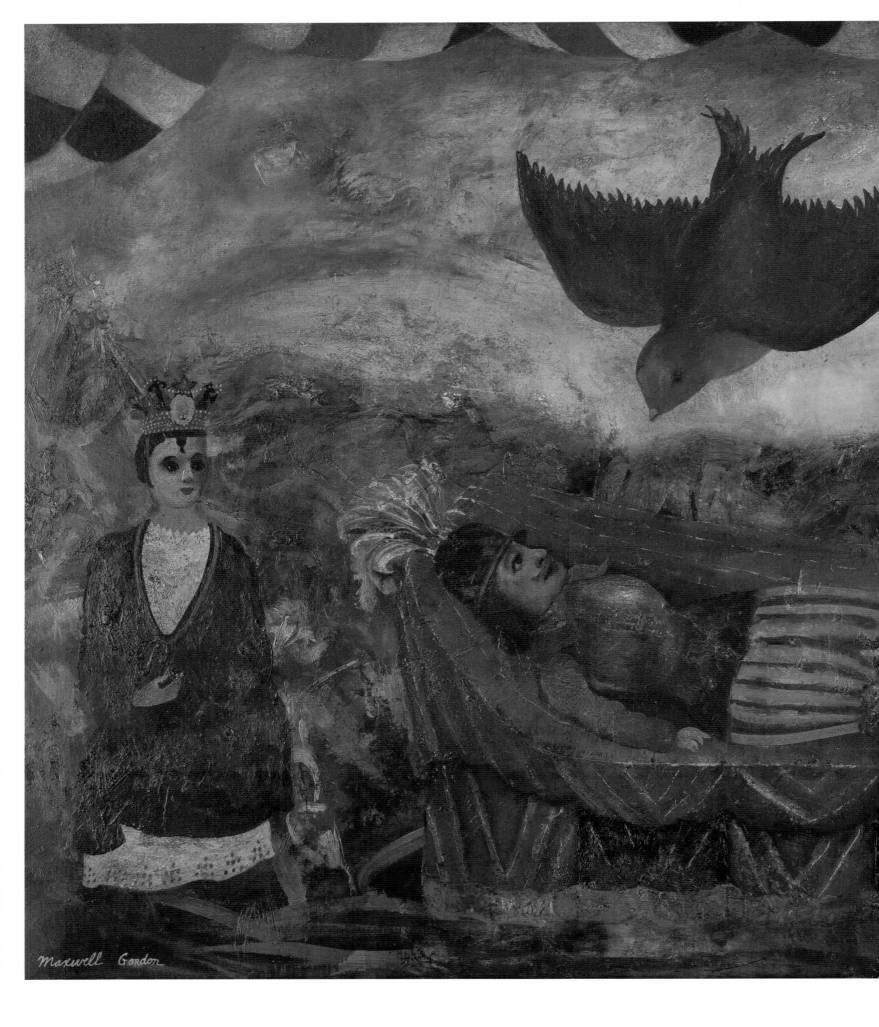

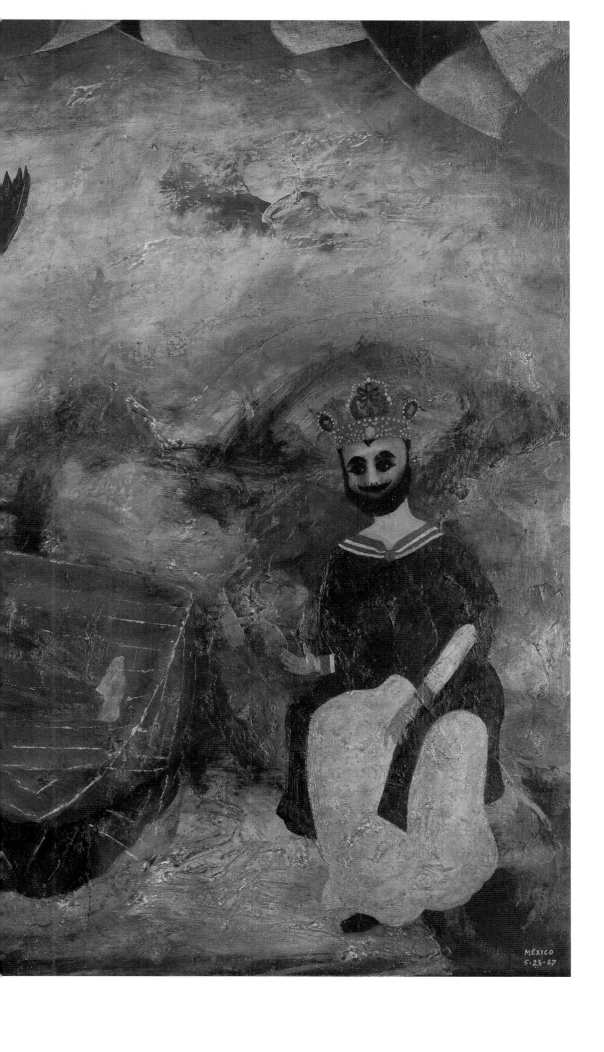

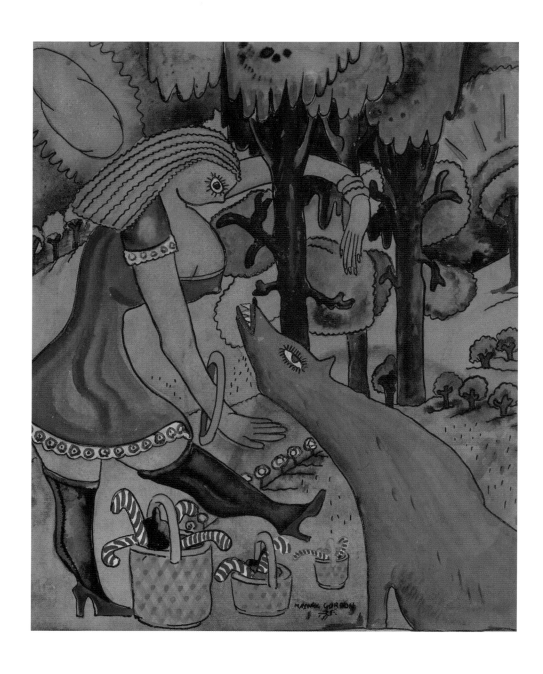

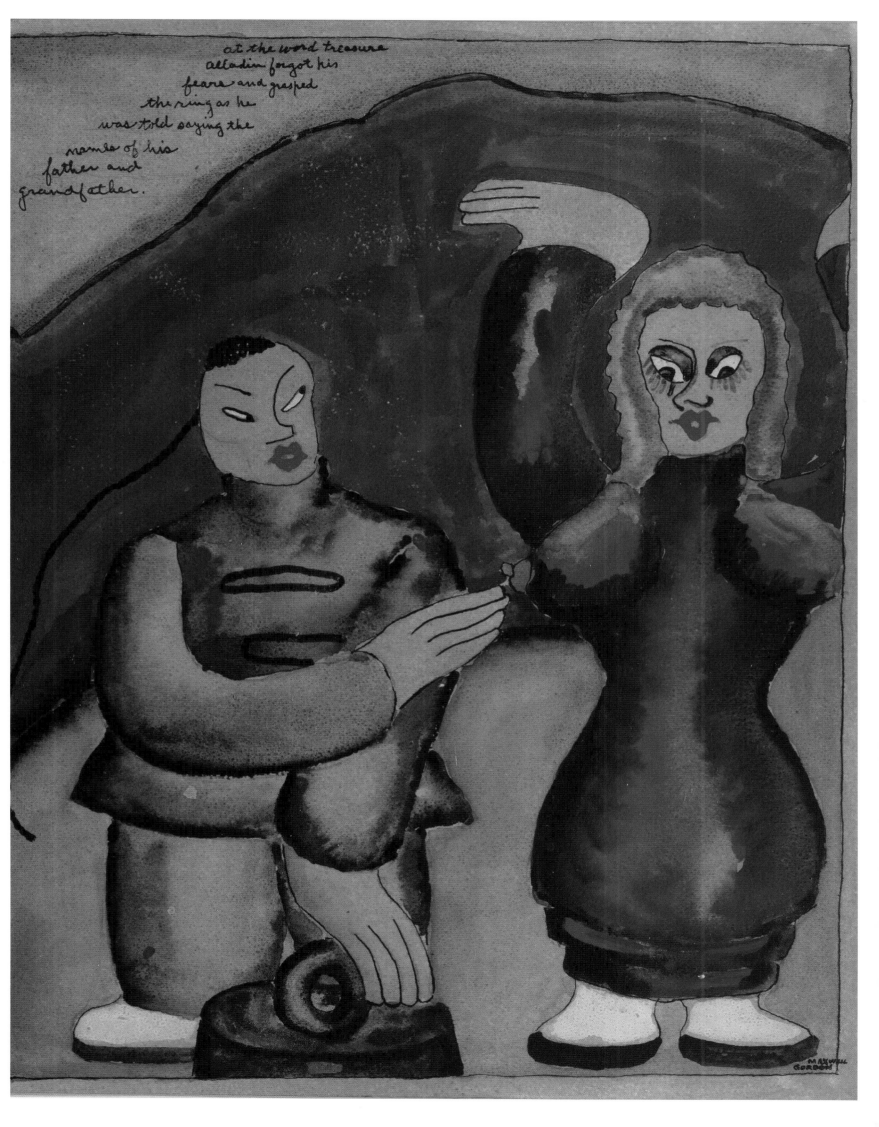

at the word treasure
alladin forgot his
fears and grasped
the ring as he
was told saying the
names of his
father and
grandfather.

Oil on canvas

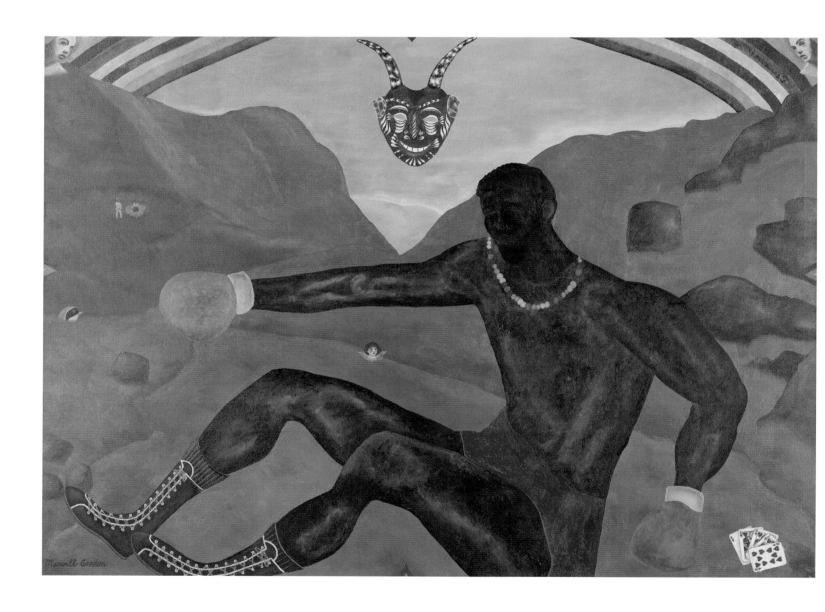

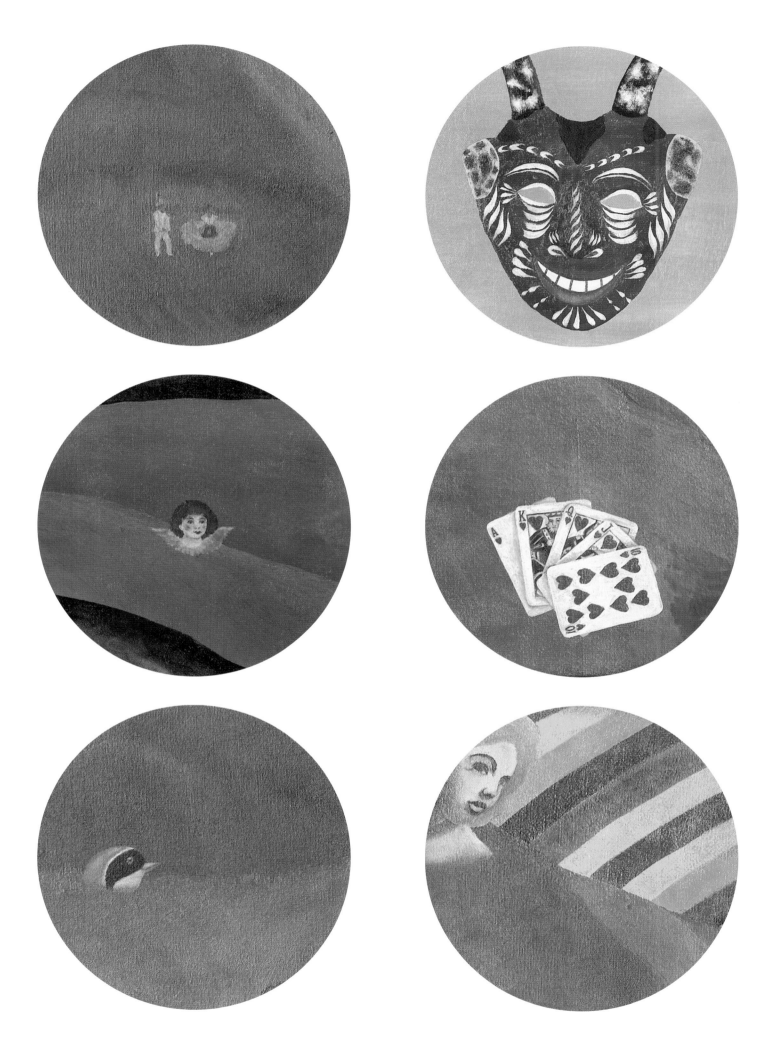

∨ Old Man Study_[undated]
Oil on canvas

> Self-Portrait_[1930s]
Oil on canvas

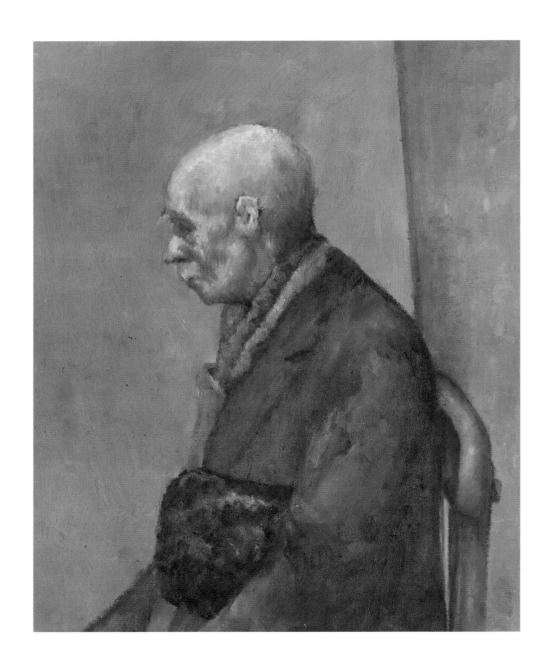

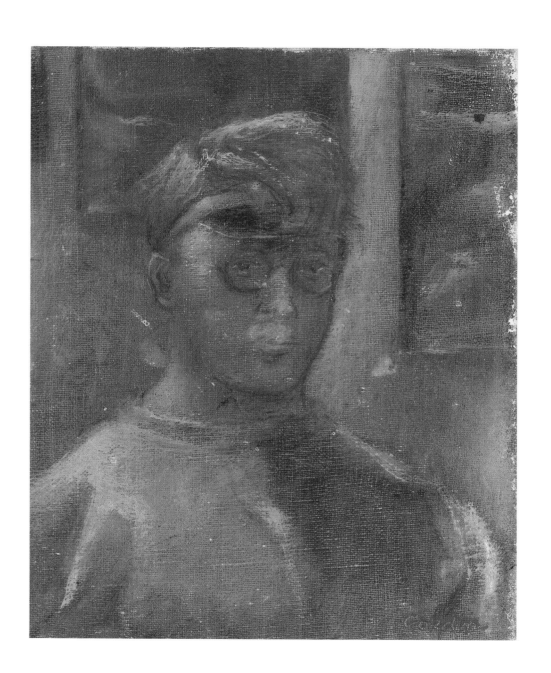

> Untitled_[1980]
Oil on canvas

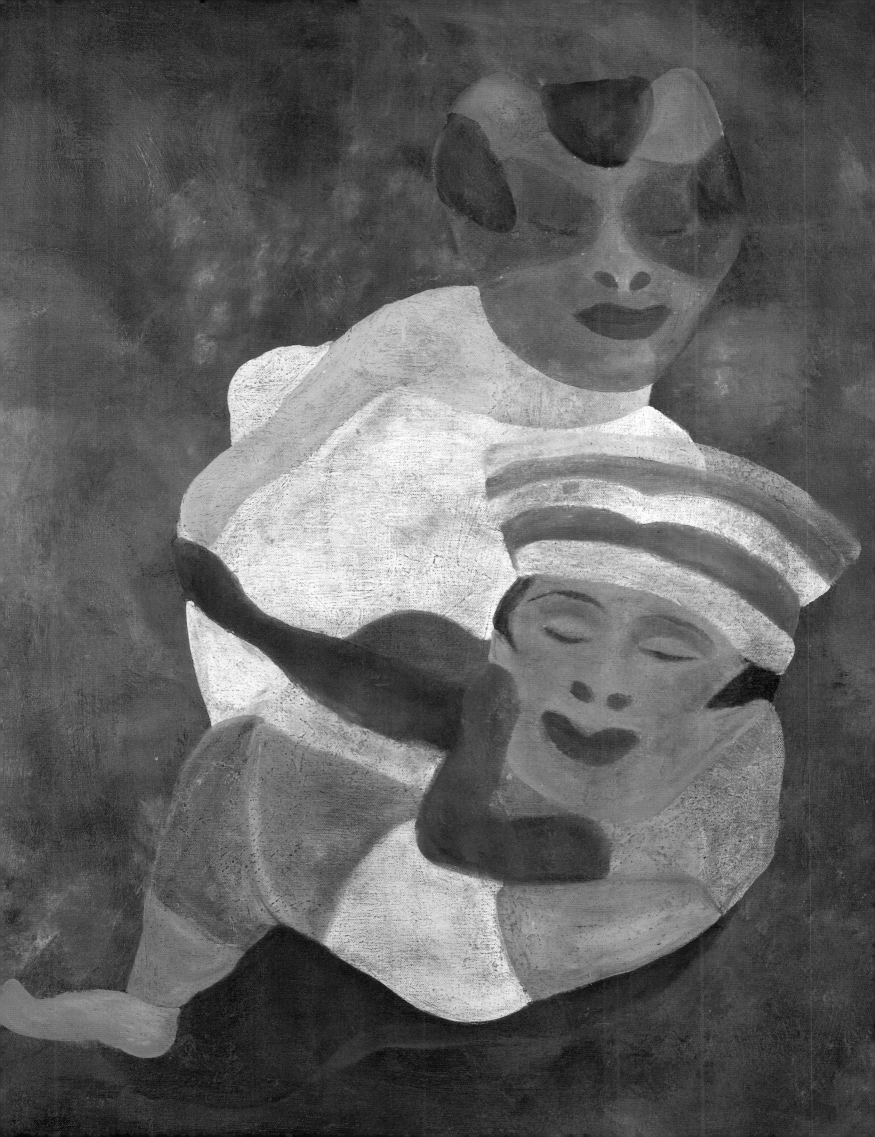

∨ White Hill_[1940s]
Oil on canvas

⩔ Cleve—Still Life_[1930s]
Oil on canvas

> Furnished Room_[1930s]
Oil on canvas

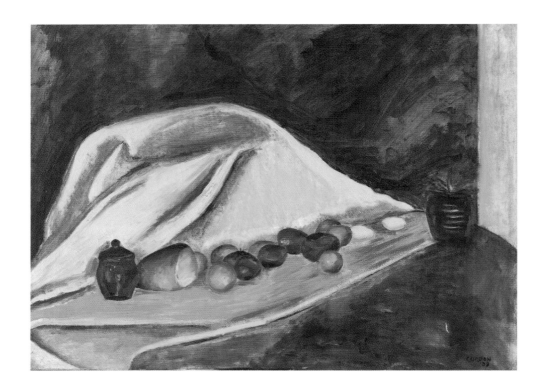

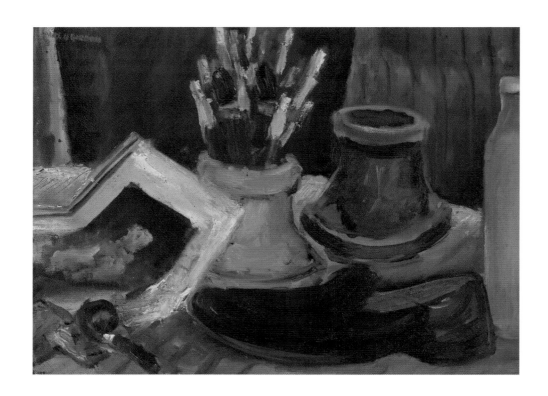

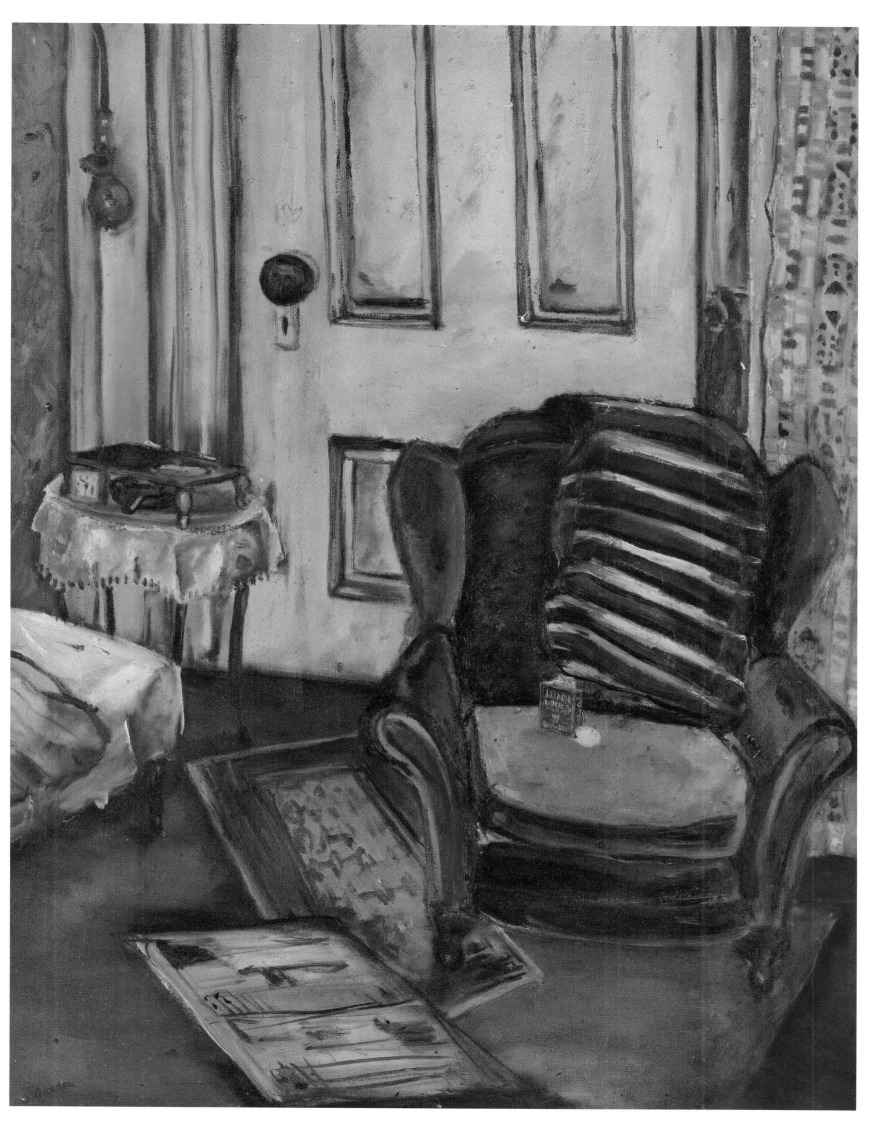

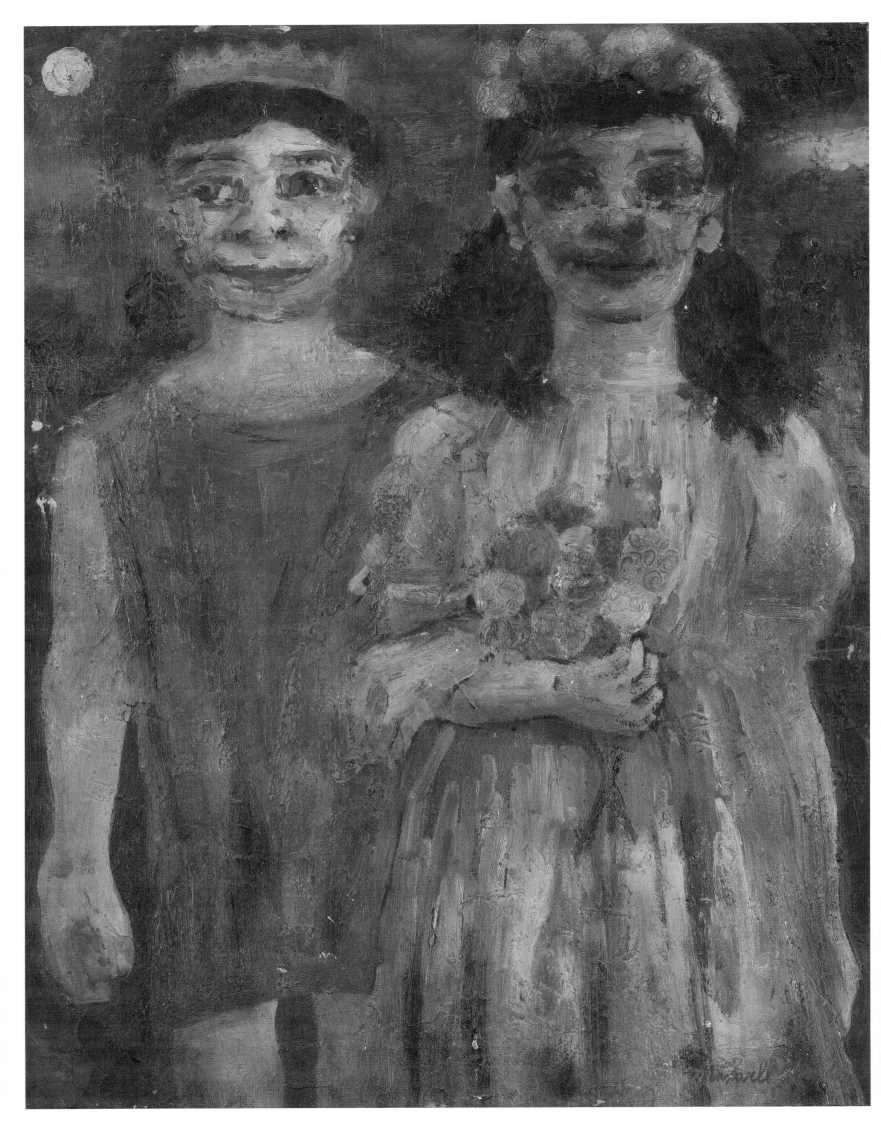

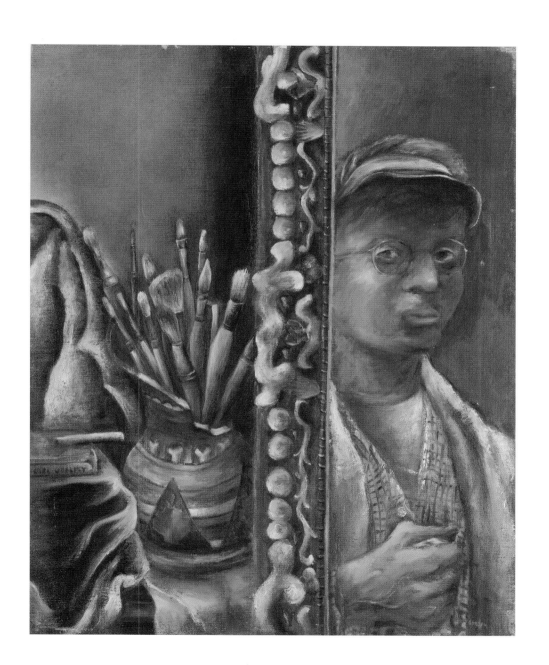

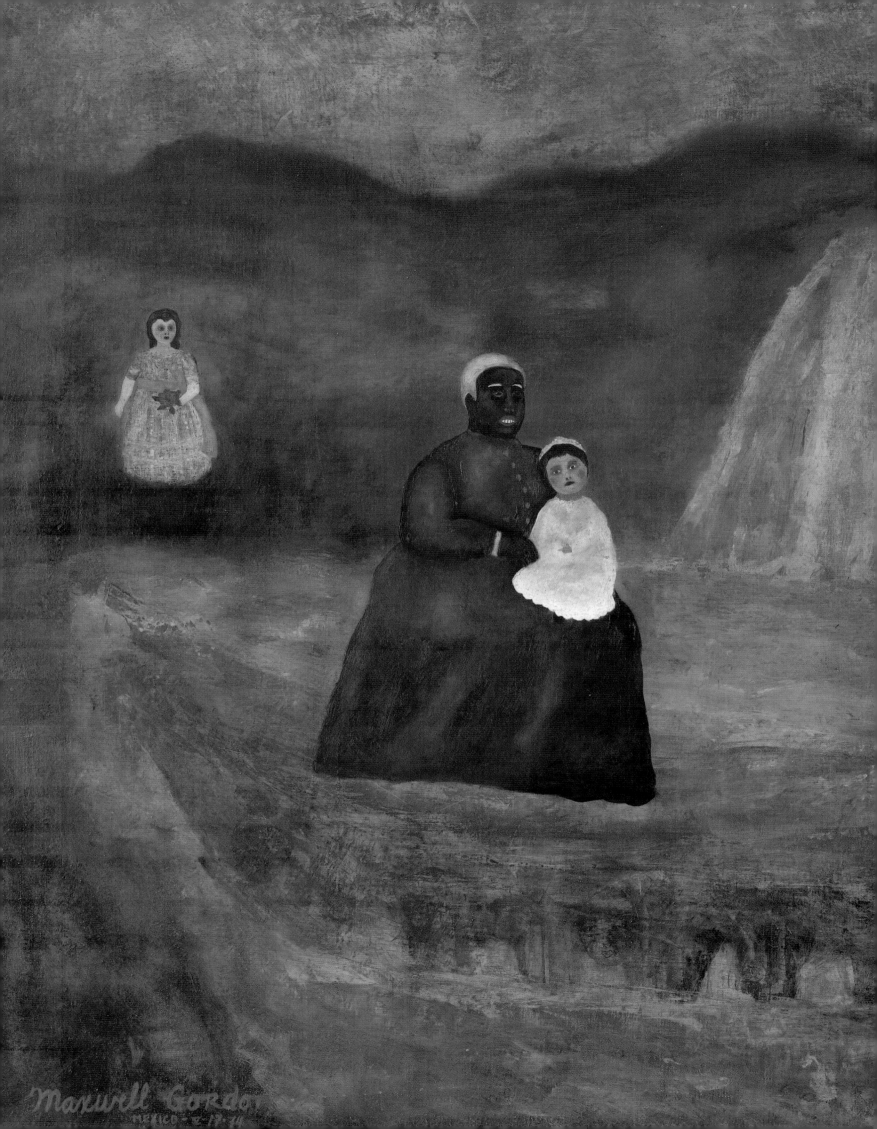

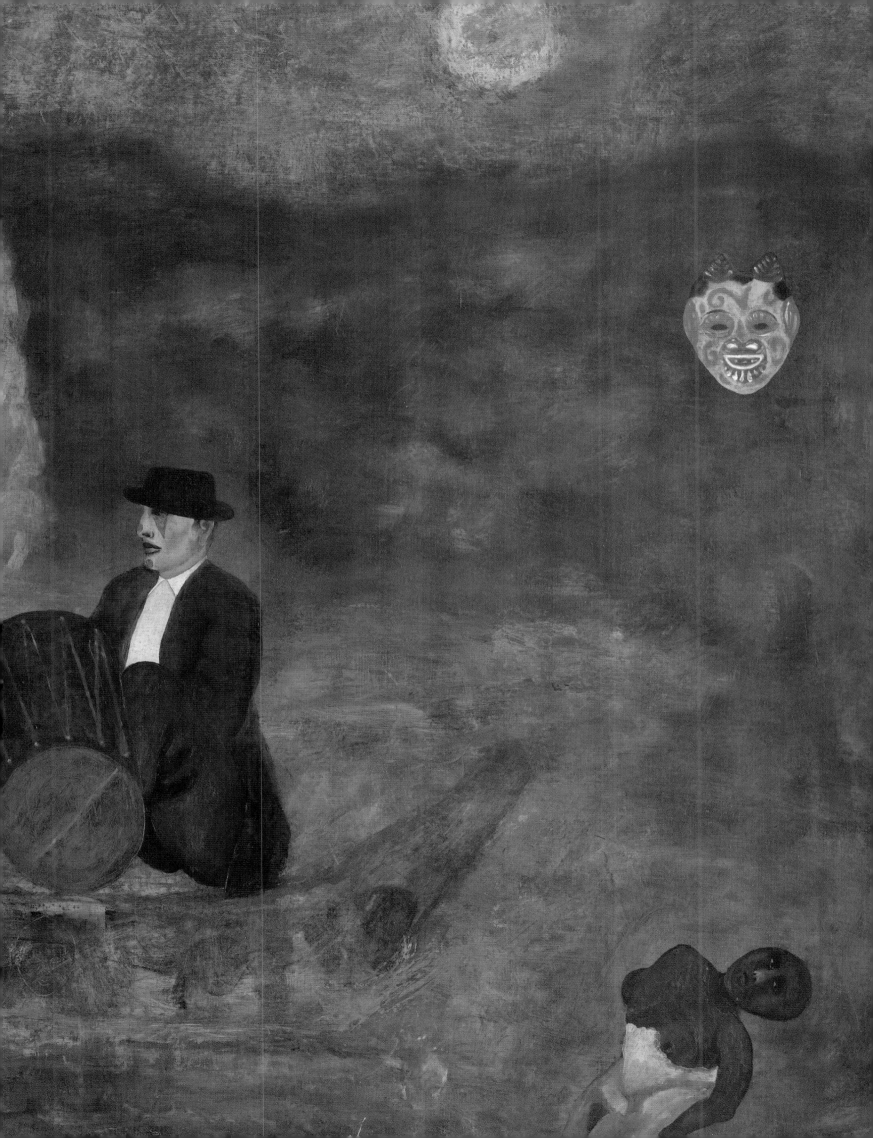

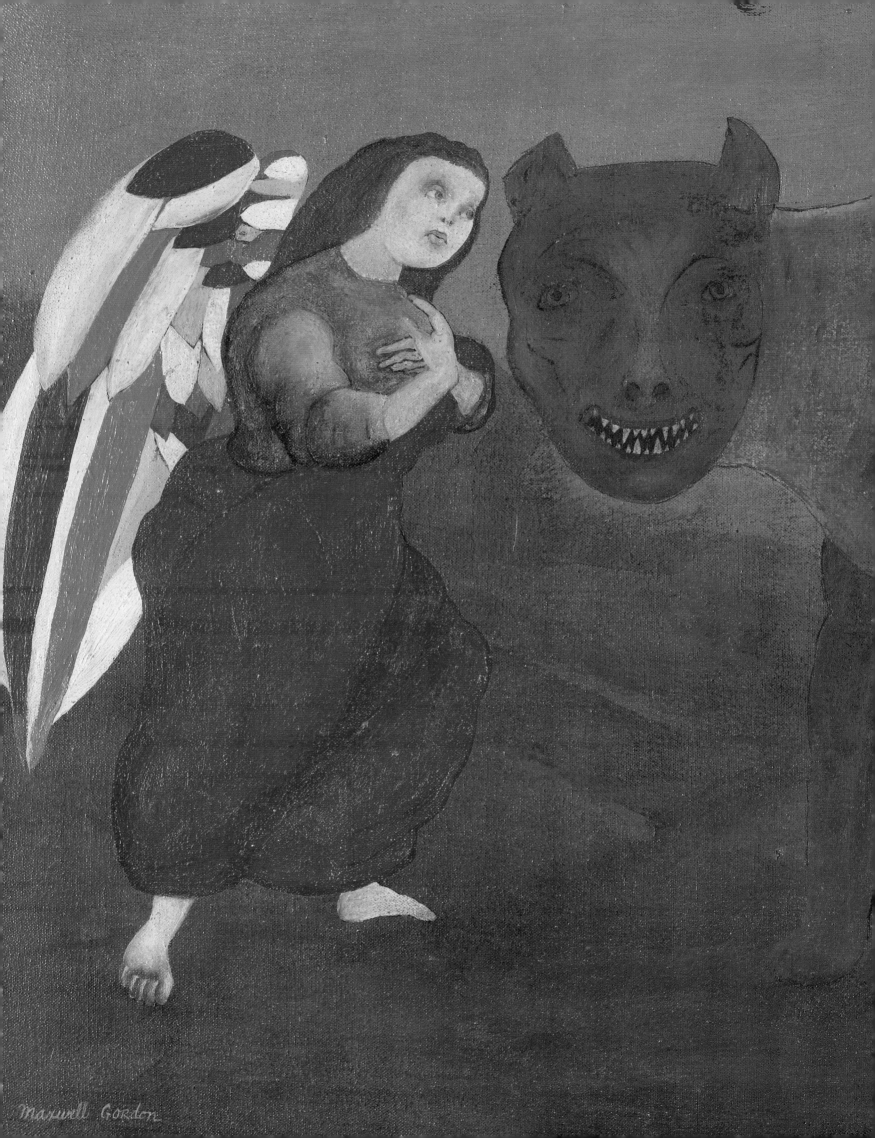

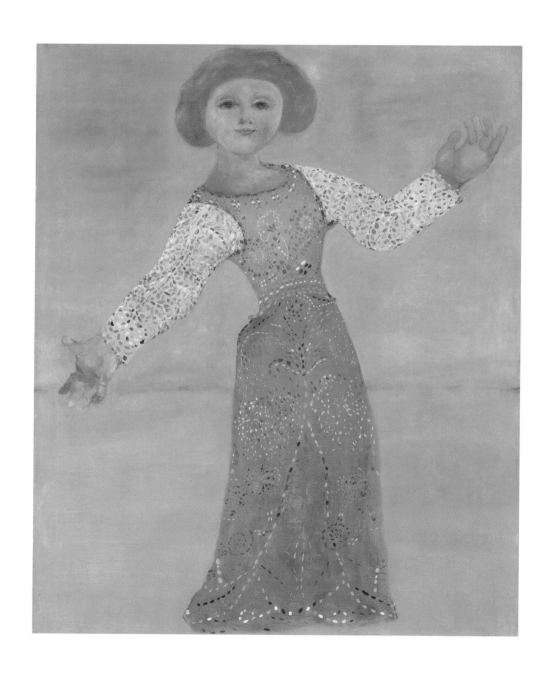

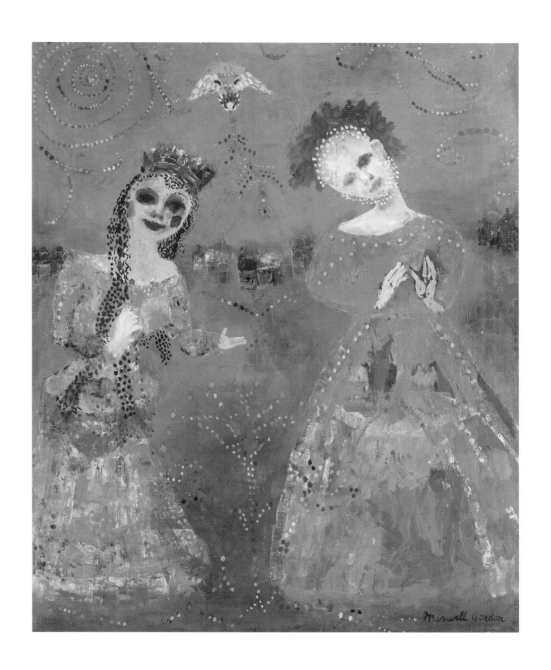

> Wounded Angel_[1950s]
Oil on canvas
>> The Jugglers_[undated]
Oil on canvas

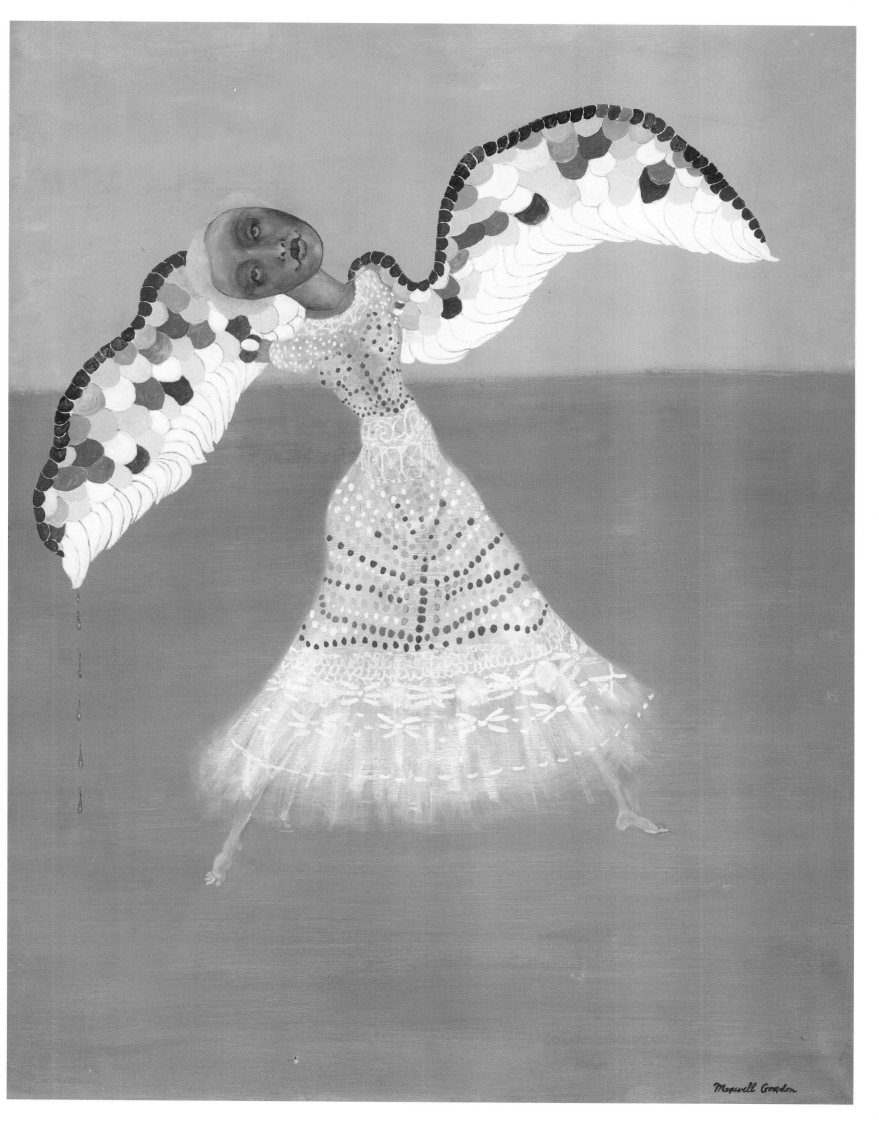

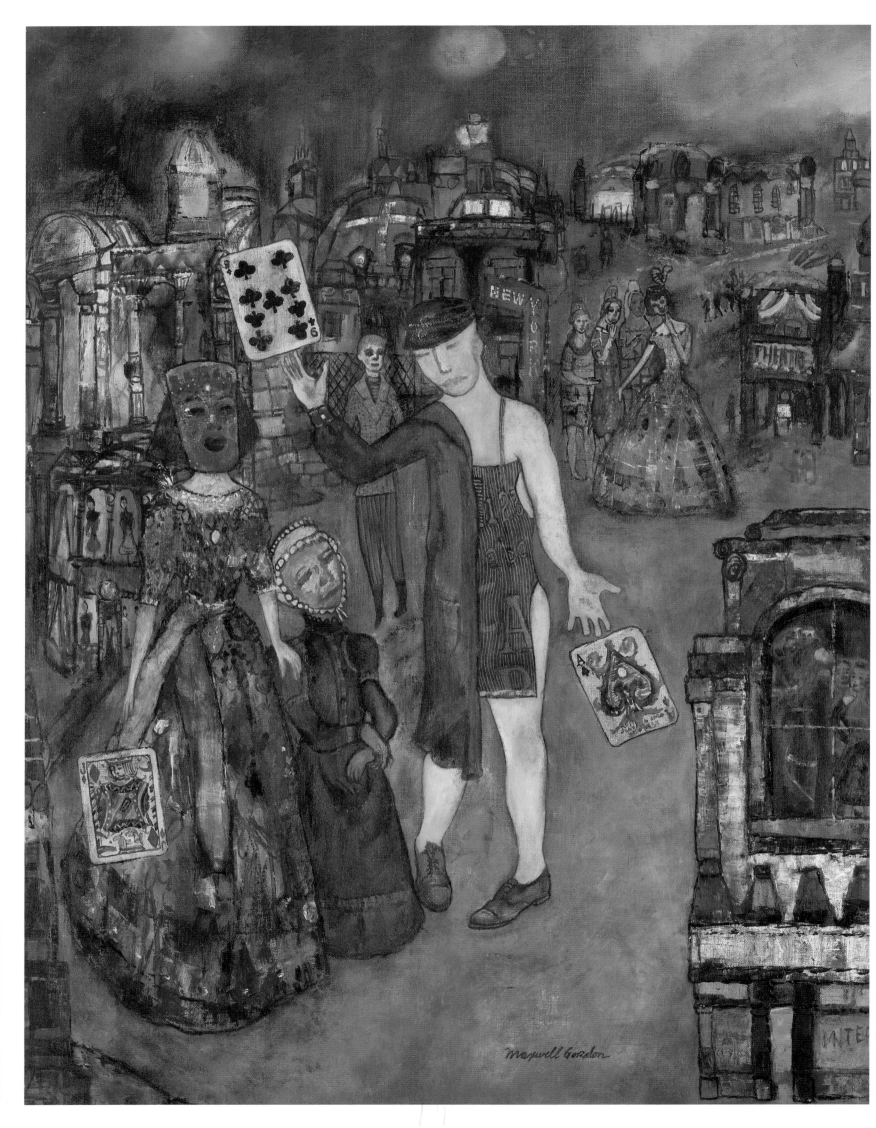

> Self-Portrait_[1972]
Oil on canvas
∨ Untitled_[undated]
Oil on canvas

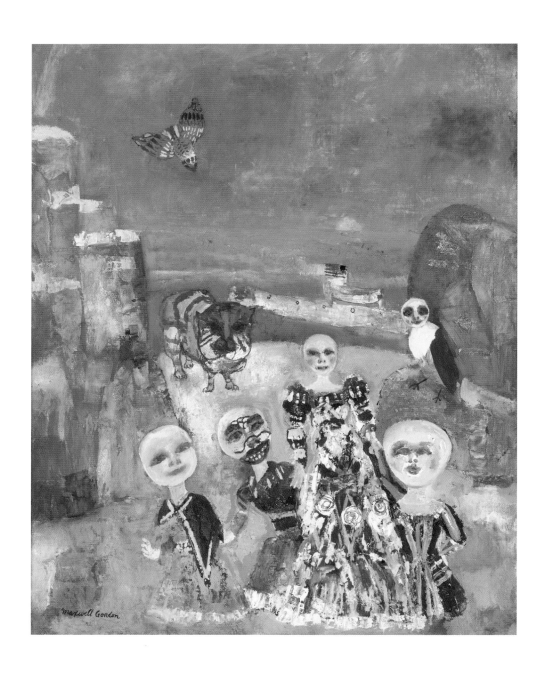

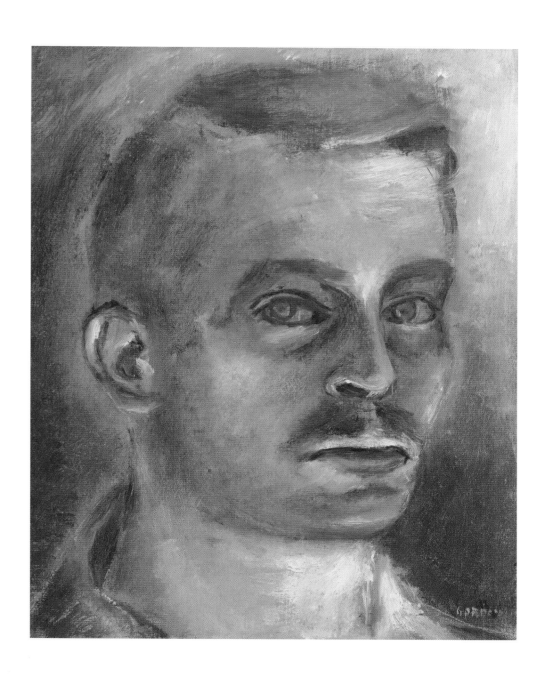

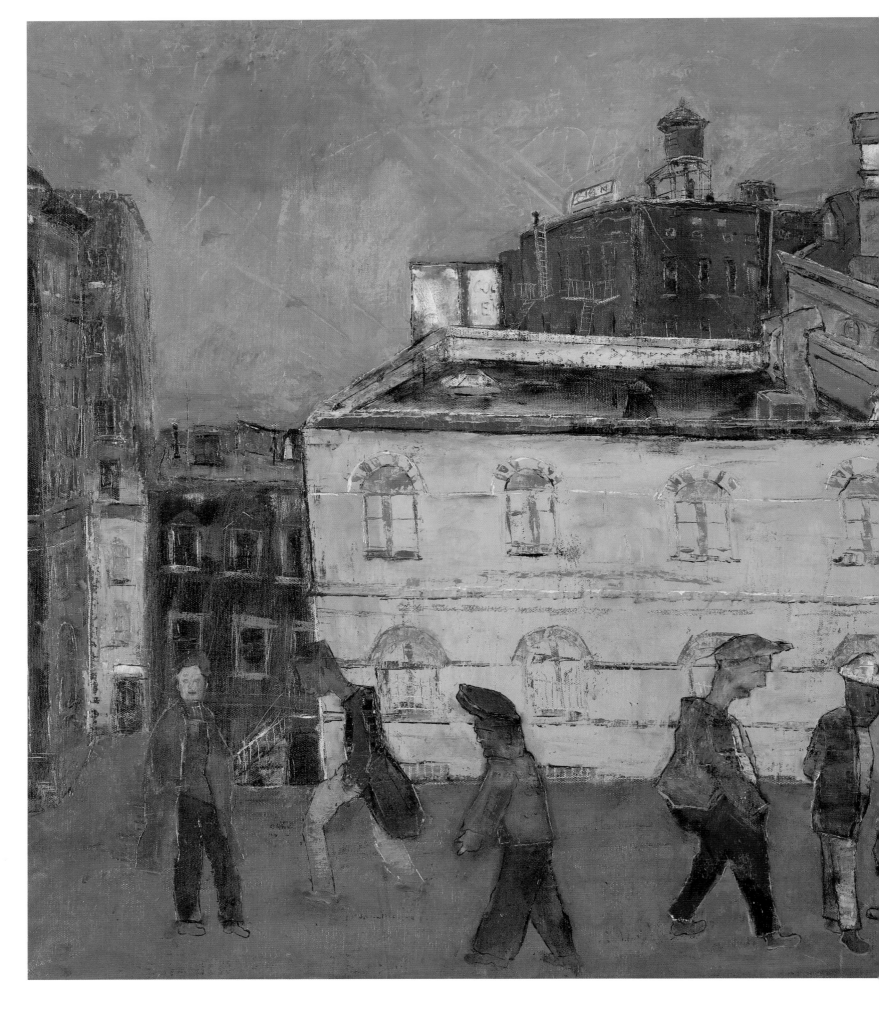

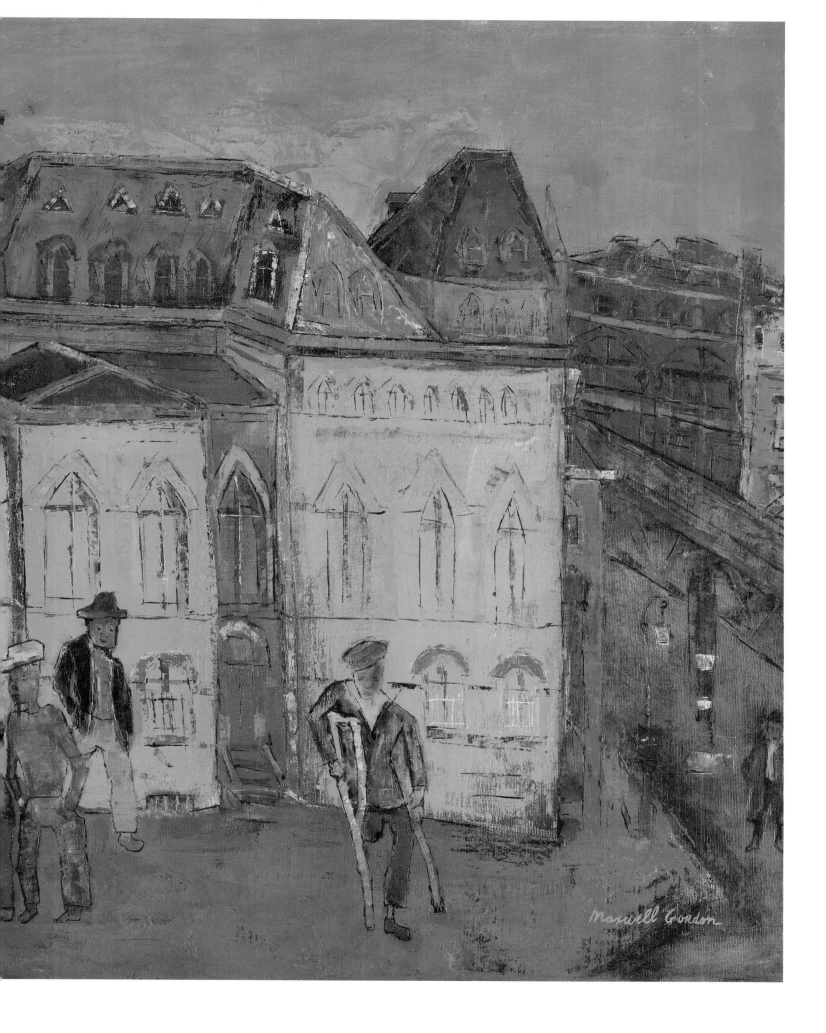

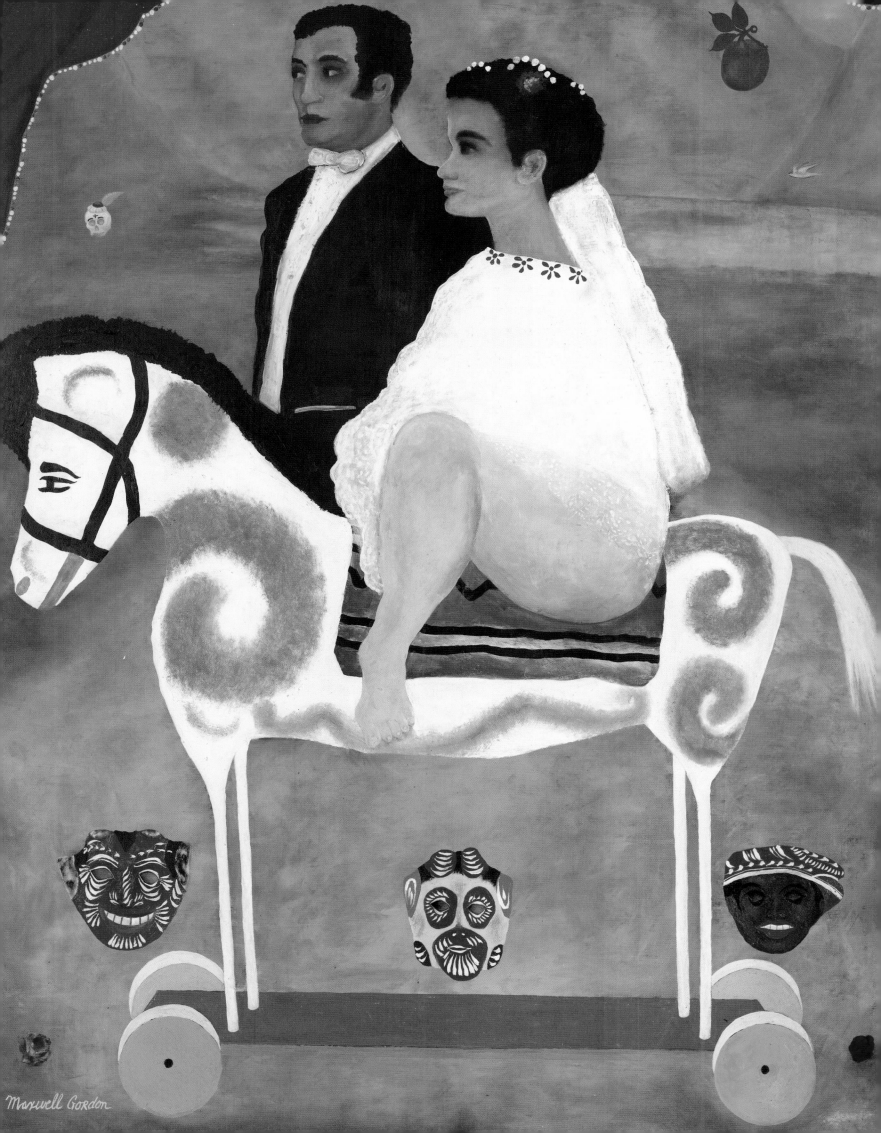

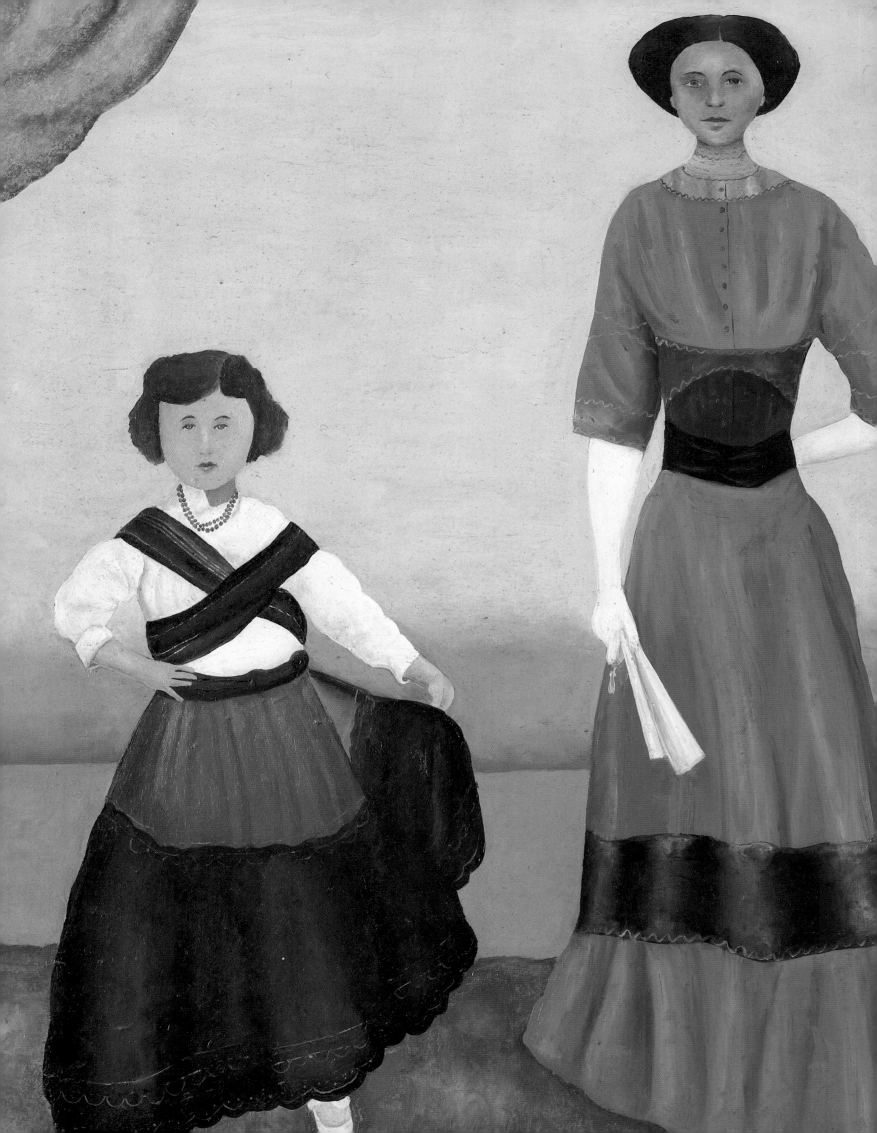

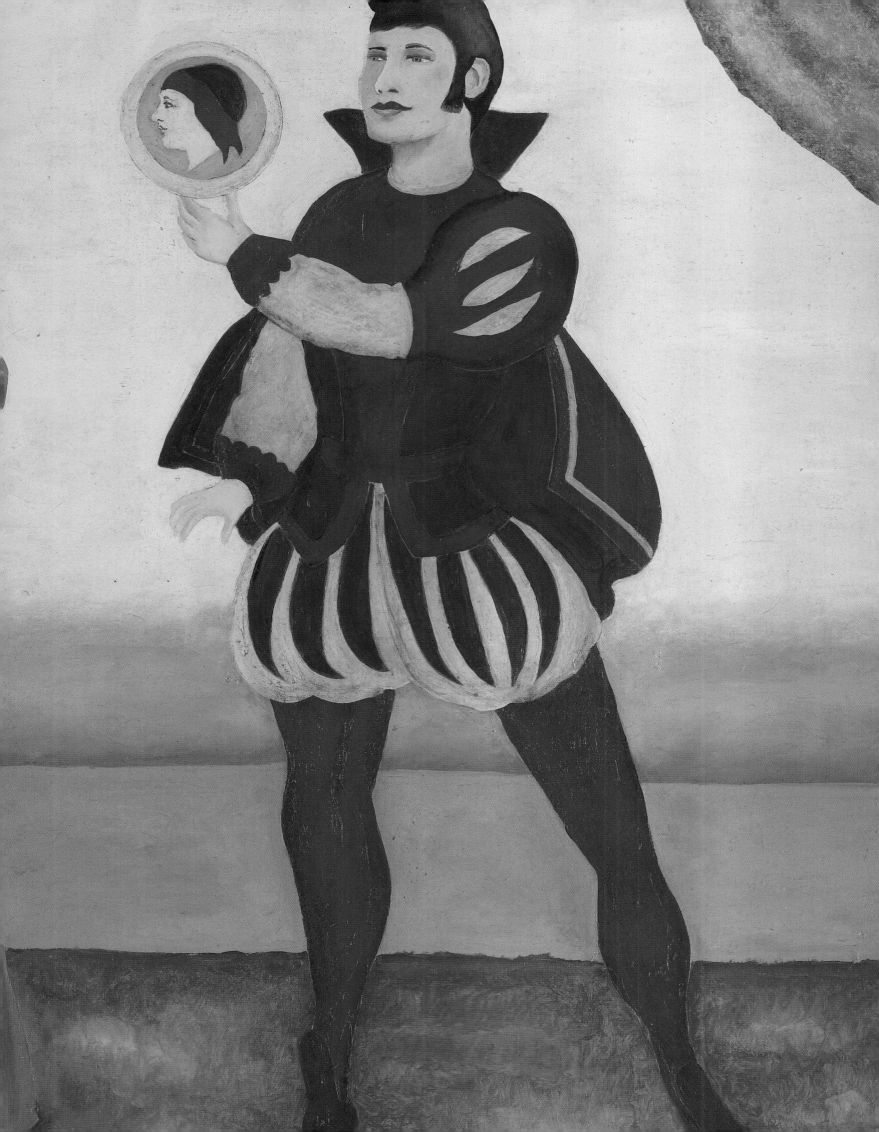

< Family_[1970s]
Oil on canvas
> Farewell the Tranquil Mind
(Adam and Eve)_[1971]
Oil on canvas

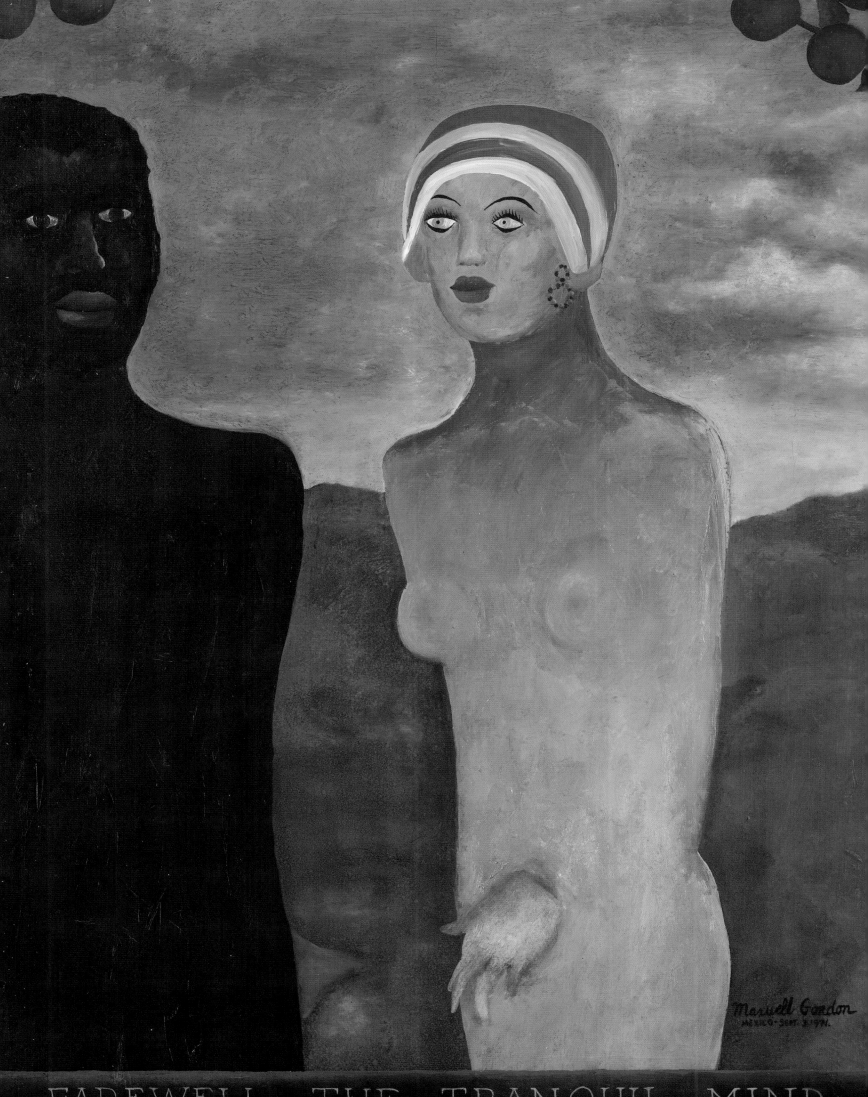

FAREWELL THE TRANQUIL MIND

> Rome in
My Memories_[1970s]
Oil on canvas

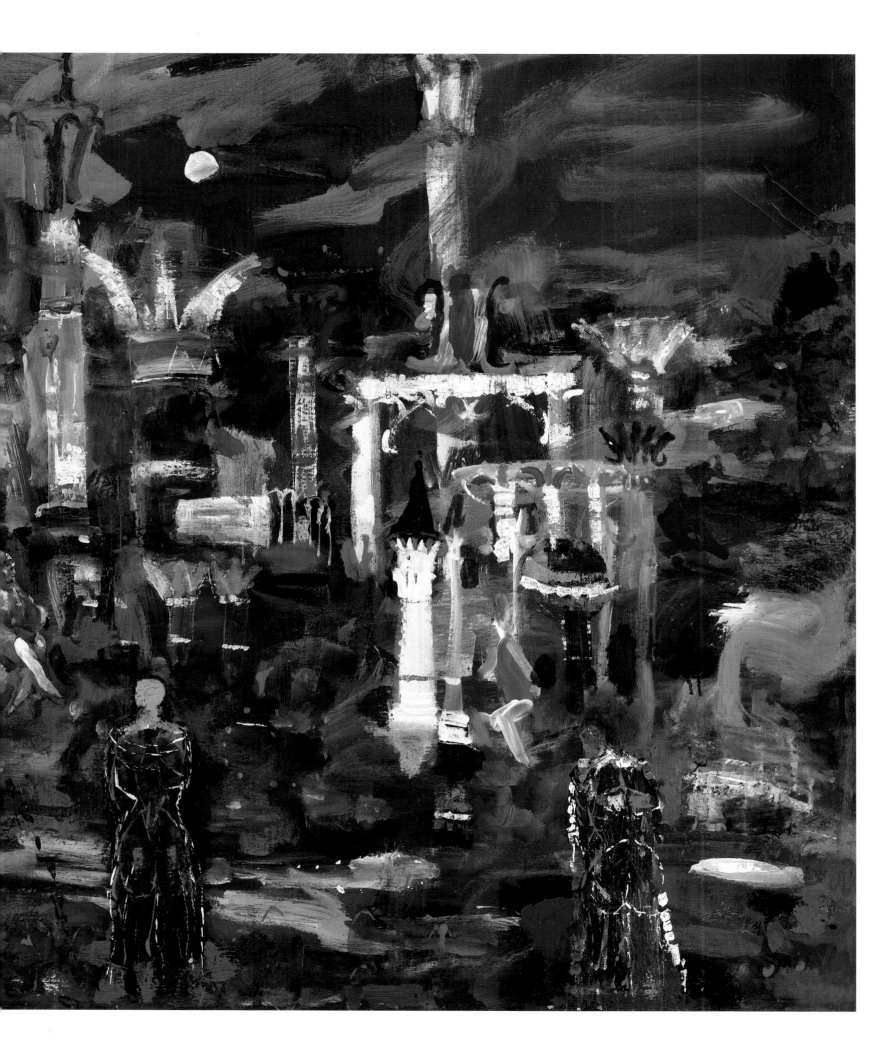

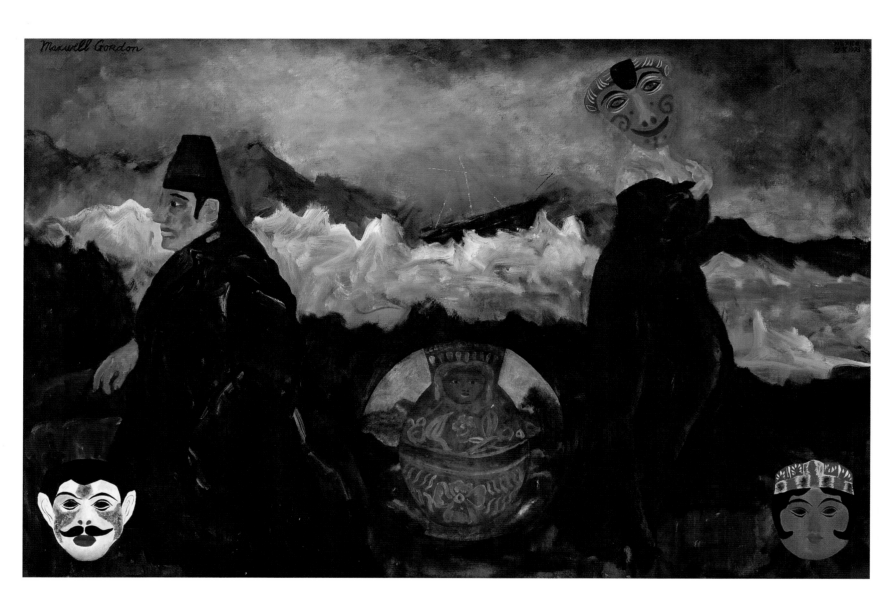

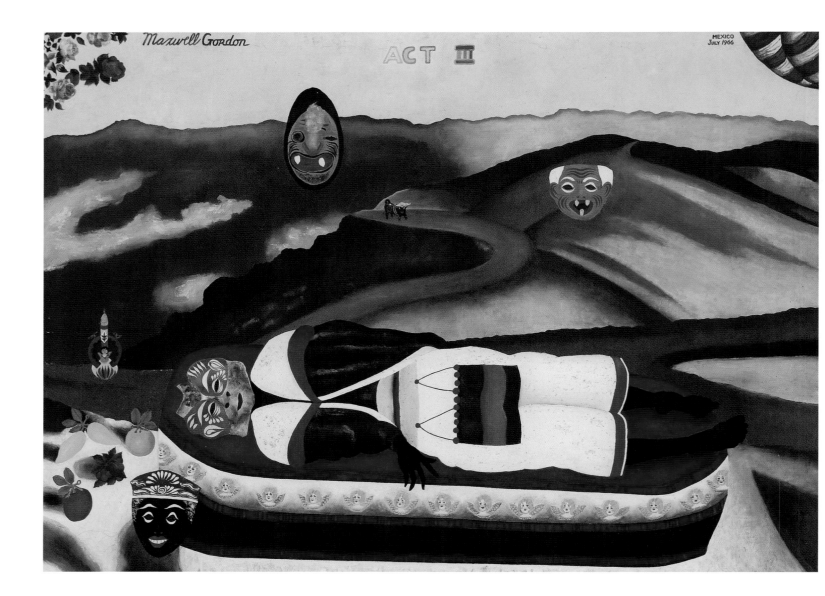

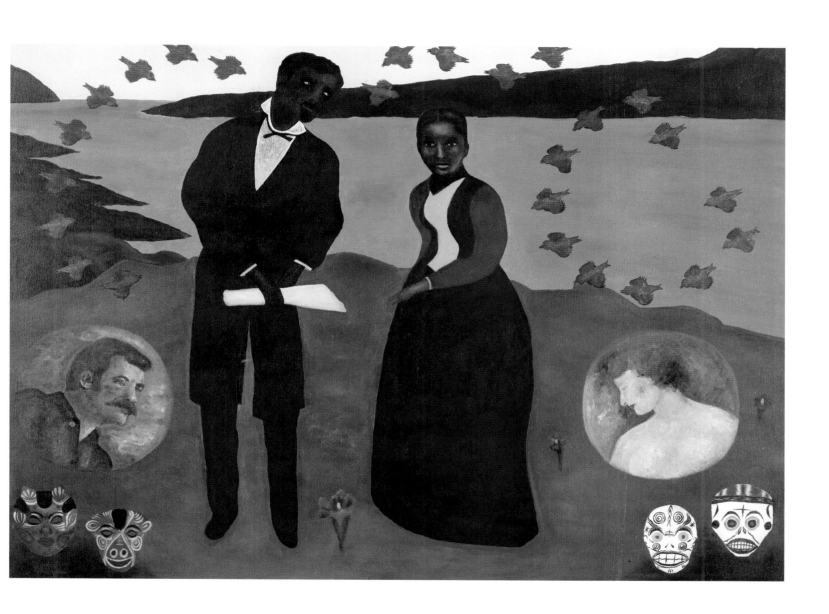

∨ Ring around
the Rosie_[undated]
Oil on canvas

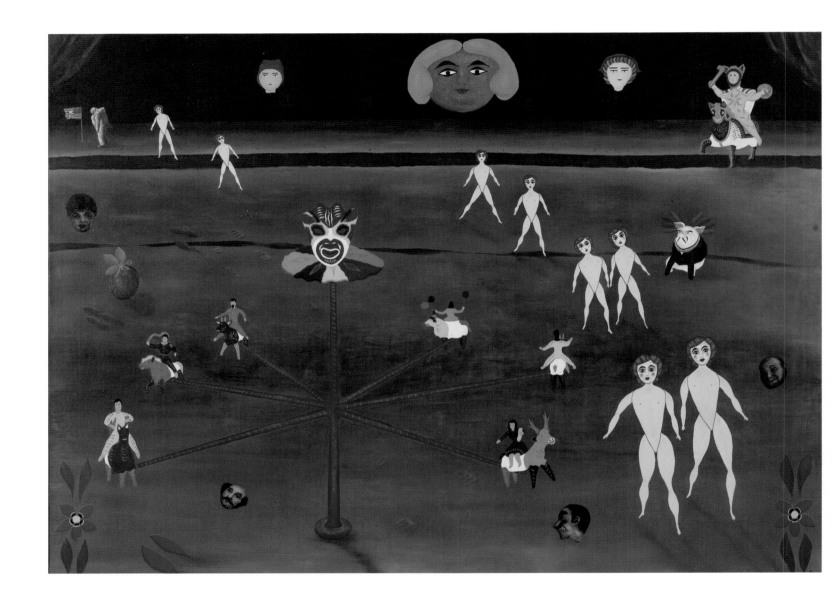

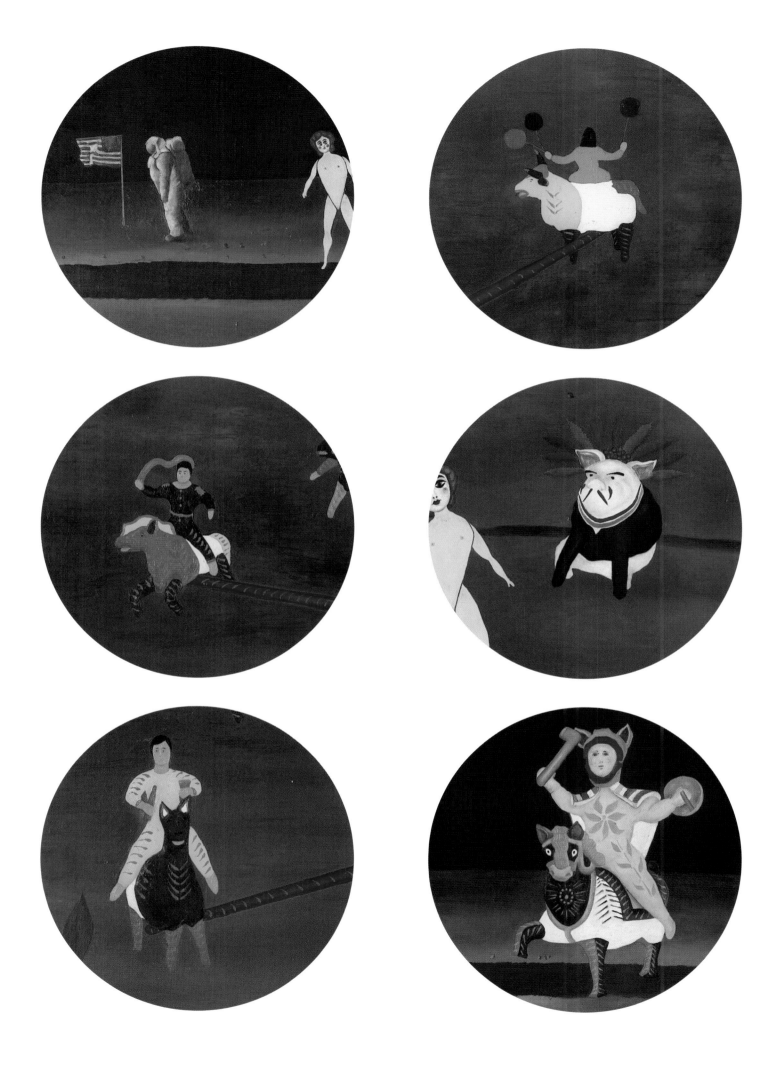

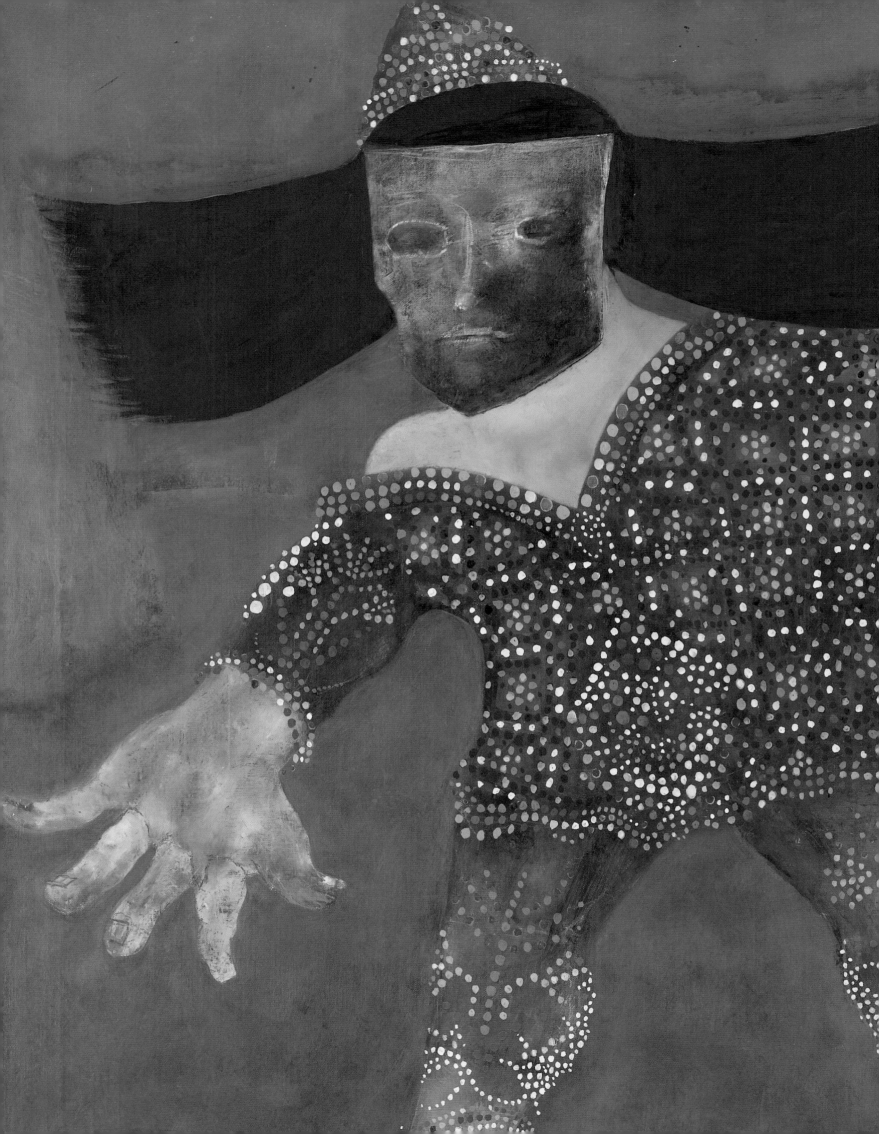

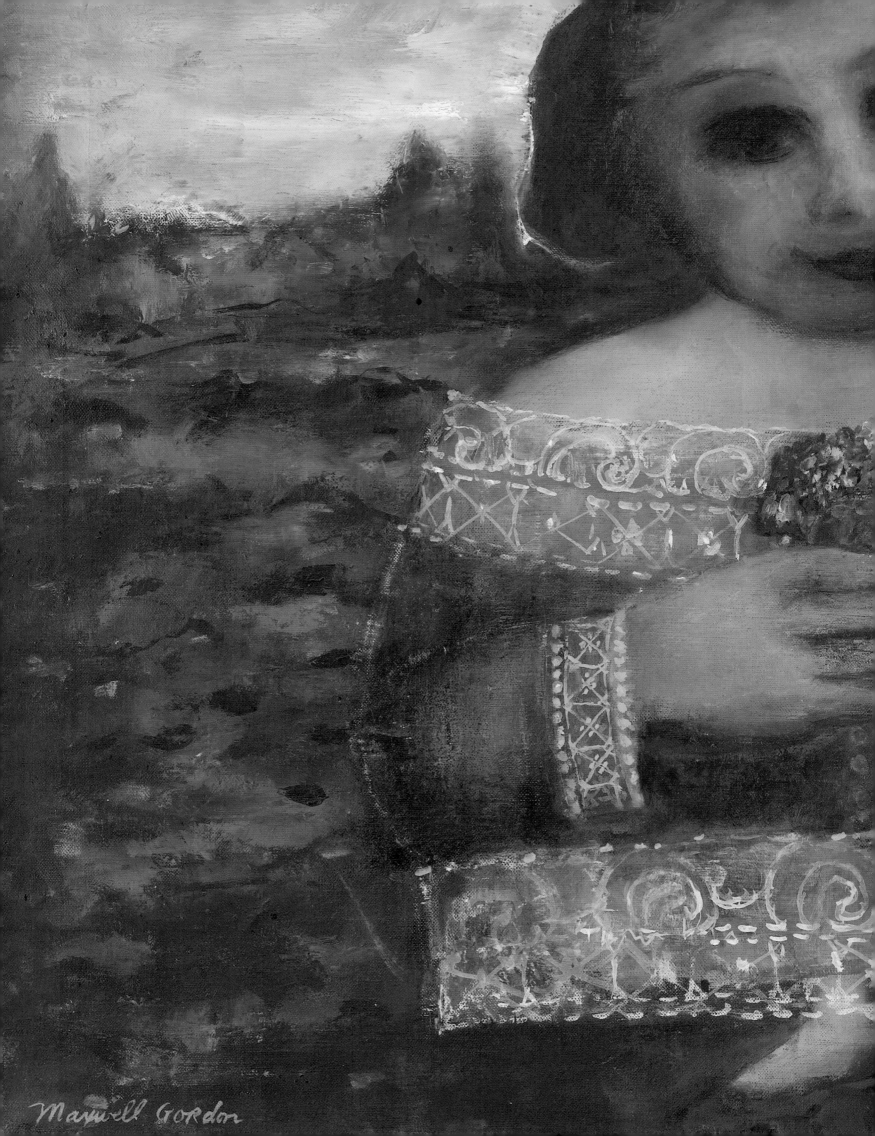

Maxwell Gordon

Holiday Inn

THE WORLD'S

Maxwell Gordon

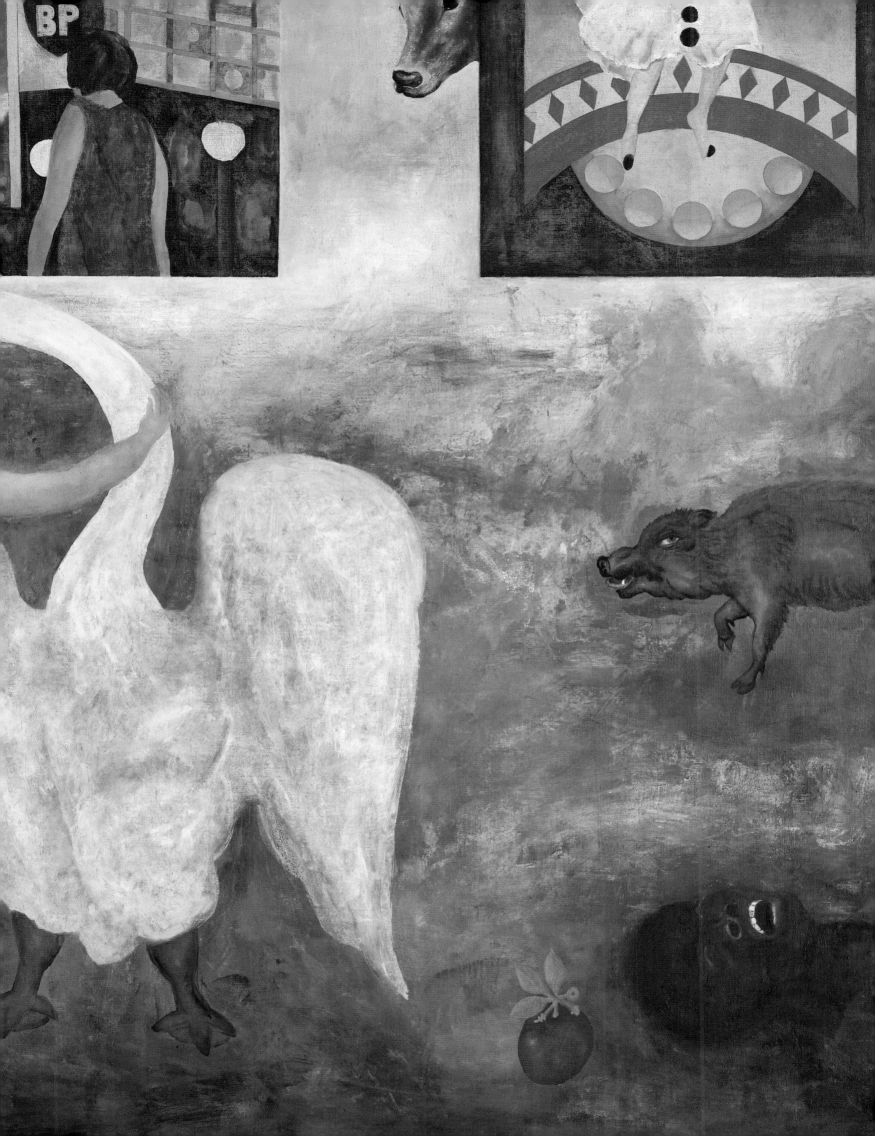

<<< Clown_[1950s]
Oil on canvas
<< Tryst_[1958]
Oil on canvas

< Leda and the Swan
_[undated]
Oil on canvas
> La Fiesta En El Cuarto
(The Party in
the Room)_[undated]
Oil on canvas

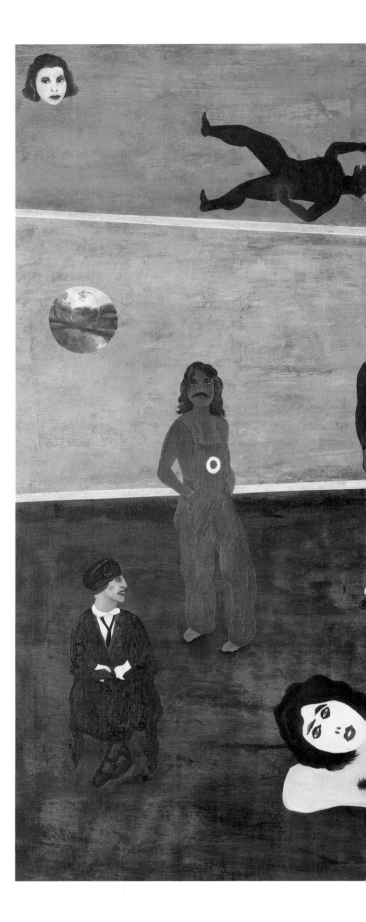

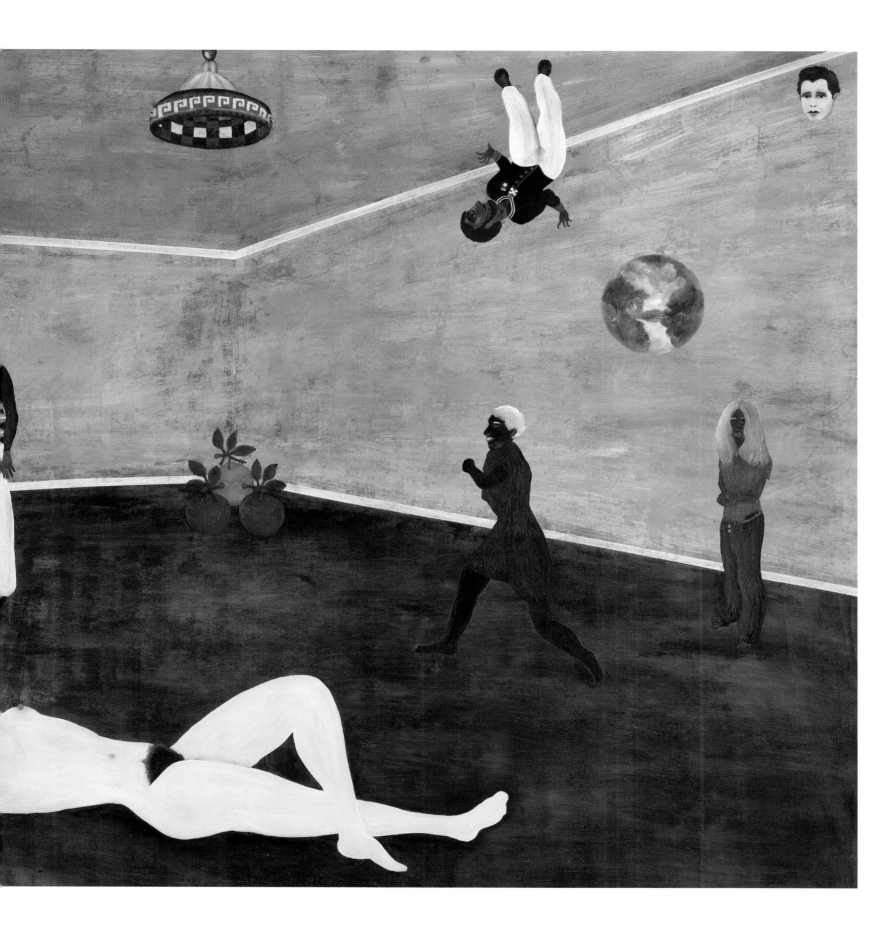

∨ Death of a Warrior_[1974]
Oil on canvas
> Cousin Waiting_[1977]
Oil on canvas

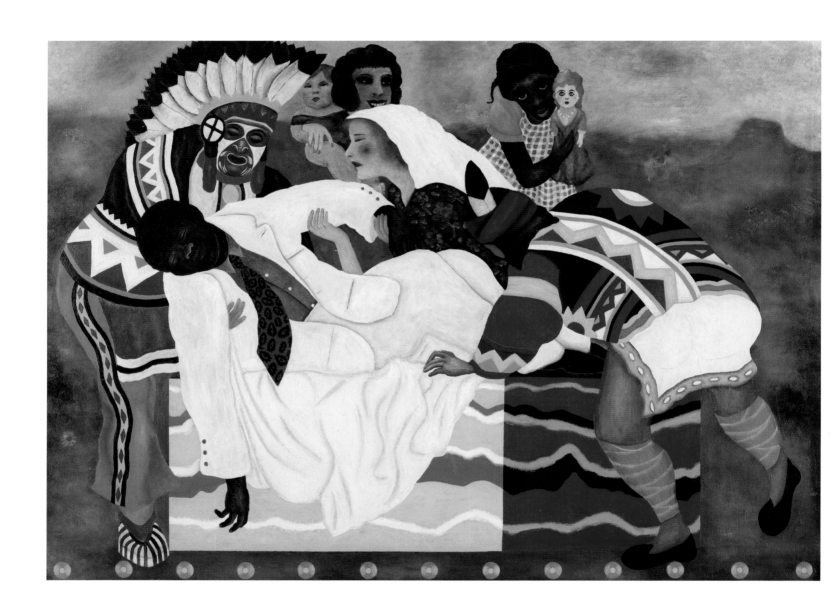

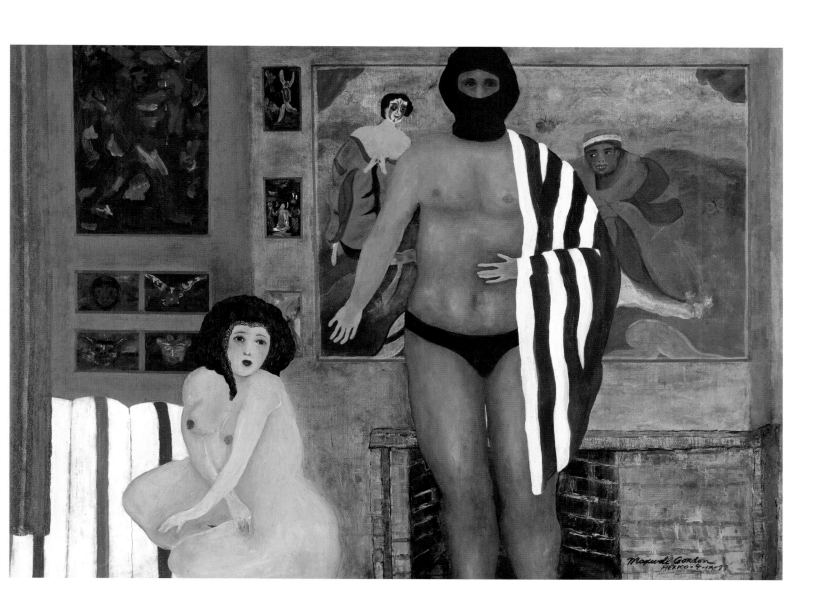

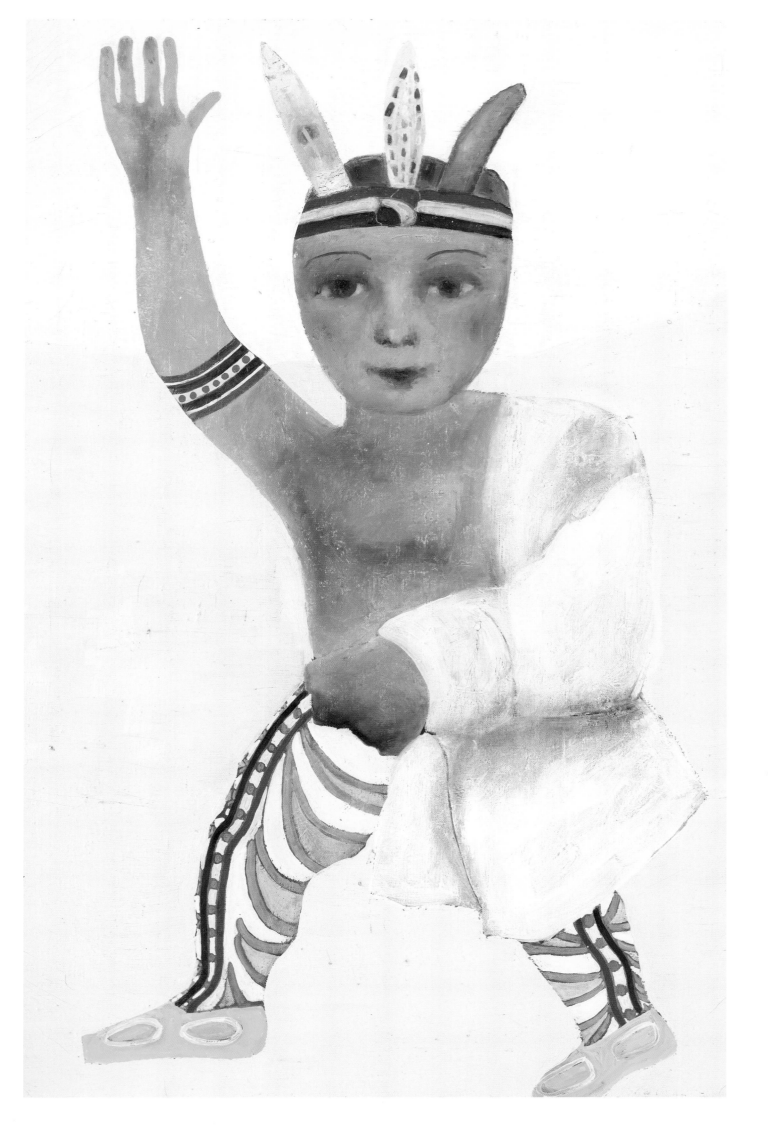

< Indian_[1959]
Oil on canvas
> Environment_[1948]
Oil on canvas

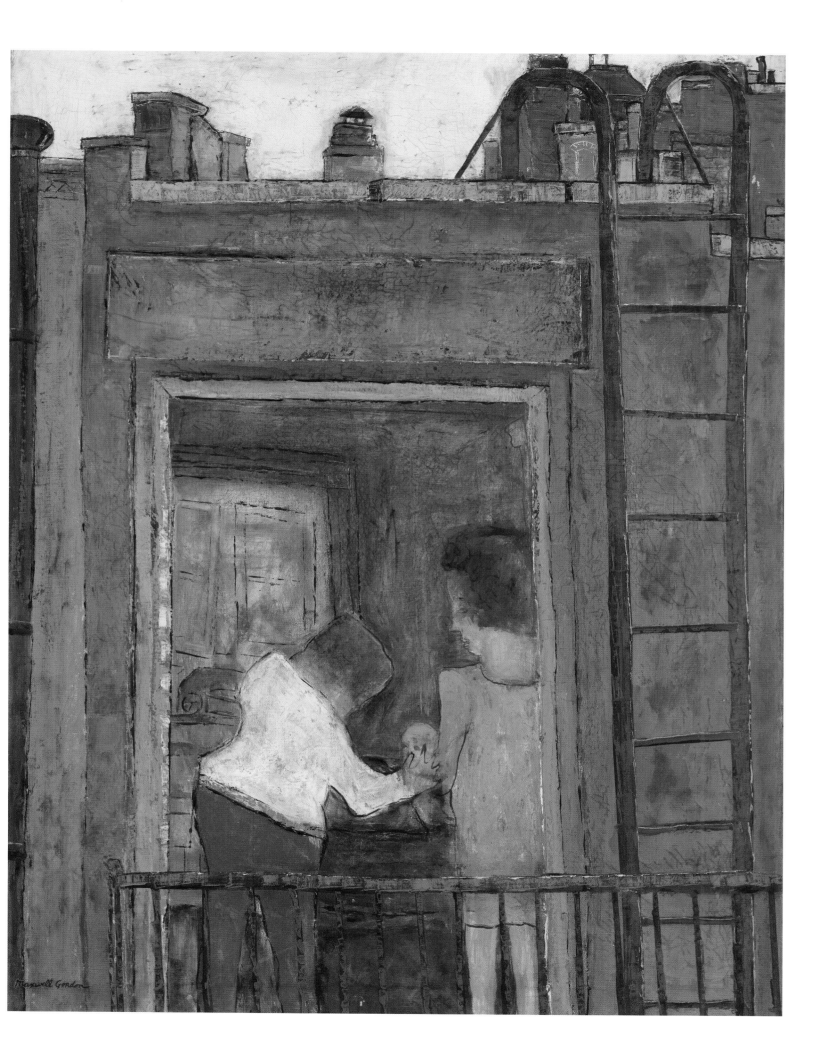

⌄ Hero_[1960s]
Oil on canvas

⌄ Philosopher_[1959]
Oil on canvas

> Wisp_[1950s]
Oil on canvas

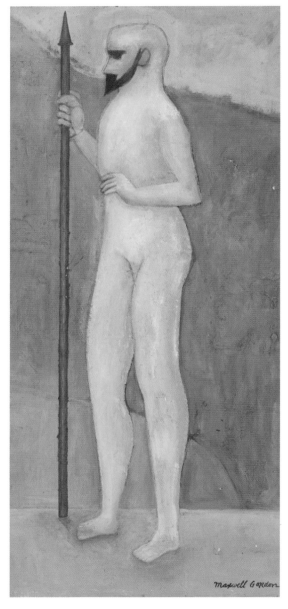

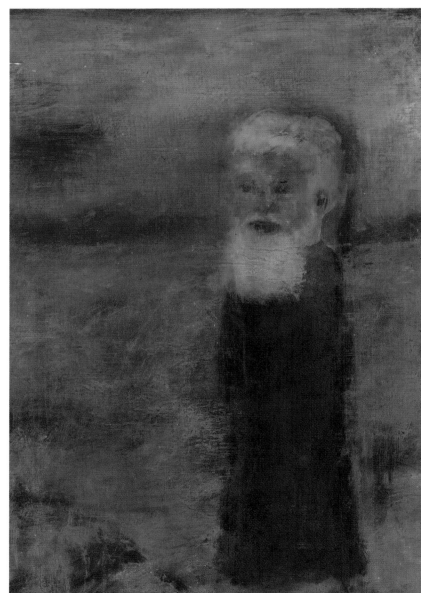

⌄ Hero_[1960s]
Oil on canvas

⌄ Philosopher_[1959]
Oil on canvas

> Wisp_[1950s]
Oil on canvas

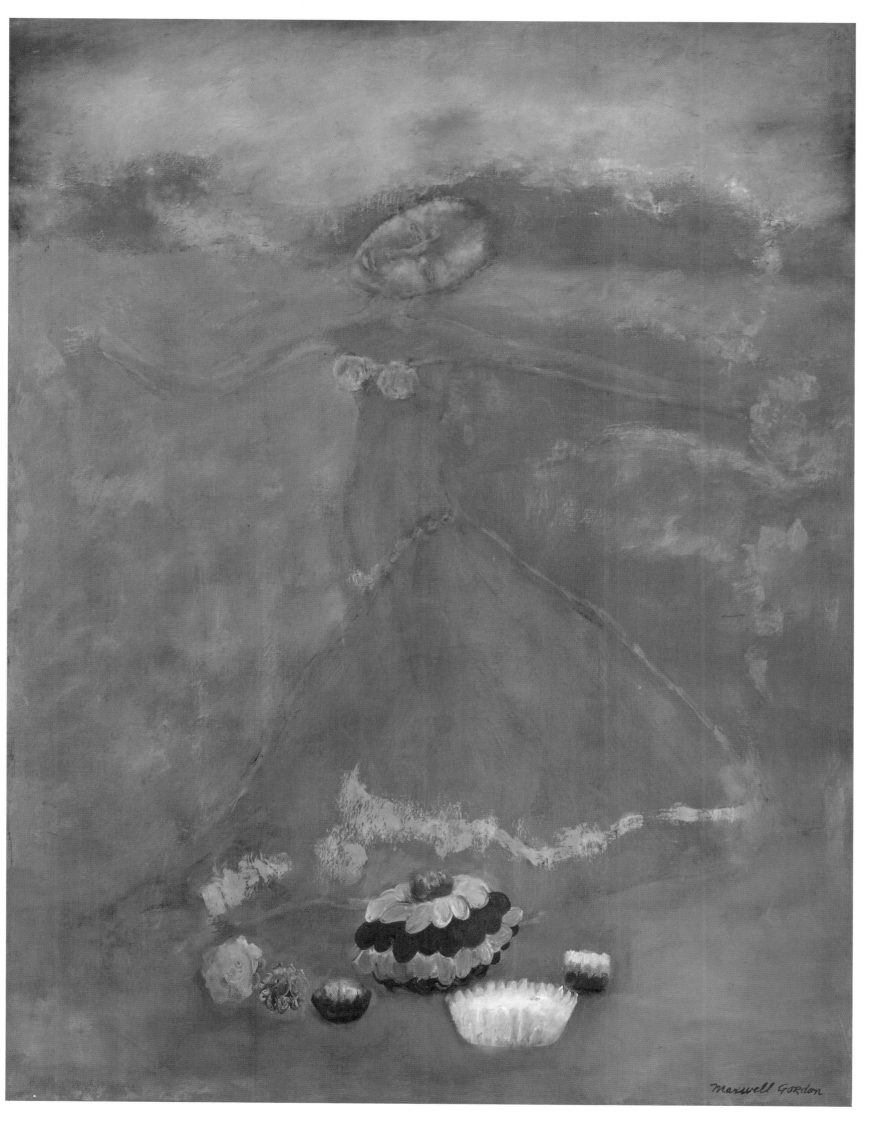

> The Story_[1977]
Oil on canvas

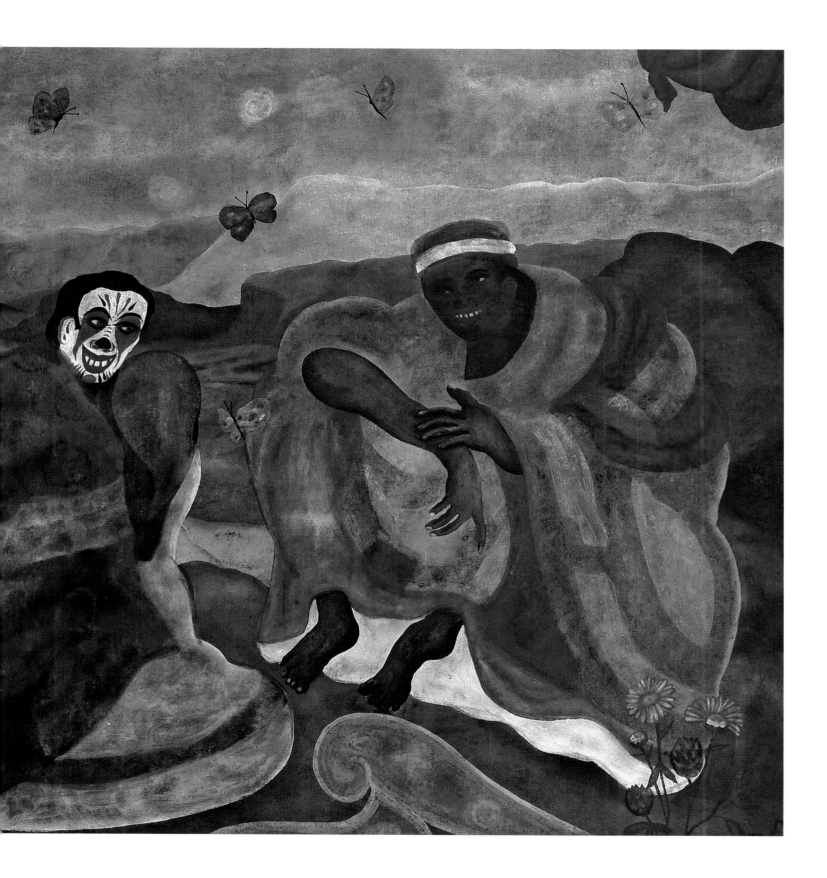

∨ The Cessation
and the Trial_[1972]
Oil on canvas

> Guarding the Sea_[1978]
Oil on canvas

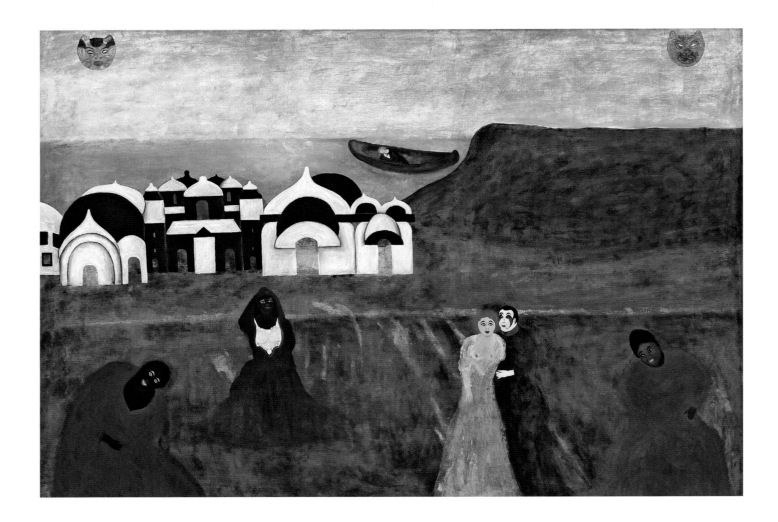

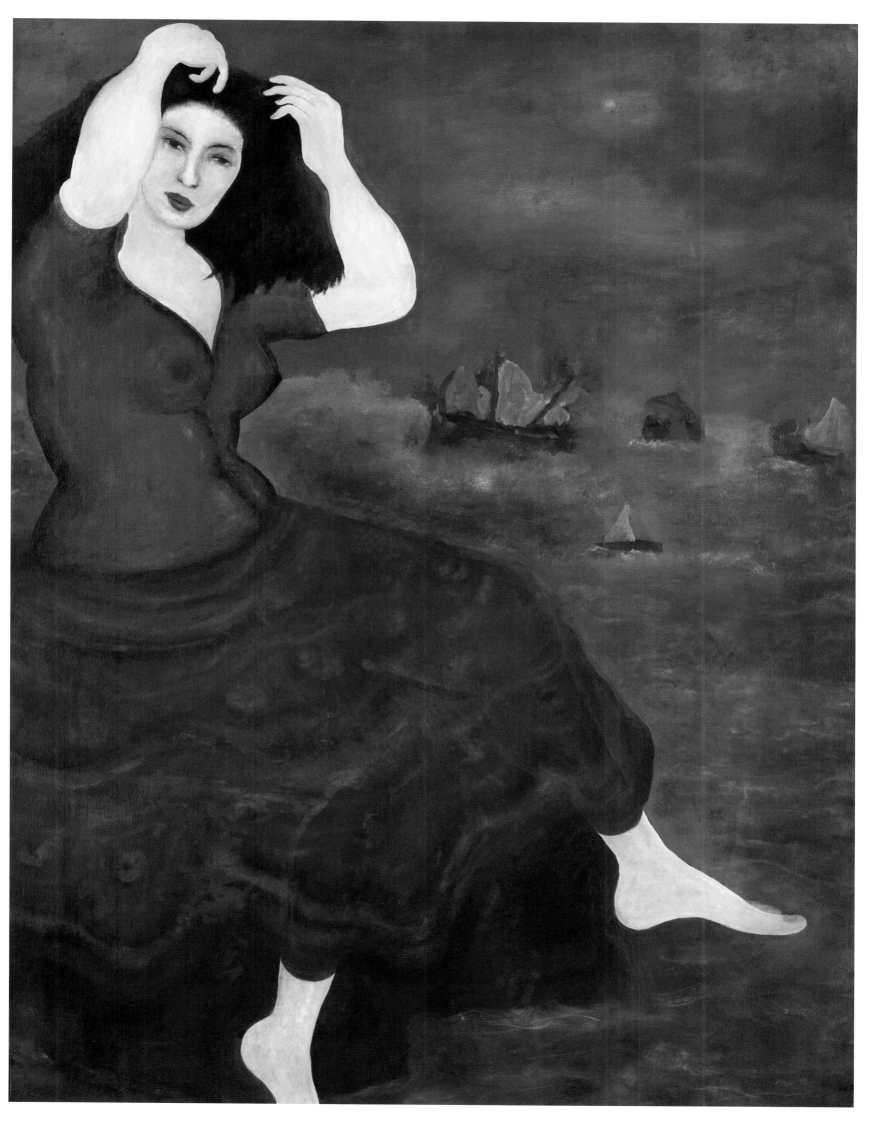

> Love at First Sight_[1968]
Oil on canvas
> Judgement No. 1_[1965]
Oil on canvas

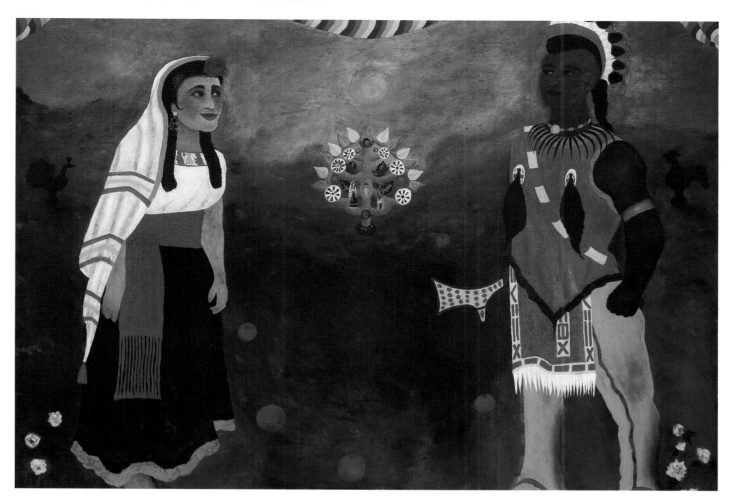

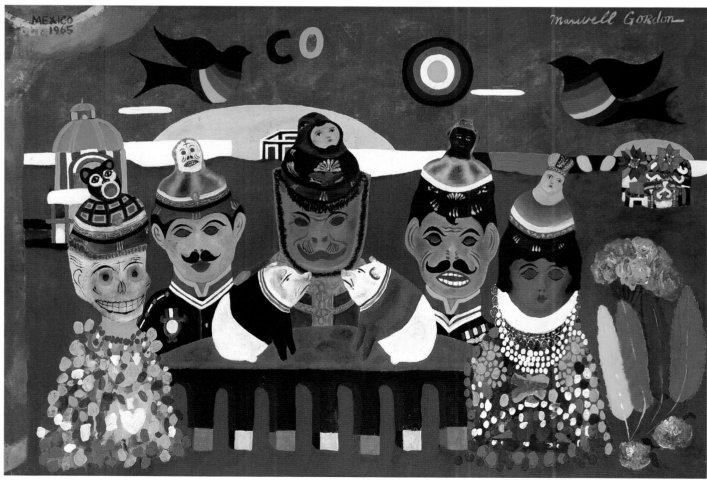

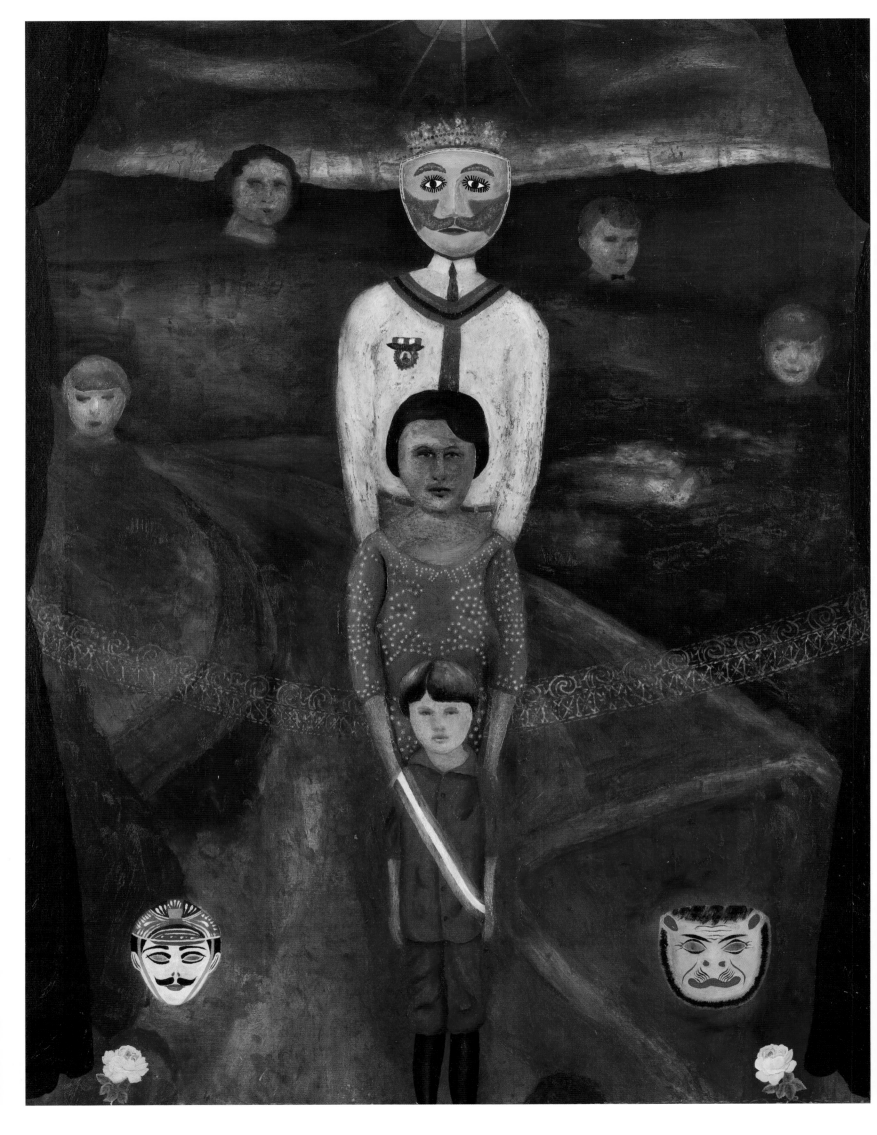

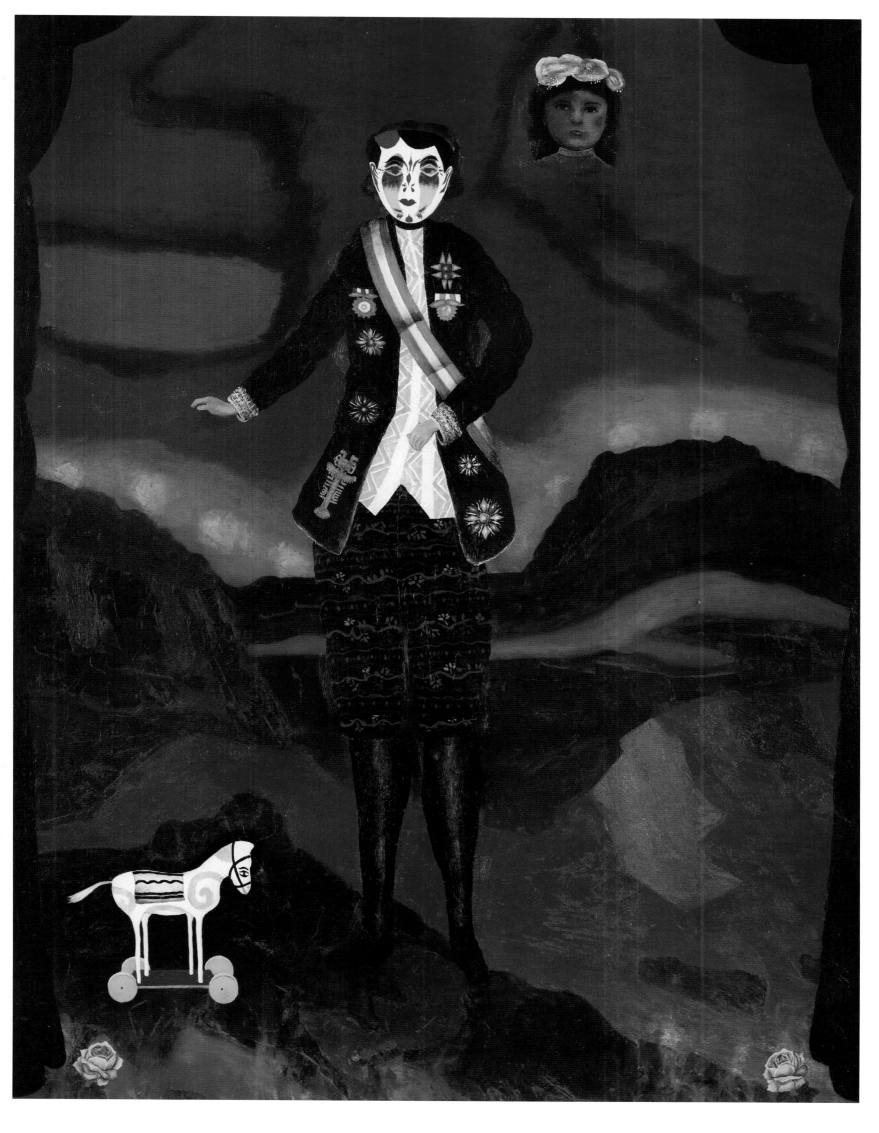

< The Overture_[1969]
Oil on canvas
<< The Performers_[1969]
Oil on canvas

> Toy Clown_[1959]
Oil on canvas
> The Temporary Disaster,
or The Last Sarape_[1965]
Oil on canvas

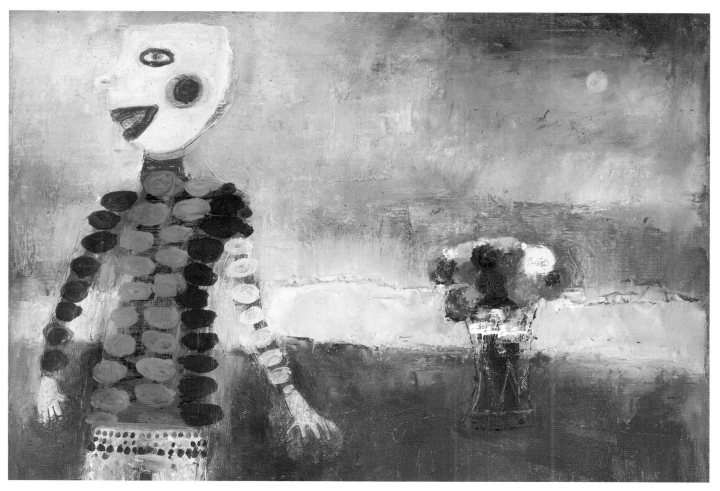

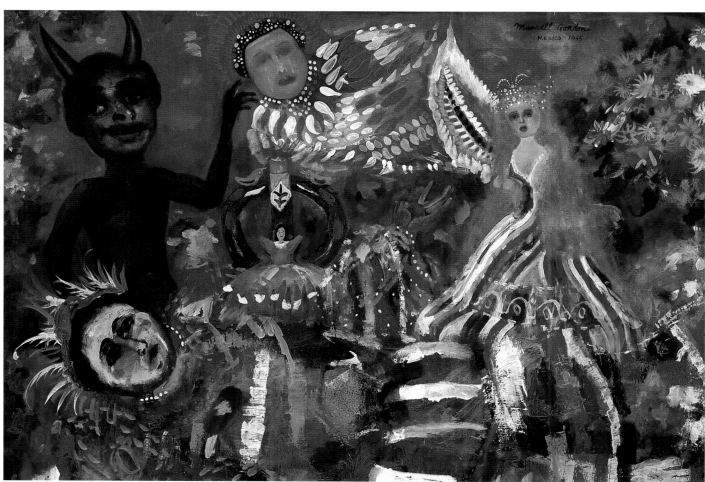

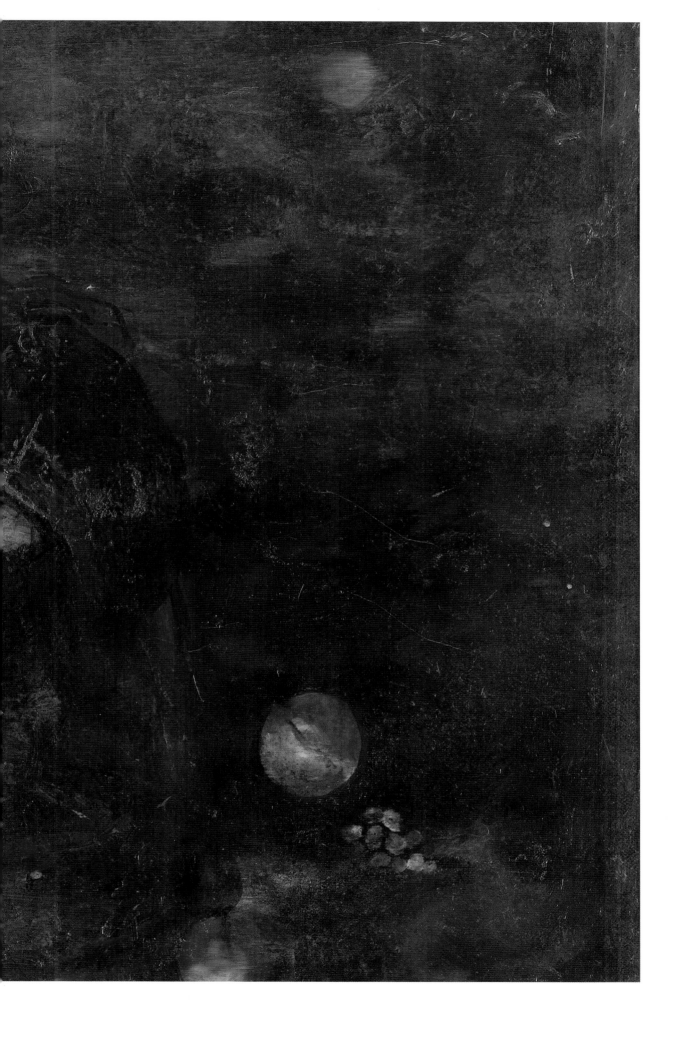

< The Sermon_[1960s]
Oil on canvas
> Contemplation_[1967]
Oil on canvas

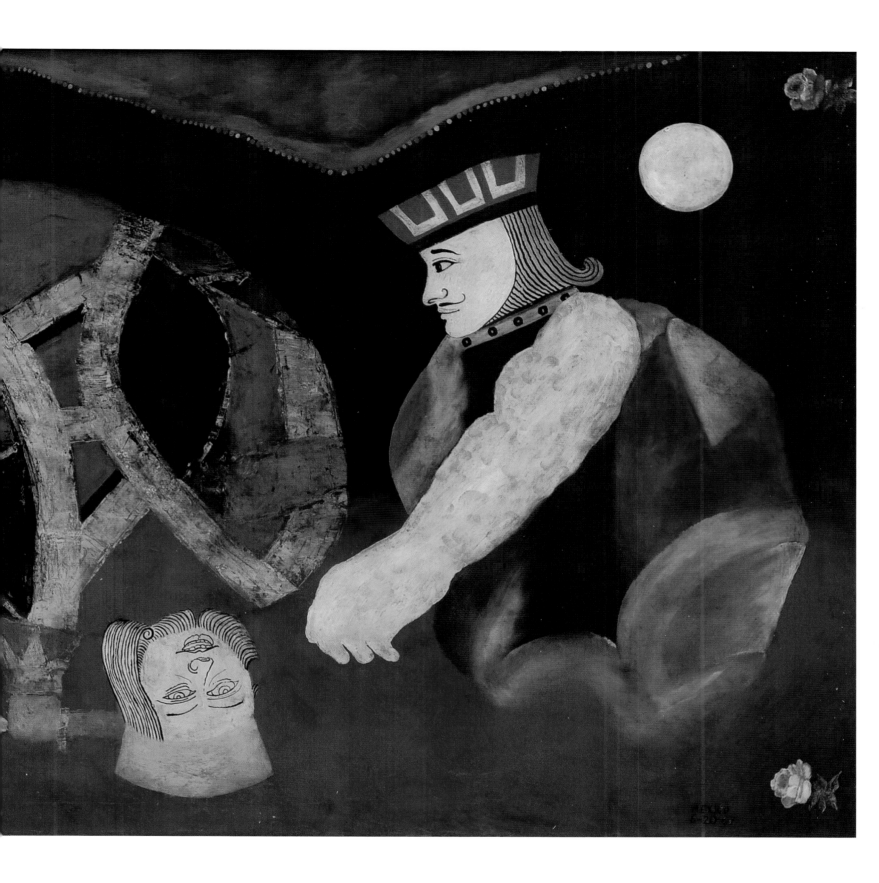

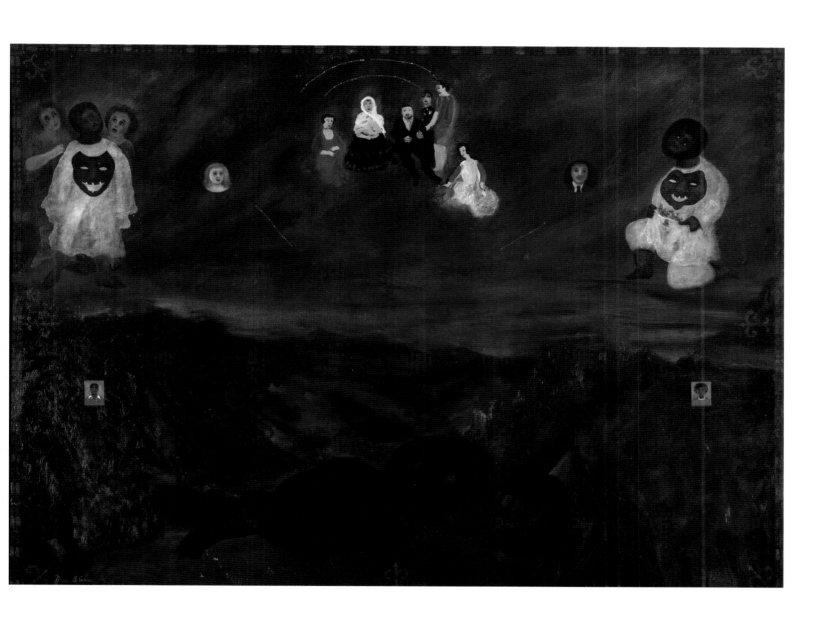

< The Mirage or Death
at a Party_[1964]
Oil on canvas
> Extranos (Strangers)_[1973]
Oil on canvas

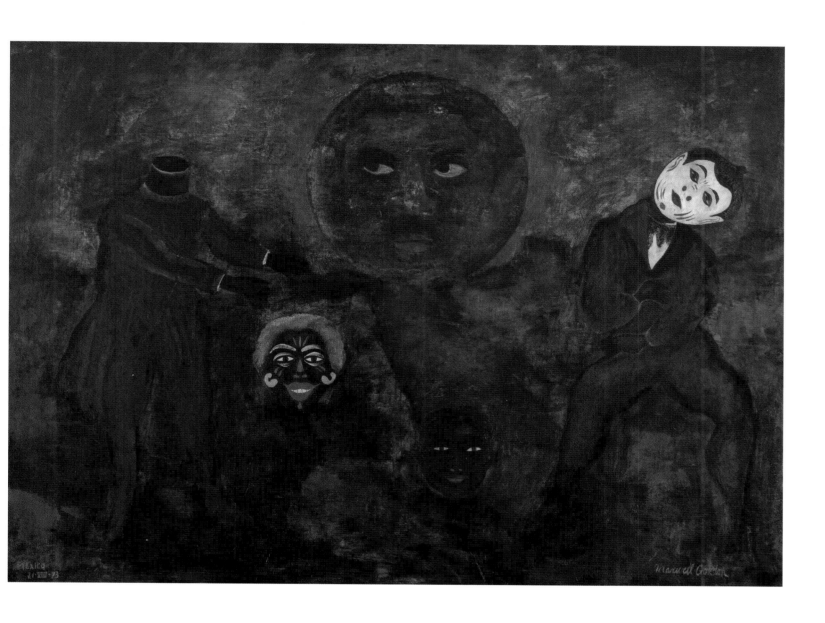

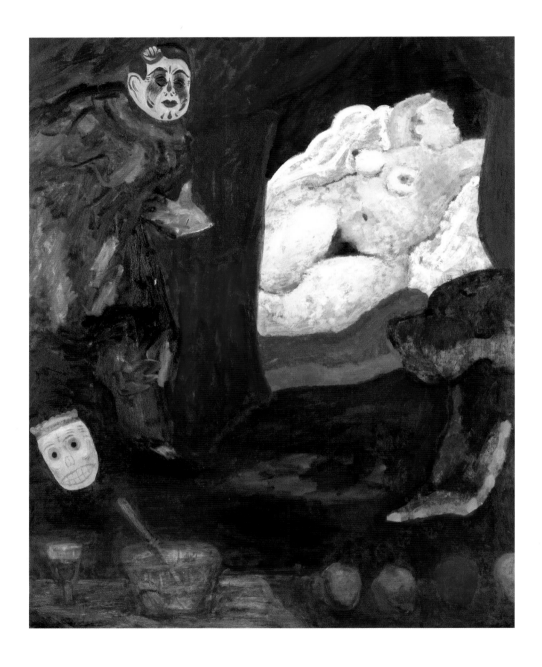

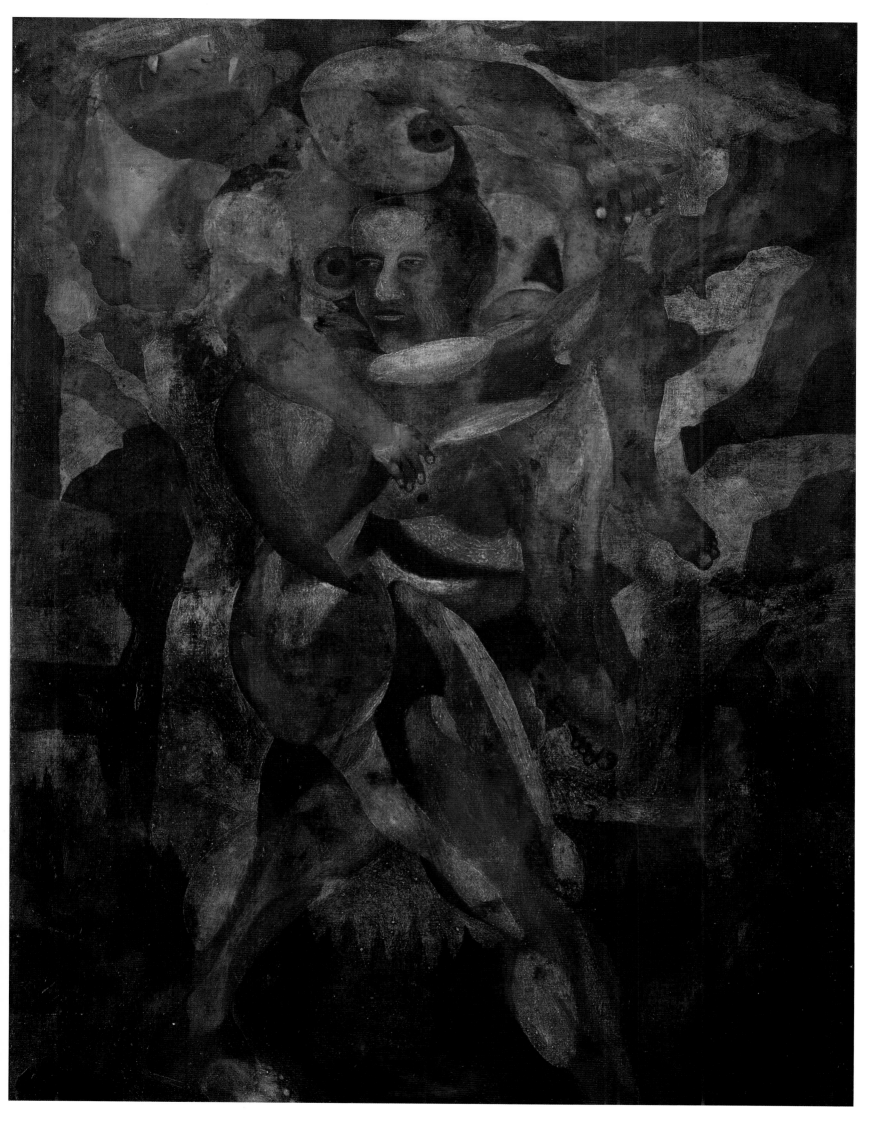

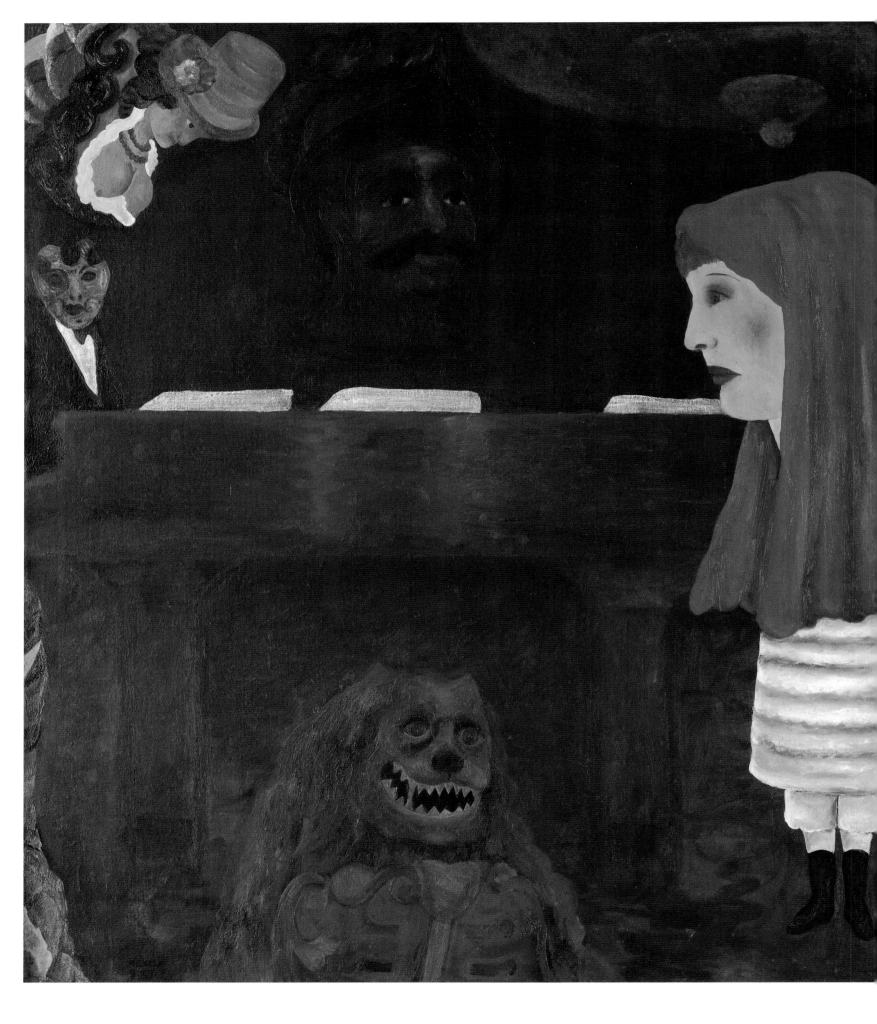

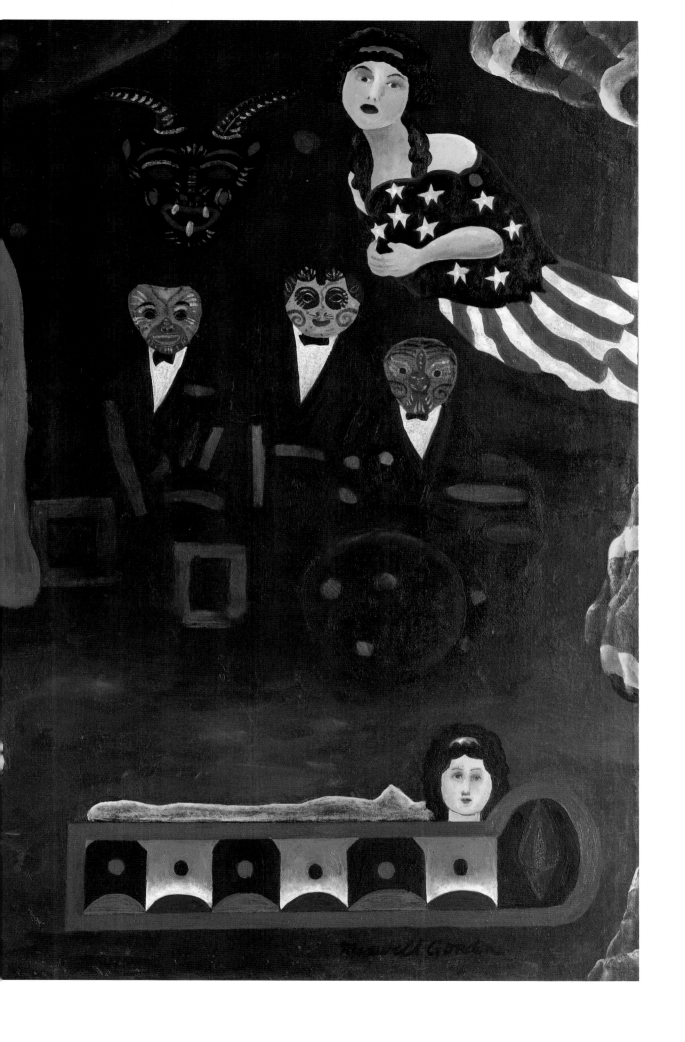

Maxwell Gordon

< El Peregrinaje y los
desconocidos (Little Red
Riding Hood)_[1960s]
Oil on canvas
∨ Variation 7_[1975]
Oil on canvas

> Variation 9_[1975]
Oil on canvas
>> Party Woman in
the Country_[1970s]
Oil on canvas

>>> Young Man in
the Evening_[1960s]
Oil on canvas

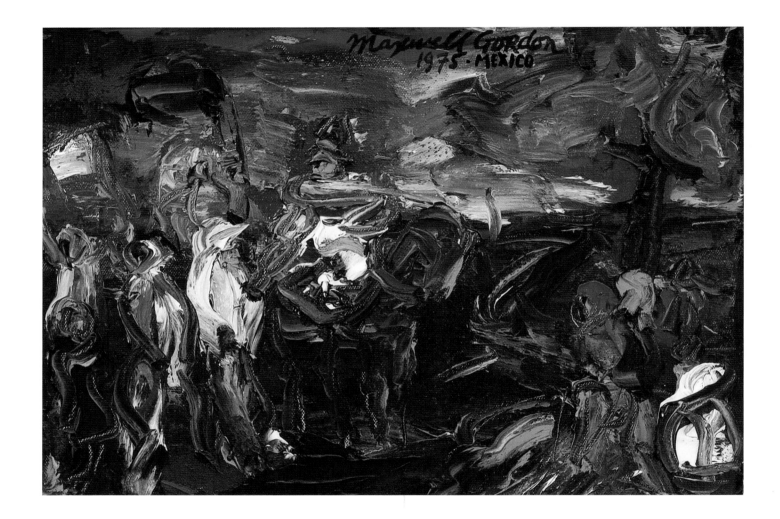

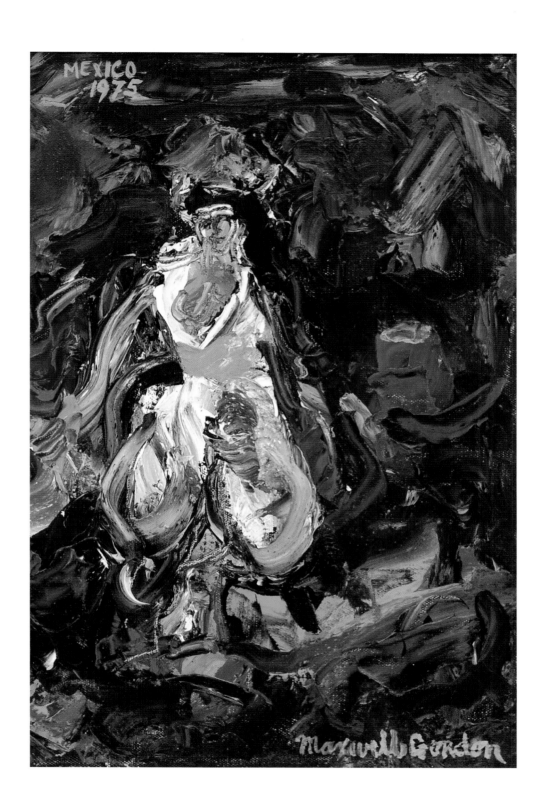

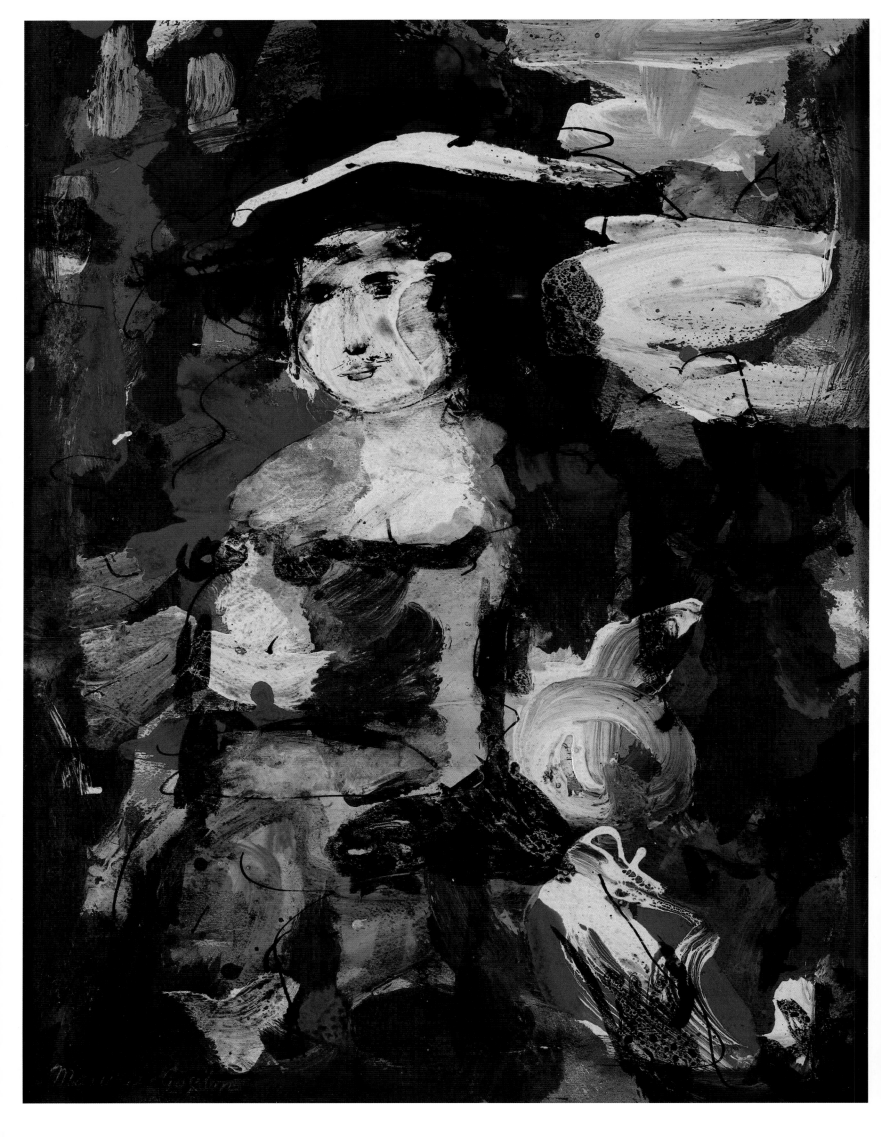

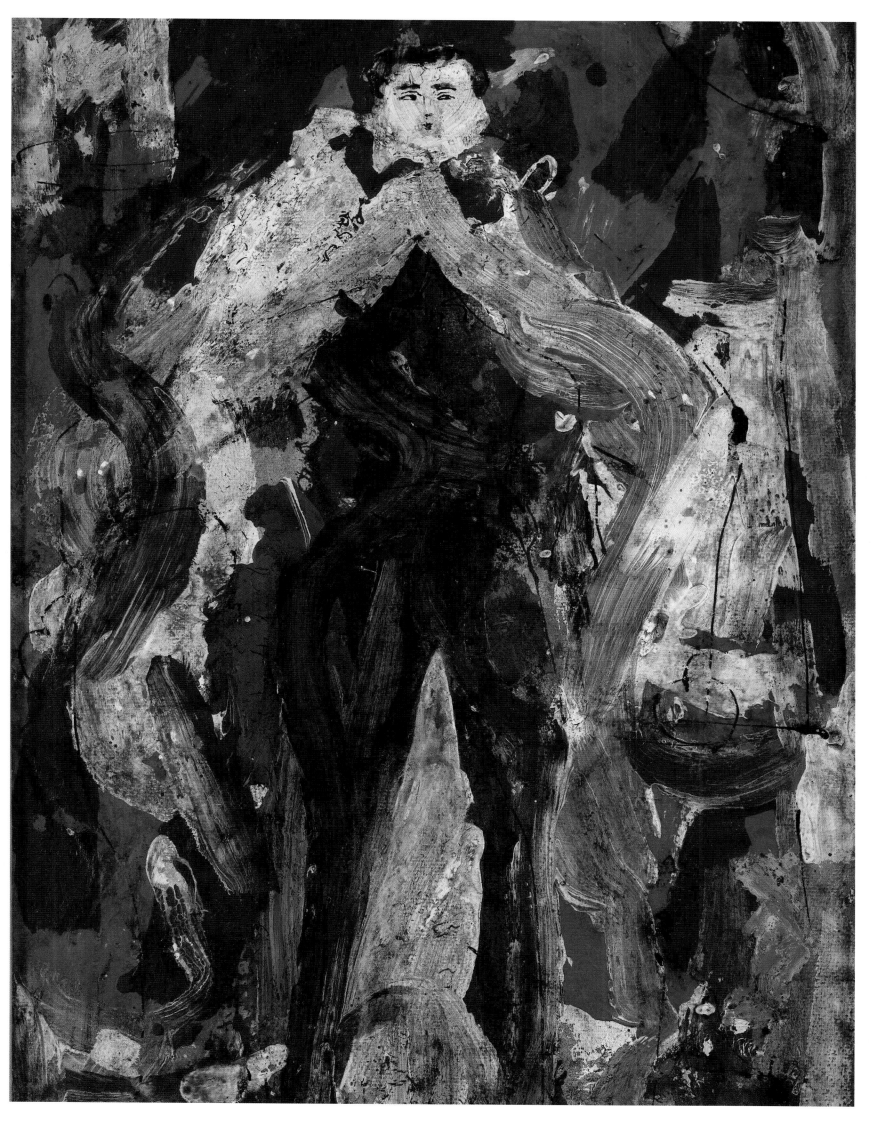

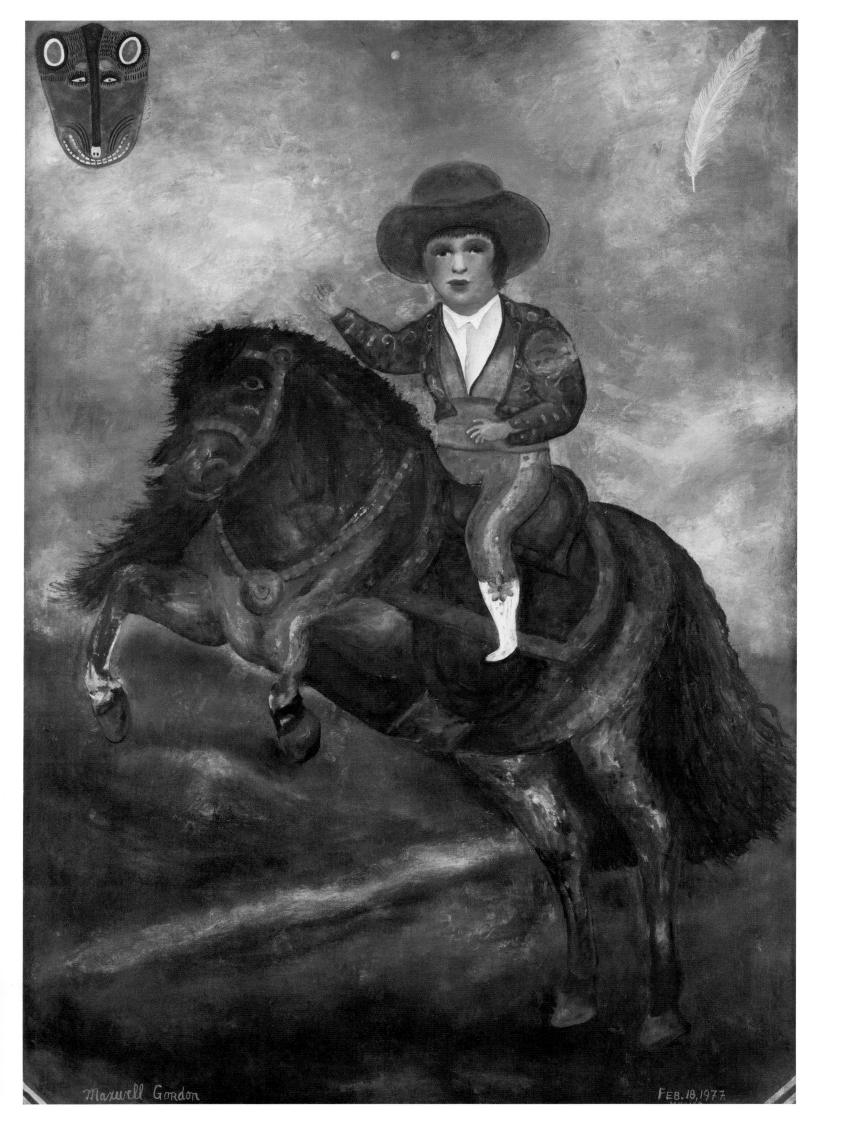

Maxwell Gordon FEB. 18, 1977

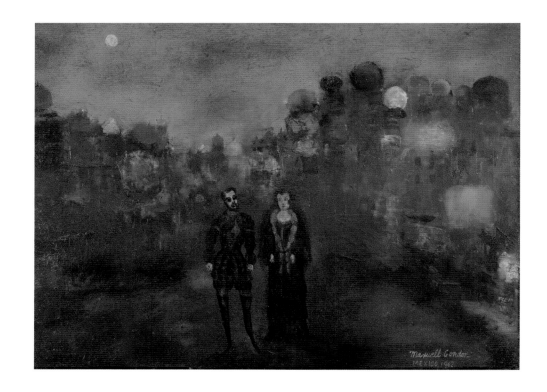
< Untitled (Baby Bret)_[1977]
Oil on canvas
> Vigilia_[1962]
Oil on canvas
⌄ Caminata (Stroll)_[1962]
Oil on canvas
⌄⌄ Port_[1959]
Oil on canvas

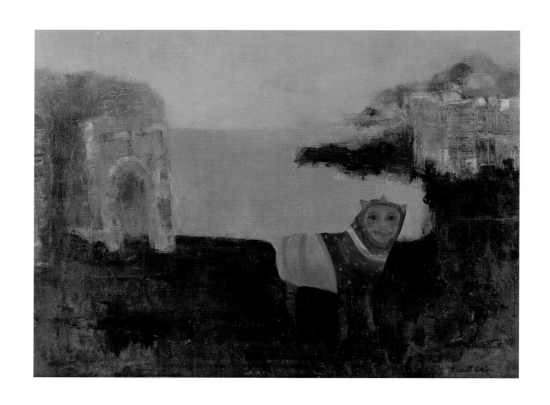

< Untitled (Baby Bret)_[1977]
Oil on canvas
> Vigilia_[1962]
Oil on canvas
⌄ Caminata (Stroll)_[1962]
Oil on canvas
⌄⌄ Port_[1959]
Oil on canvas

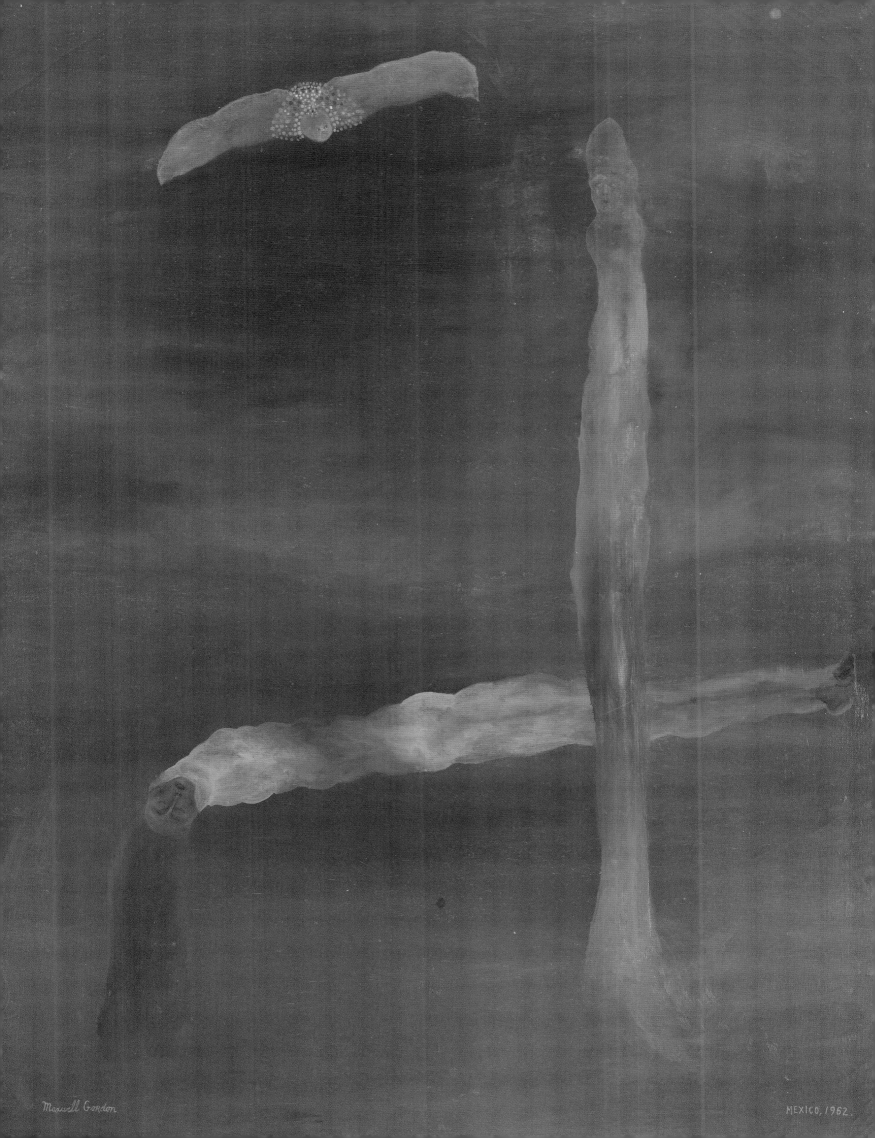

∨ Mark (Son)_[1950s]
Oil on canvas

∨ Adolescence_[1950s]
Oil on canvas

> Allen_[1937]
Oil on canvas

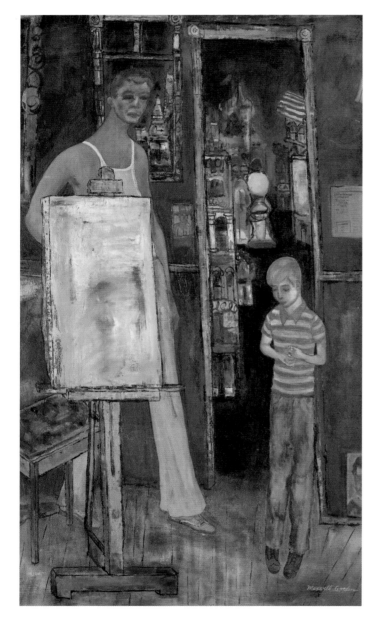

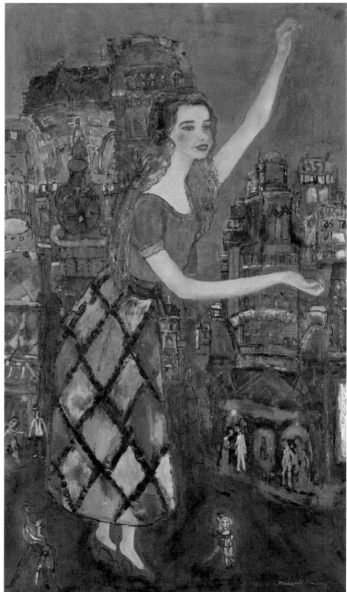

∨ Mark (Son)_[1950s]
Oil on canvas

∨ Adolescence_[1950s]
Oil on canvas

> Allen_[1937]
Oil on canvas

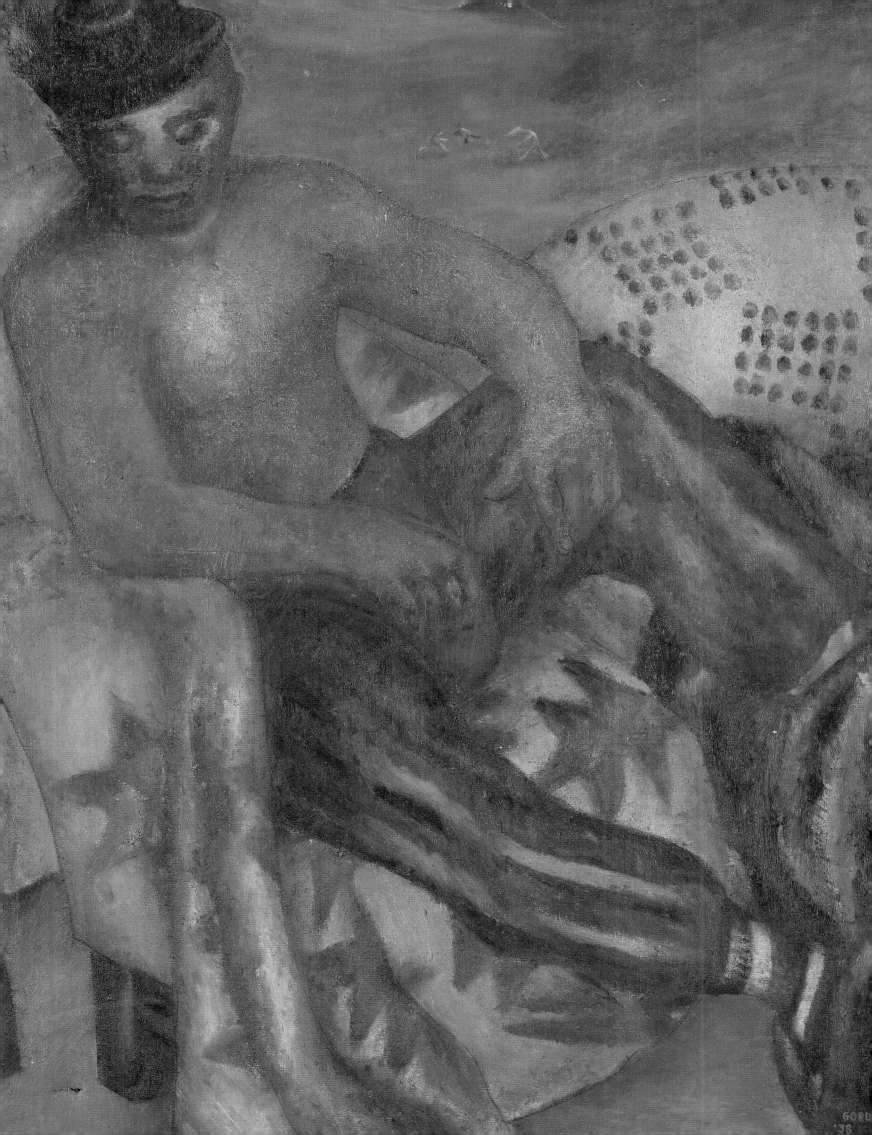

∨ Birth of a Hero_[1966] ⩗ After the Storm_[1975] > Understudy_[1940s]
Oil on canvas Oil on canvas Oil on canvas

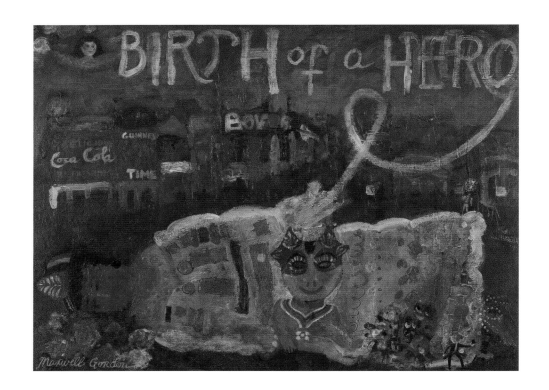

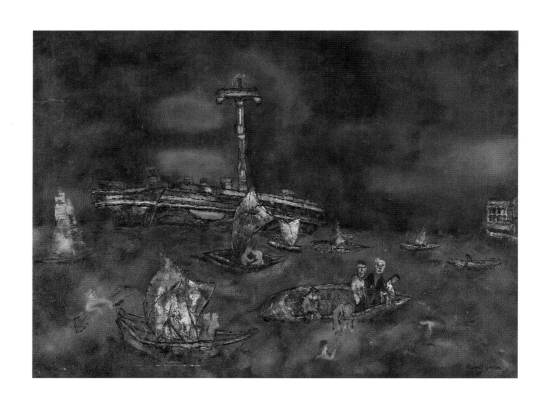

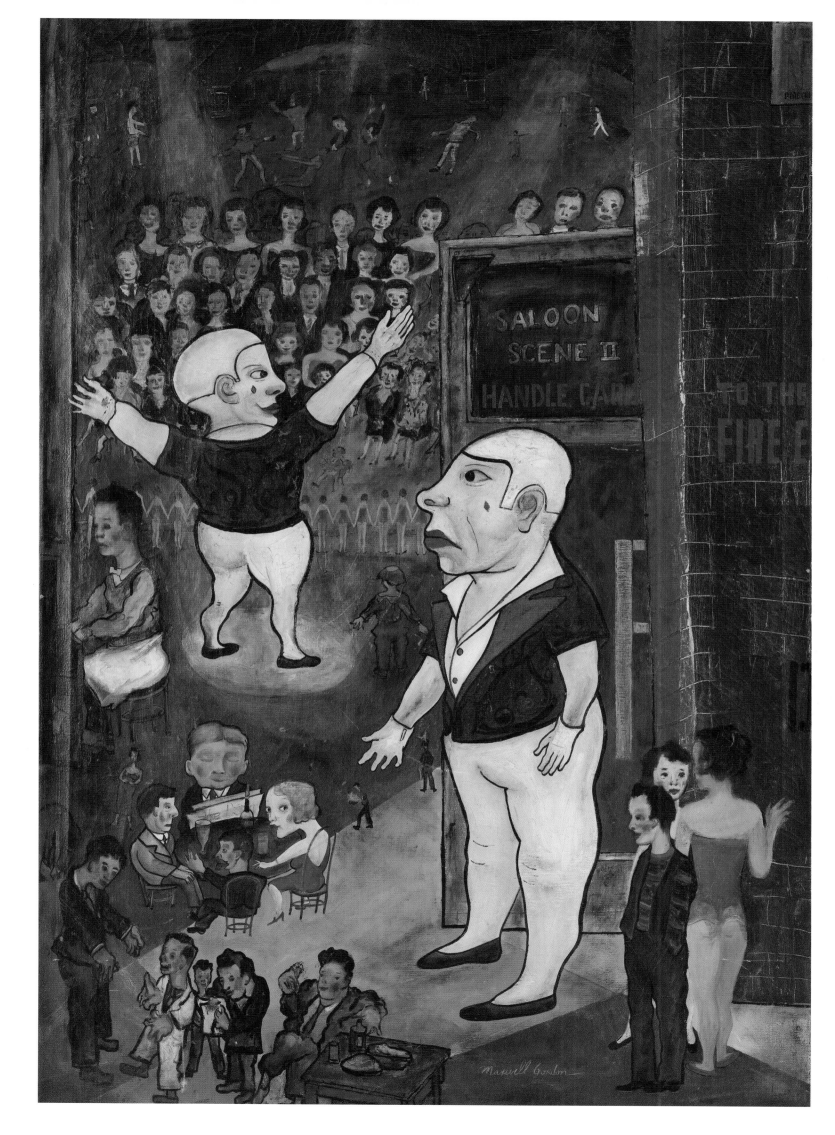

> Coquetelia_[1962]
Oil on canvas

Maxwell Gordon

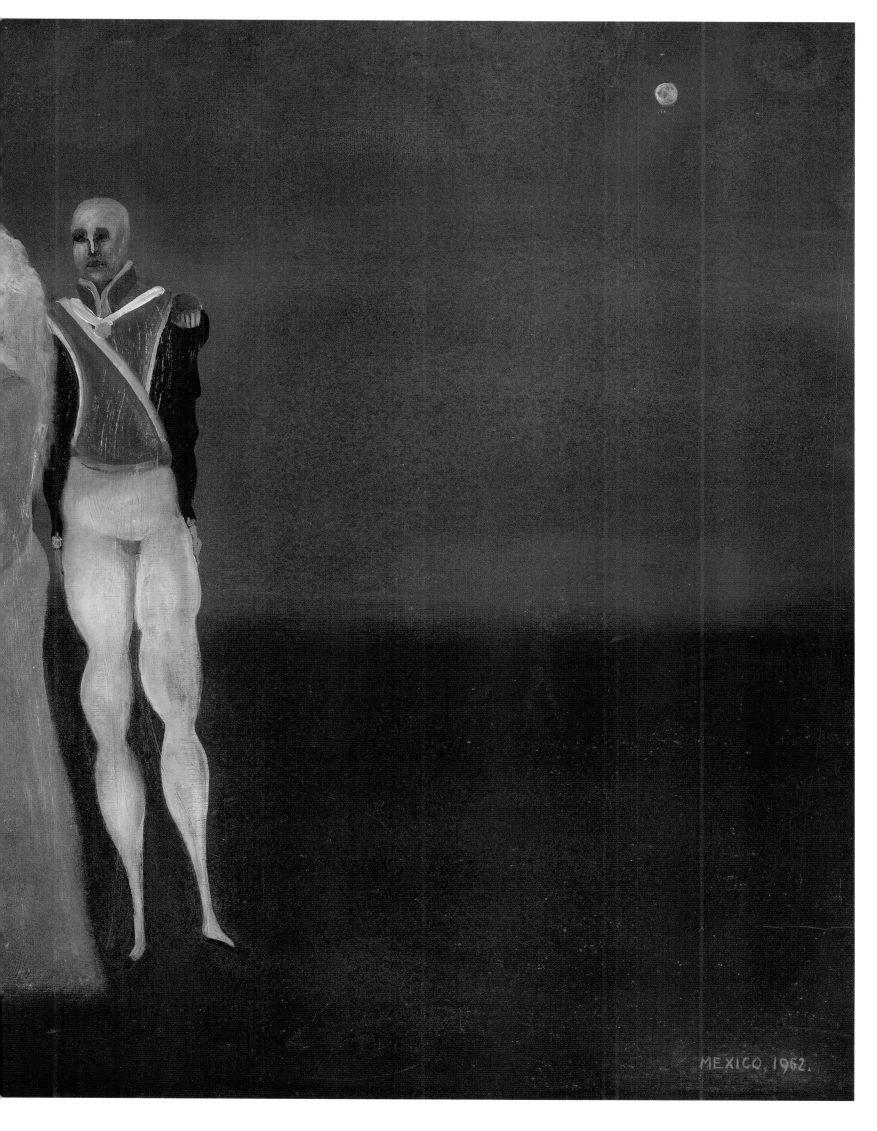

MEXICO, 1962.

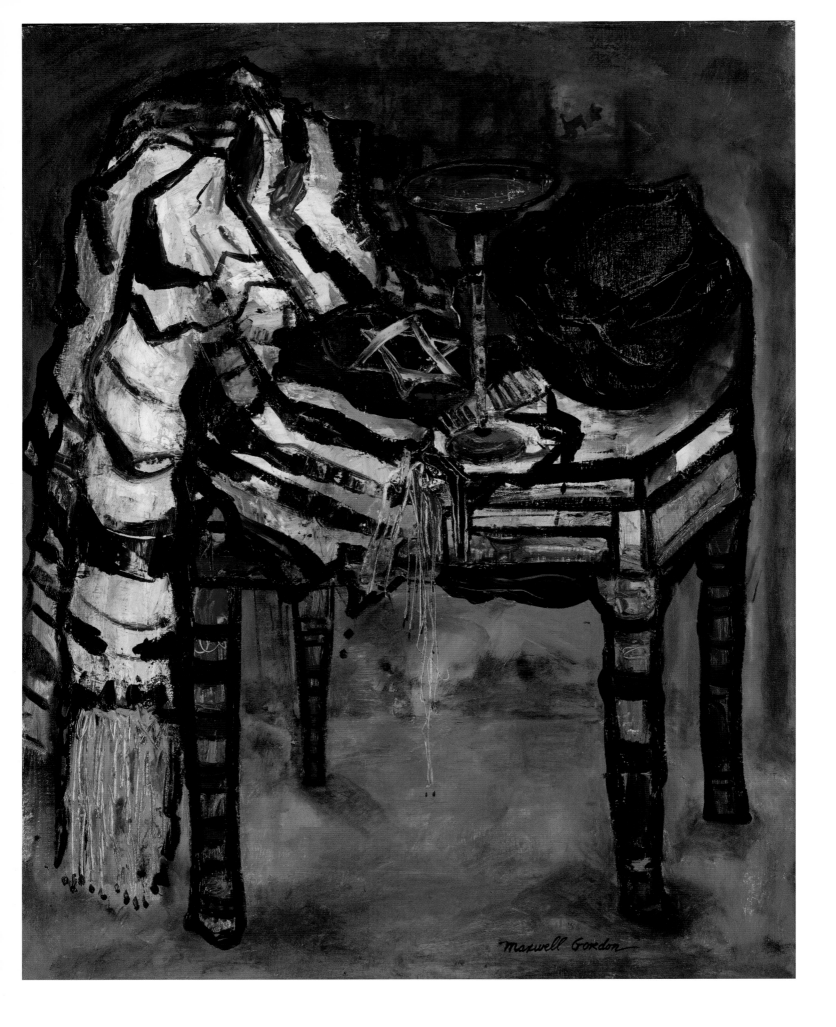

Maxwell Gordon

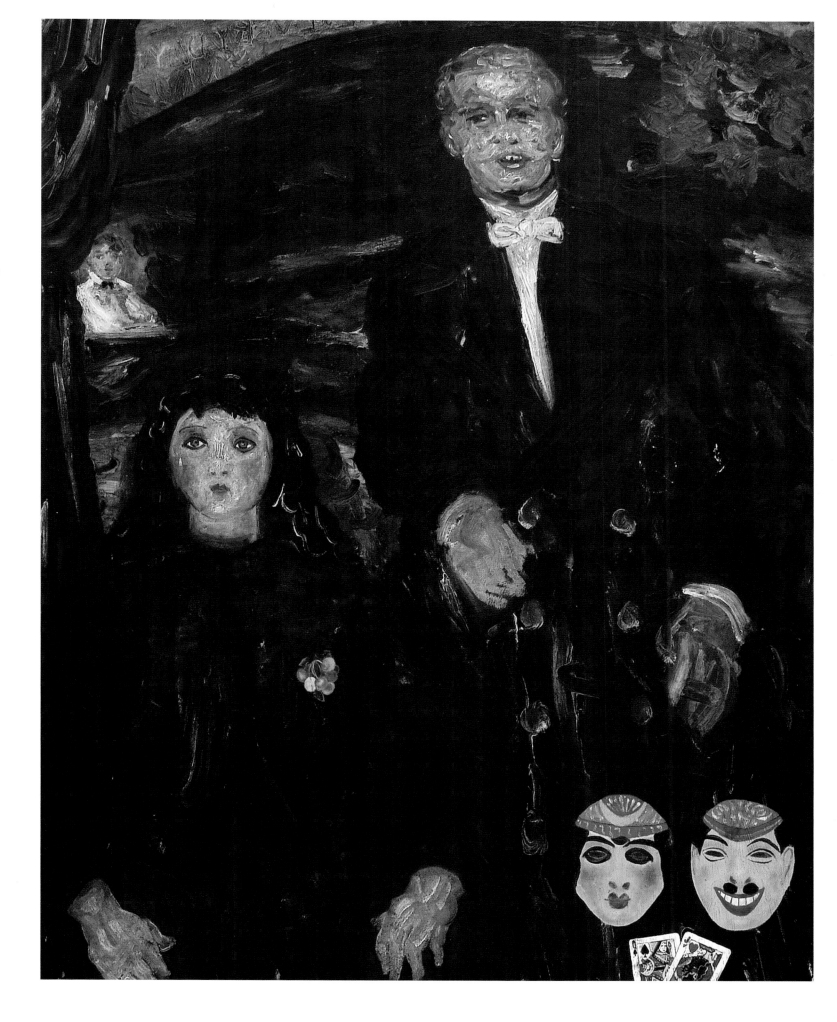

<< Ceremonial_[1930s]
Oil on canvas
< Games We Used
to Play or Fortunes Told
Here Everyday_[1971]
Oil on canvas

> Quiet Ceremony_[undated]
Oil on canvas

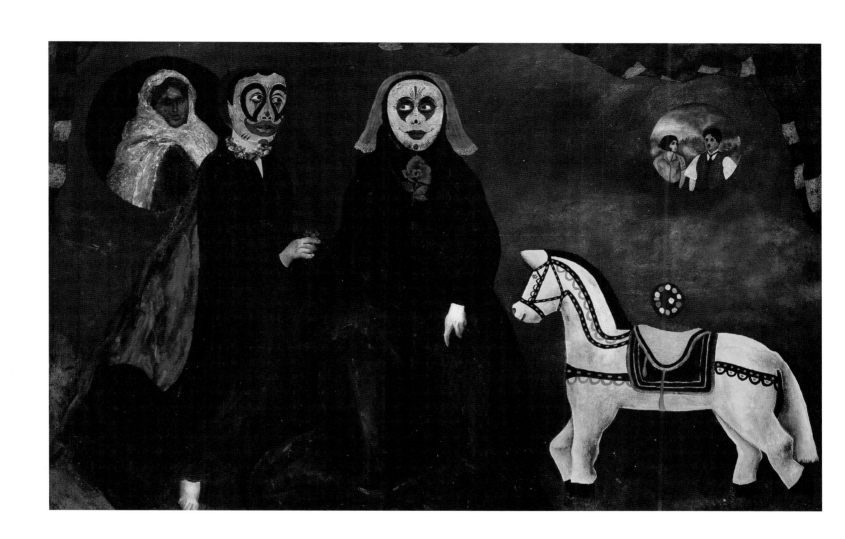

> Untitled_[1962]
Oil on canvas

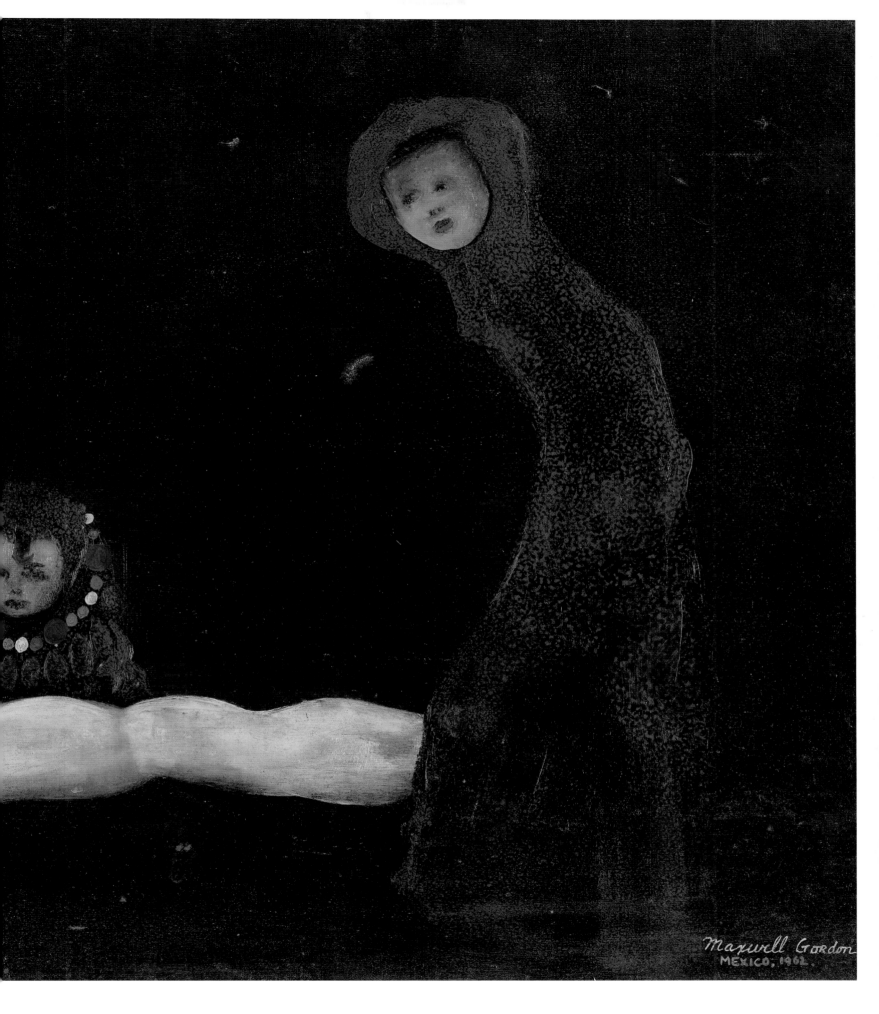

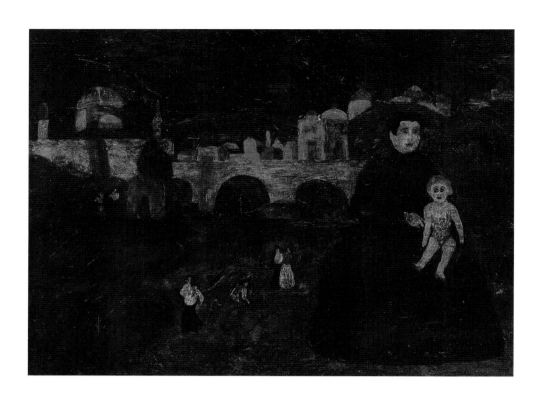

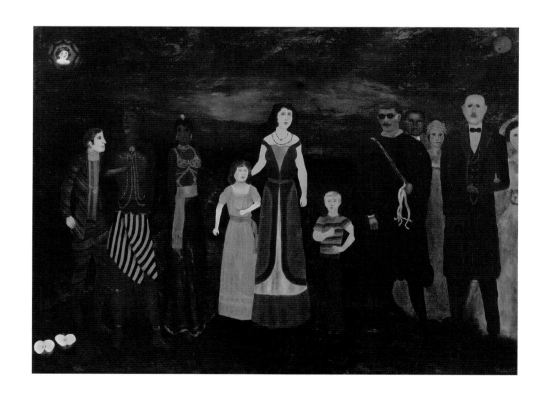

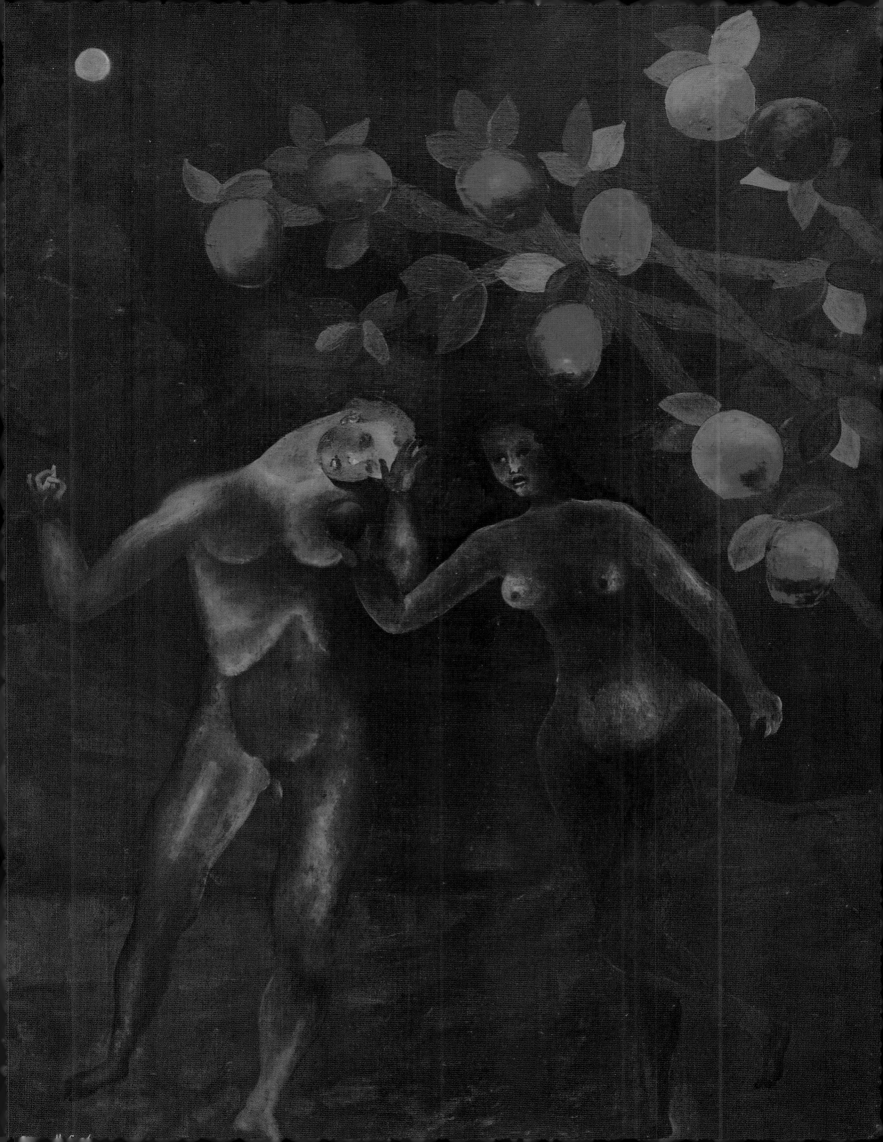

∨ Descubrimento
(Discovery)_[1962]
Oil on canvas

∨ Neighbors_[1962]
Oil on canvas

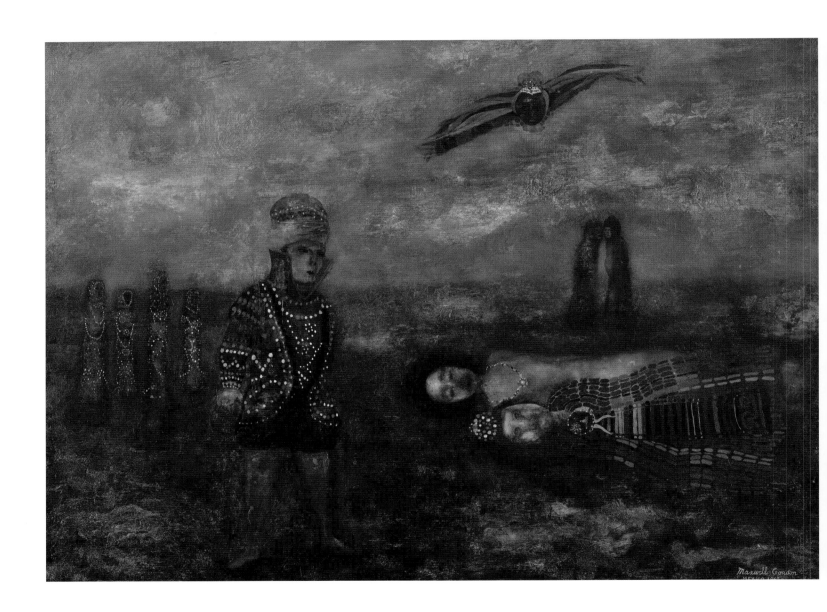

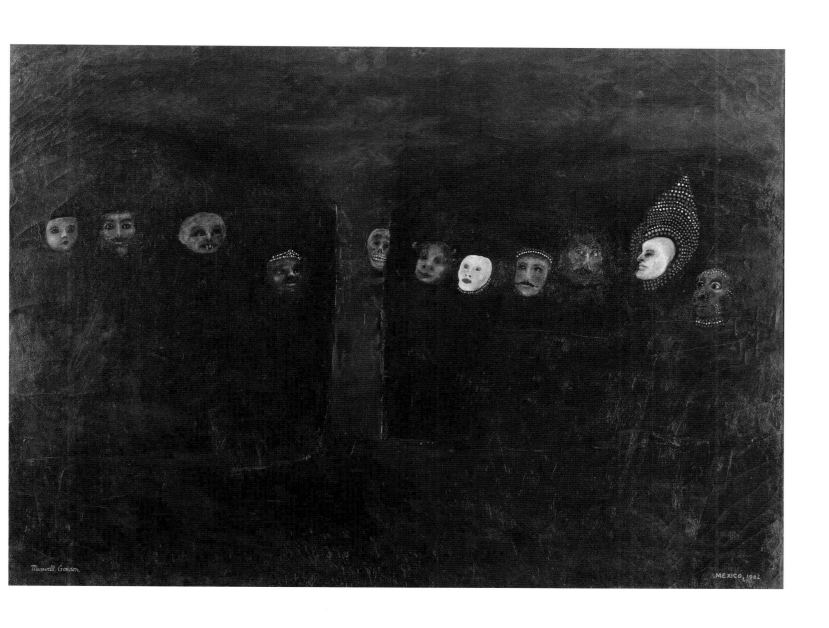

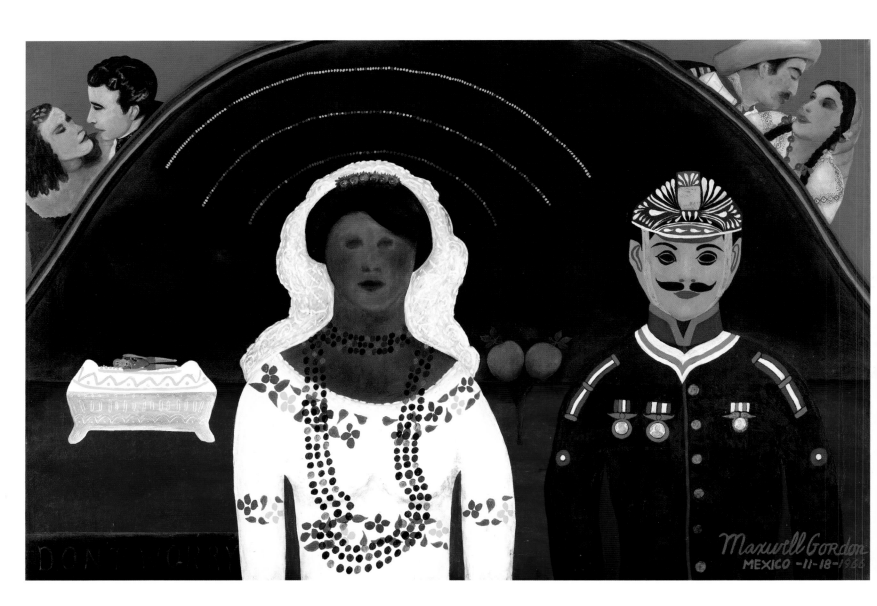

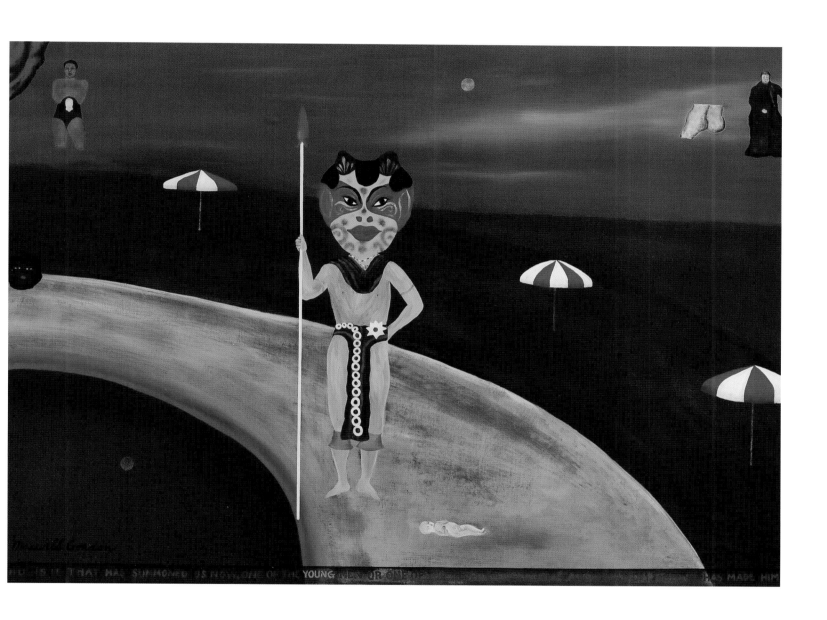

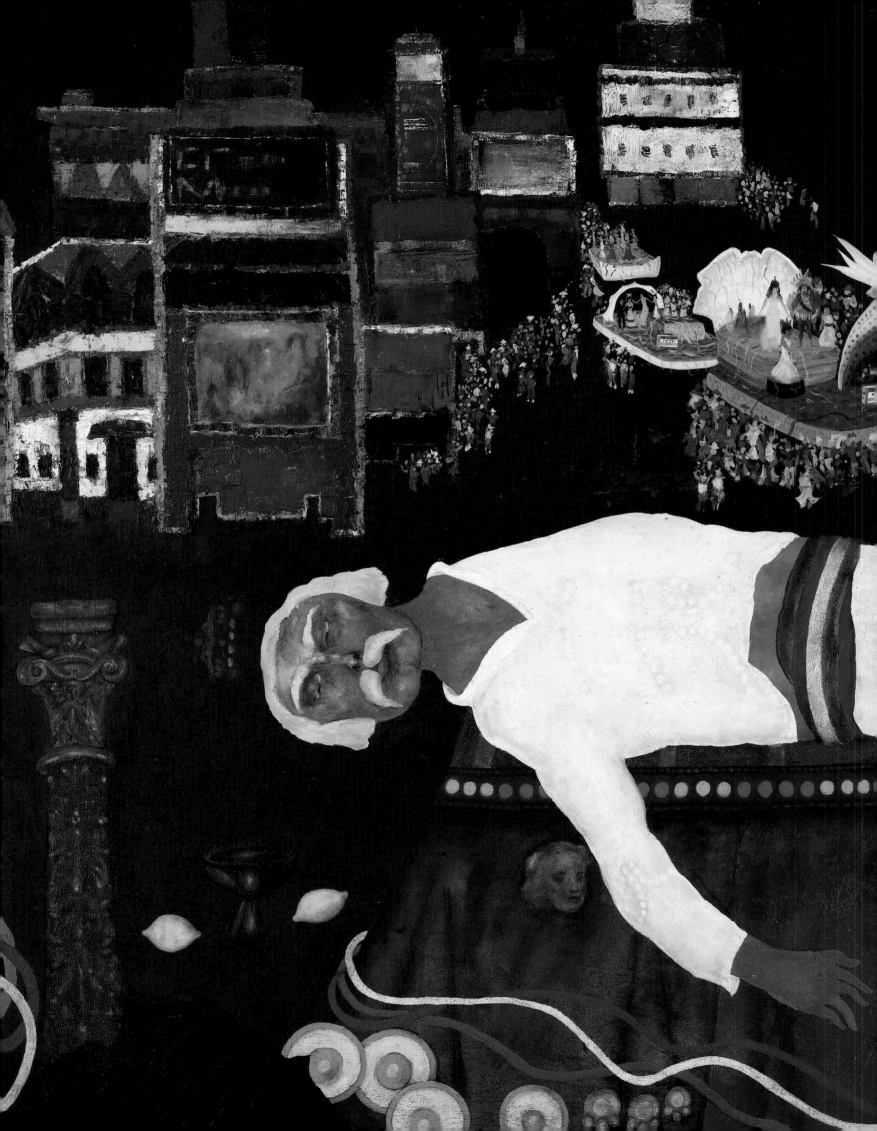

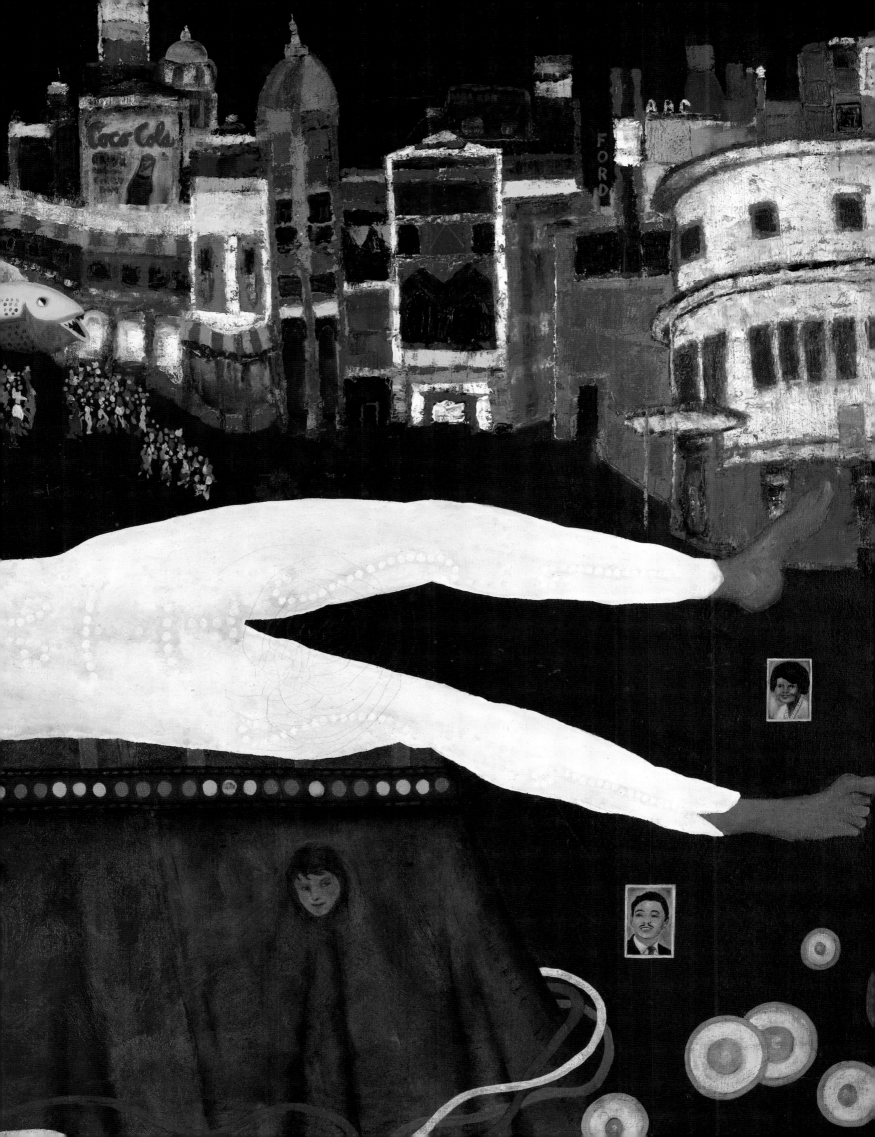

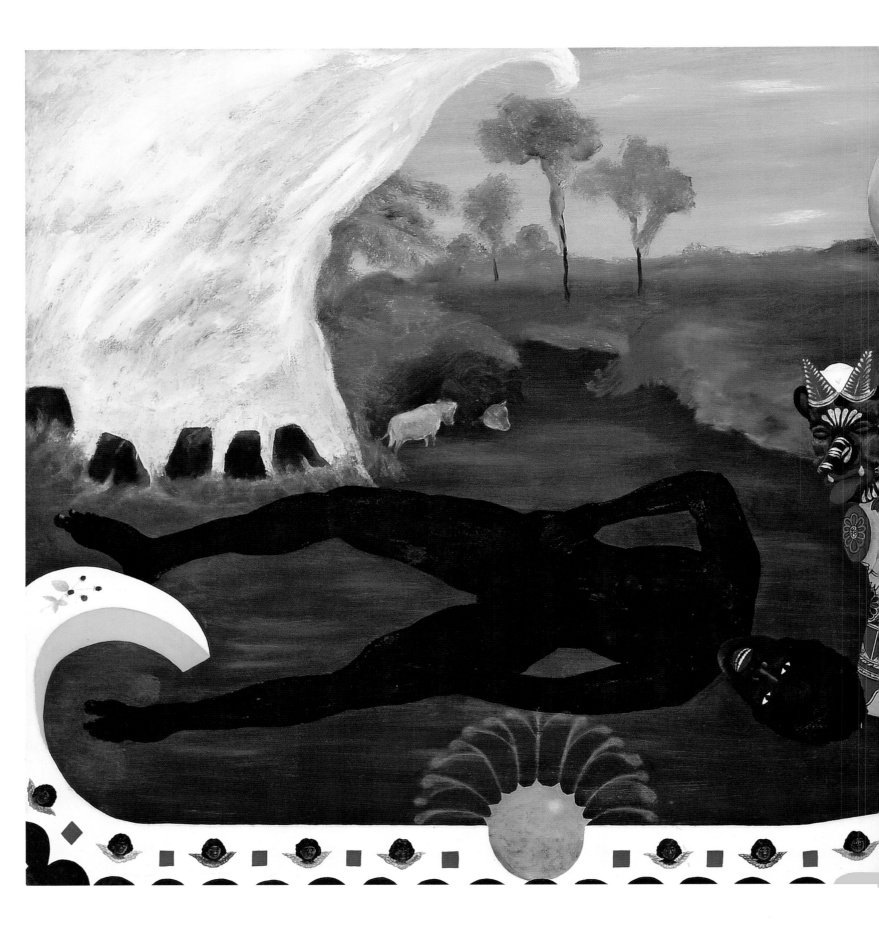

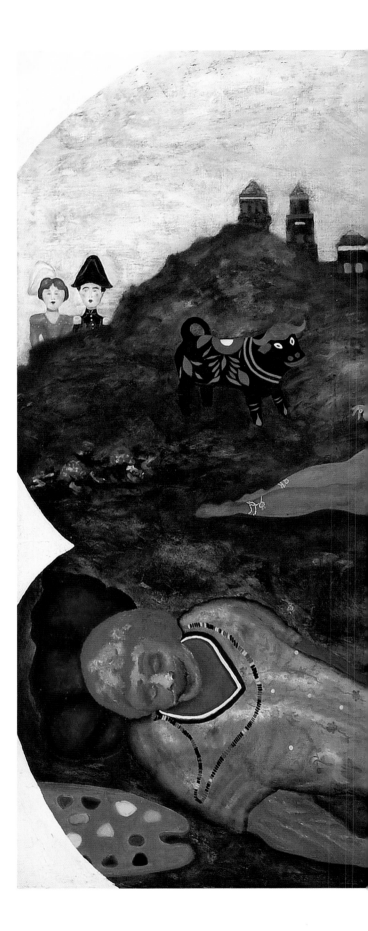

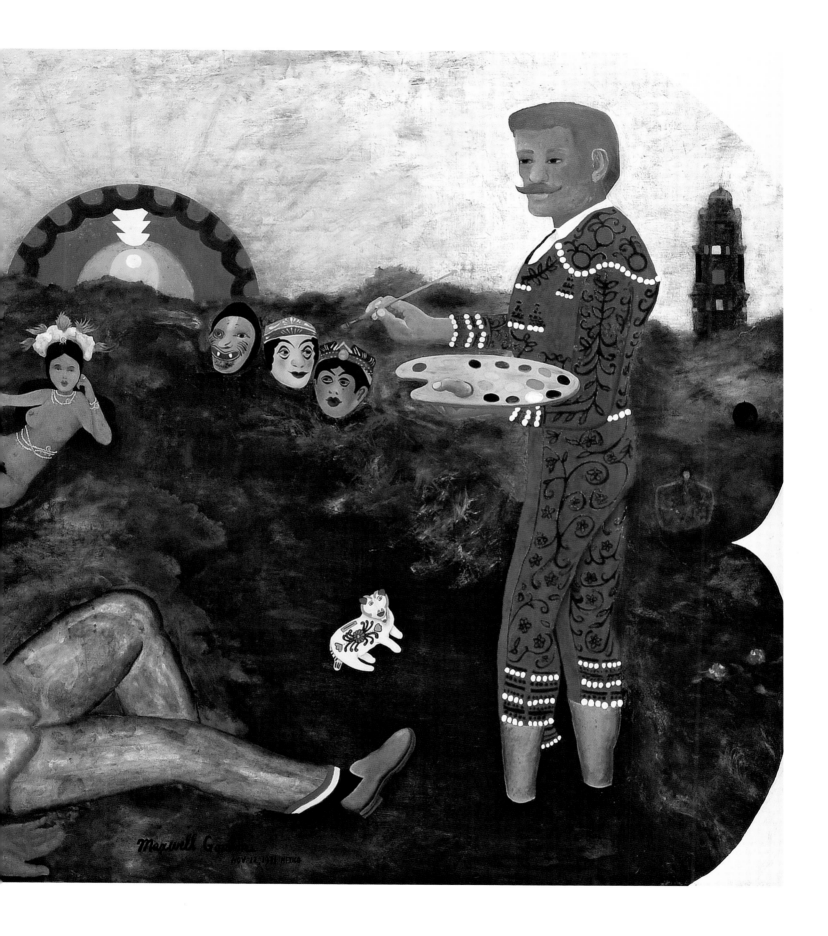

> The Courtship_[1968]
Oil on canvas

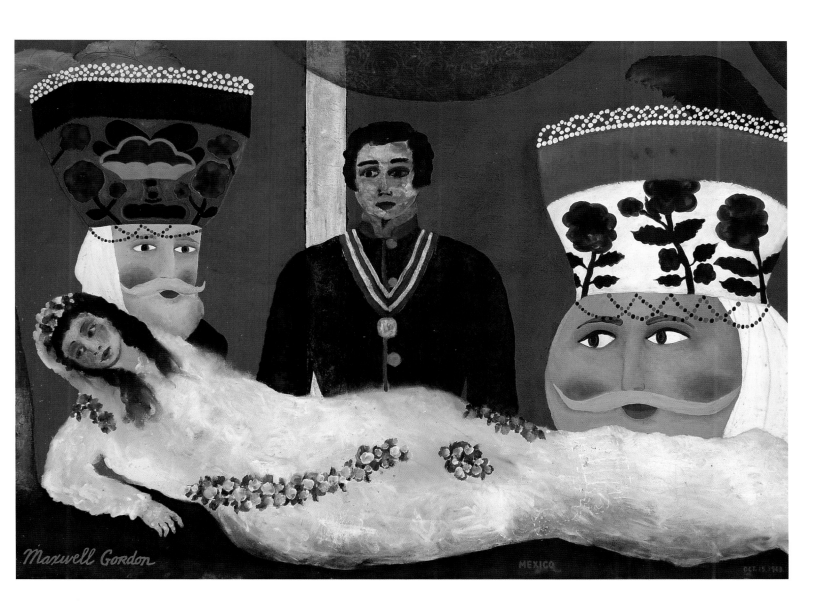

> The Concert
(El Concierto)_[1969]
Oil on canvas

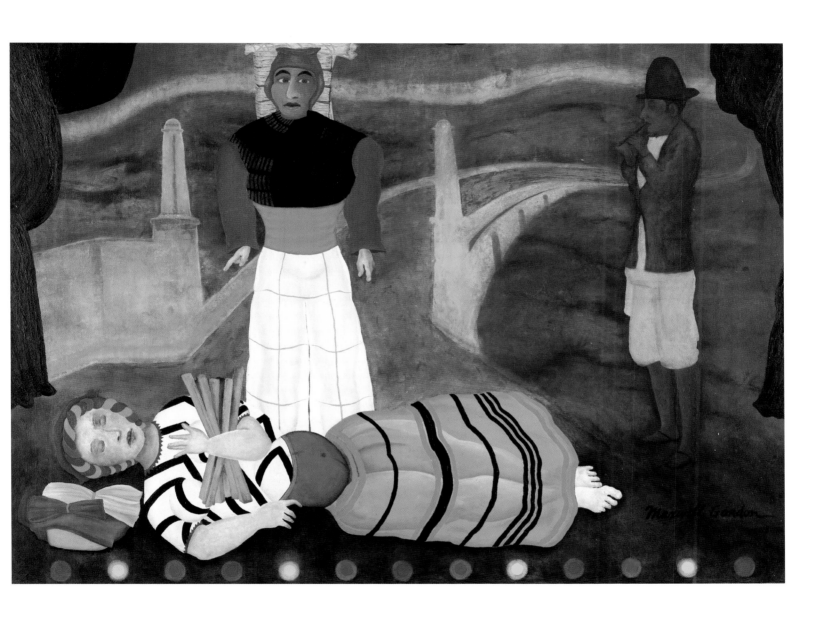

ˇ Act IV or
My Carnival Today_[1967]
Oil on canvas

> Imaginacion de Oaxaca [1965]
Oil on canvas

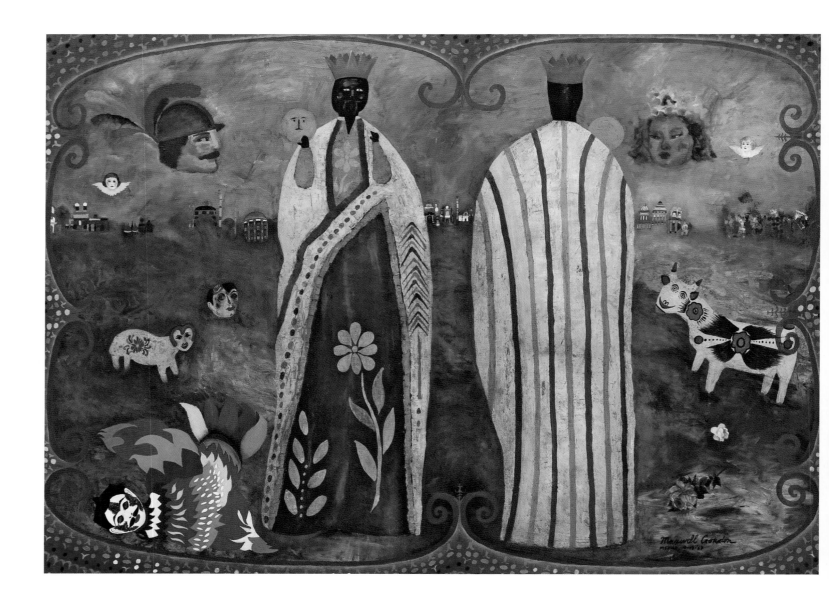

Maxwell Gordon

MEXICO
JULIO 1965

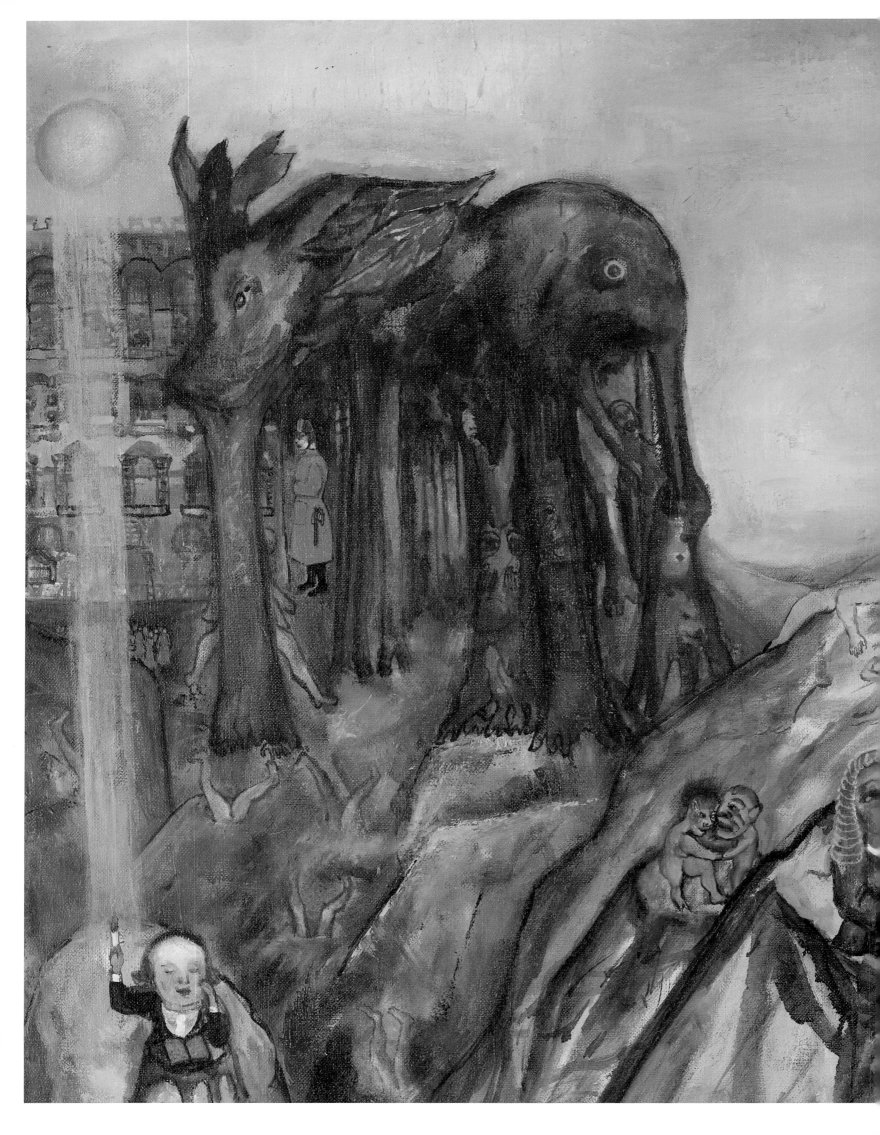

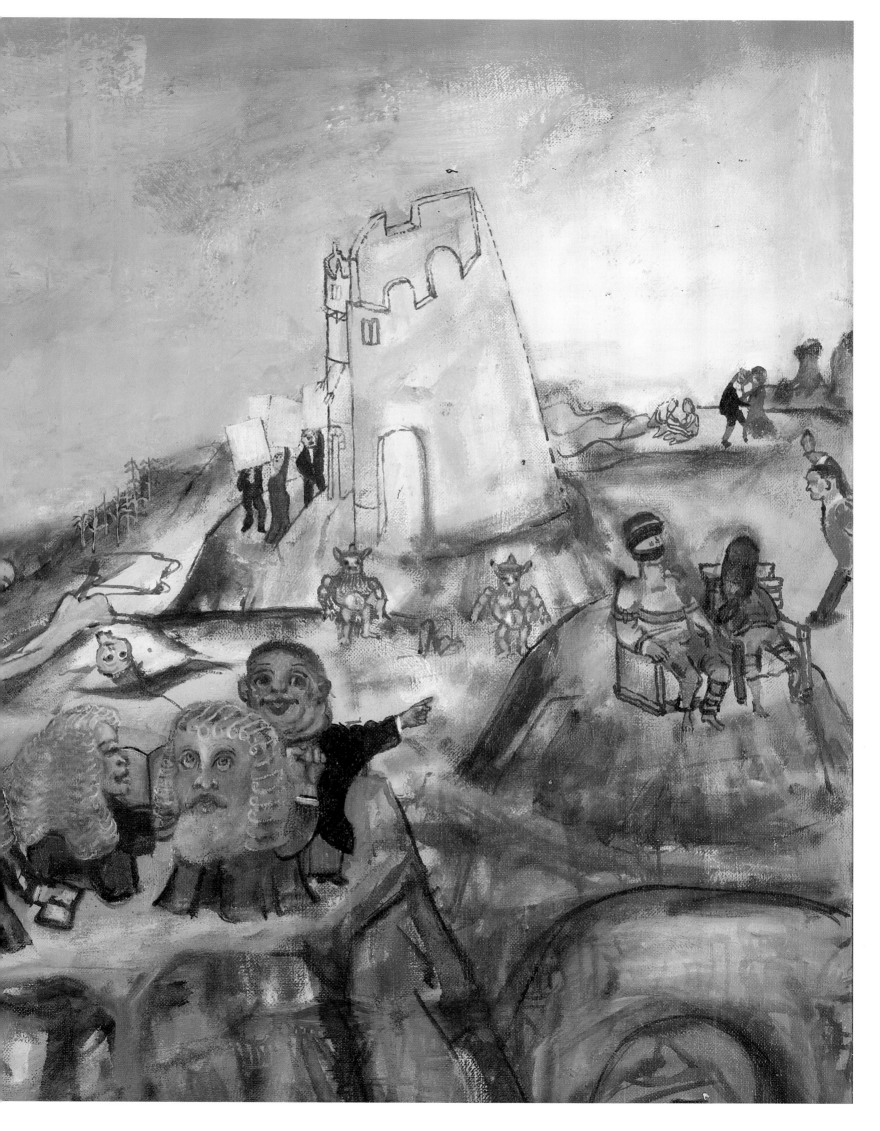

< Inferno Eve_[1953]
Oil on canvas

> River Rest_[1958]
Oil on canvas

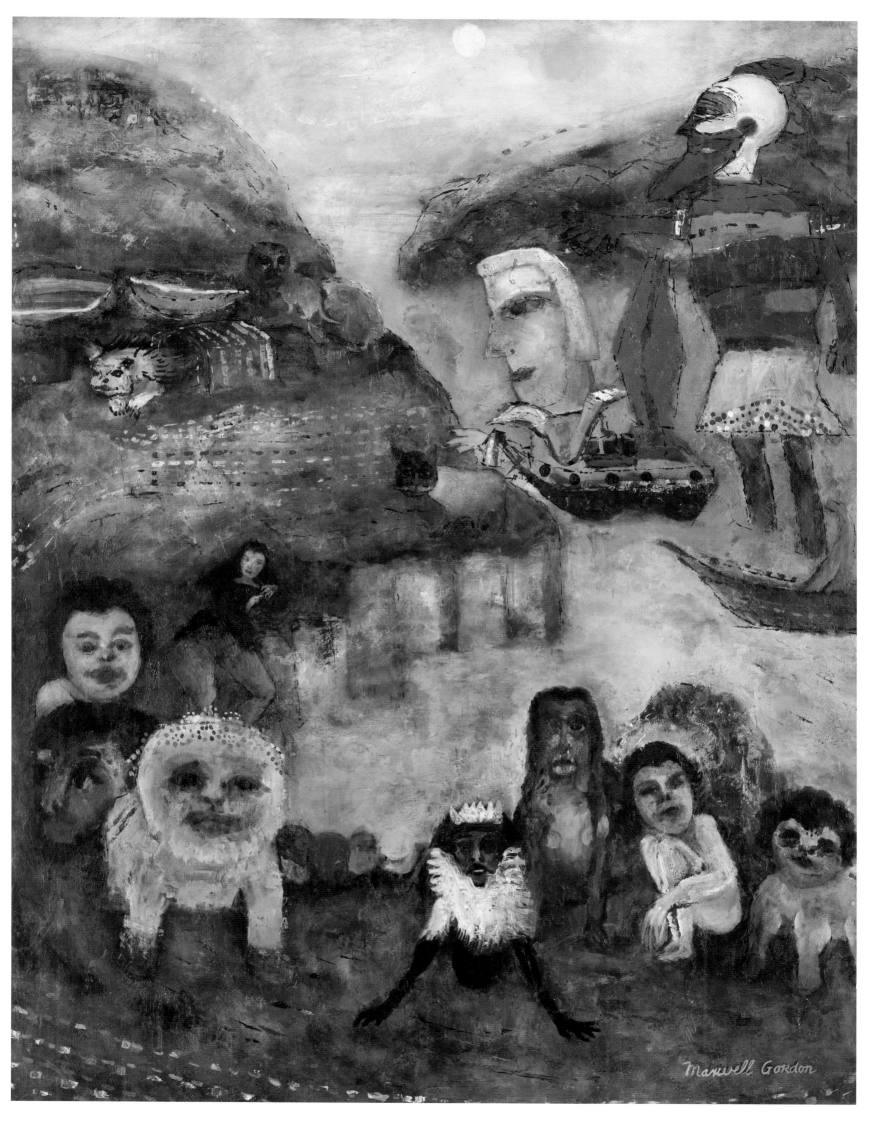

> Meditation (Self Portrait)
[1930s]
Oil on canvas

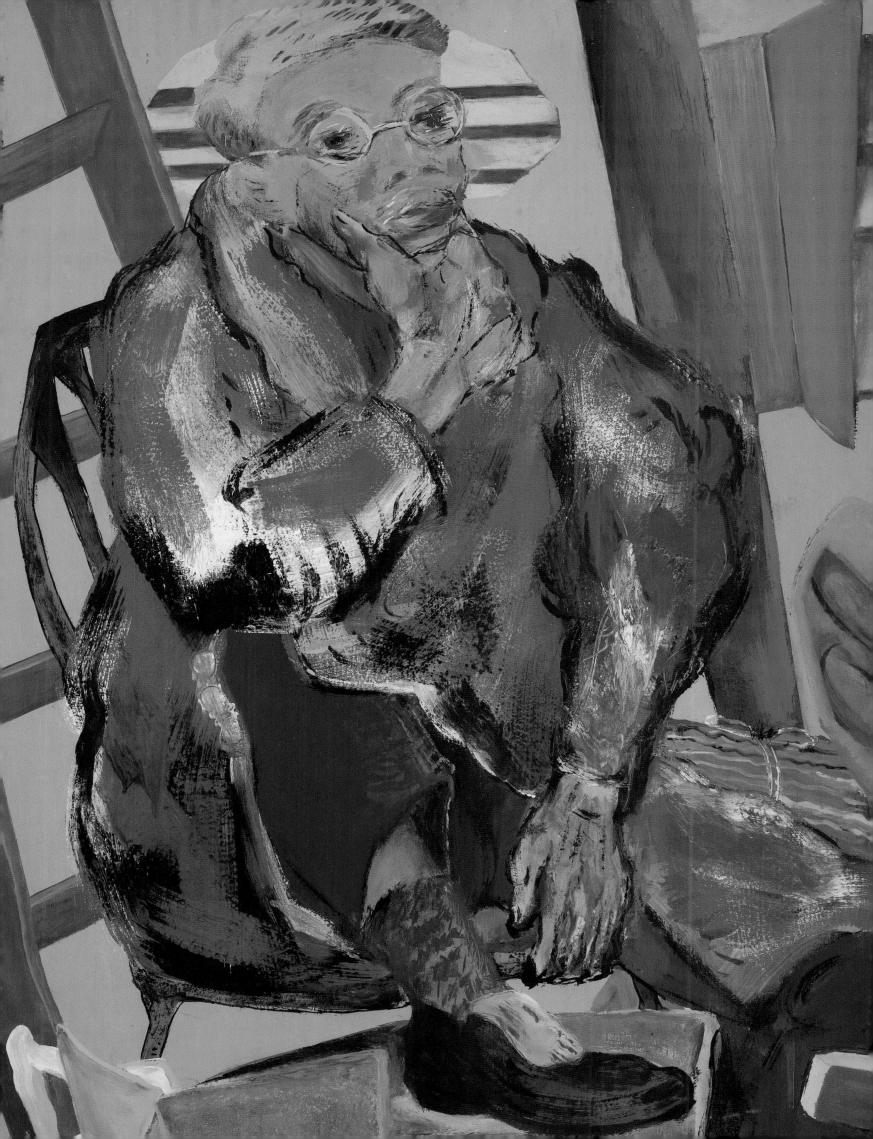

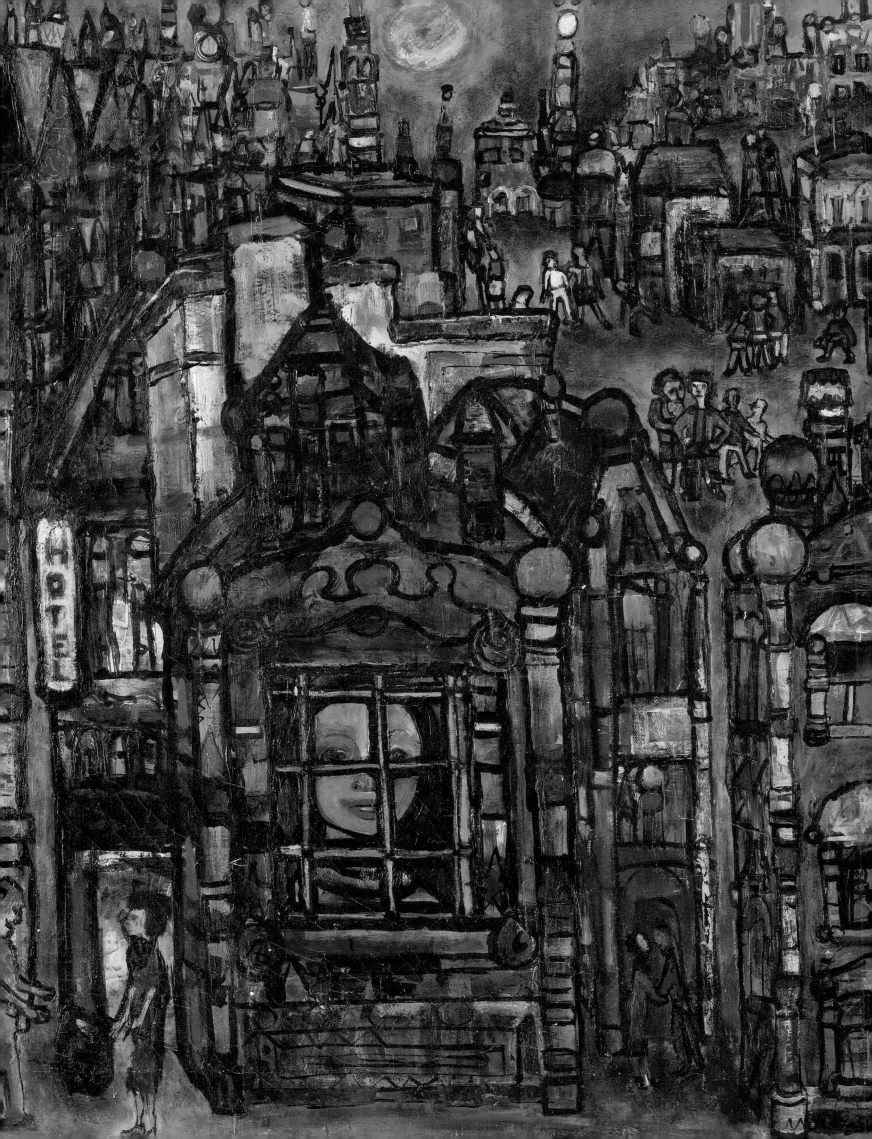

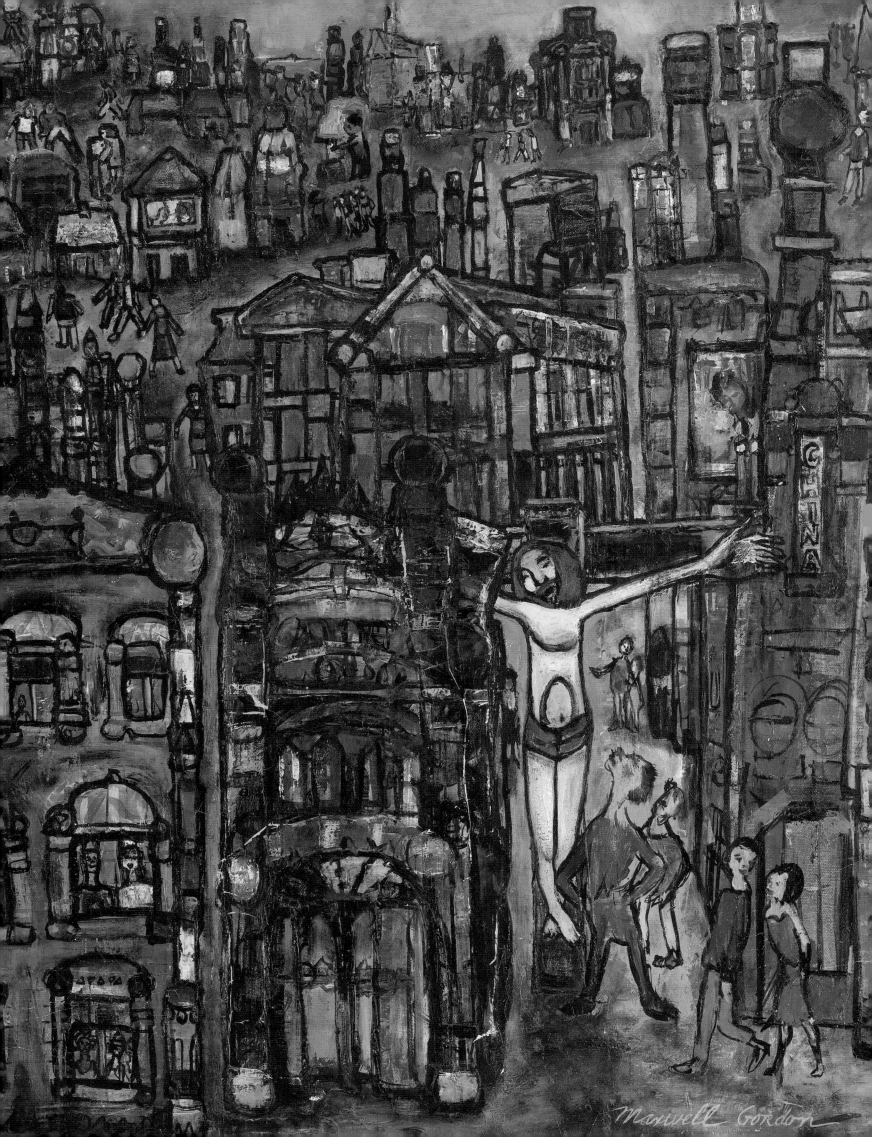

< Two Sides_[1950s]
Oil on canvas

> Parade [1953]
Oil on canvas
>> People_[1959]
Oil on canvas

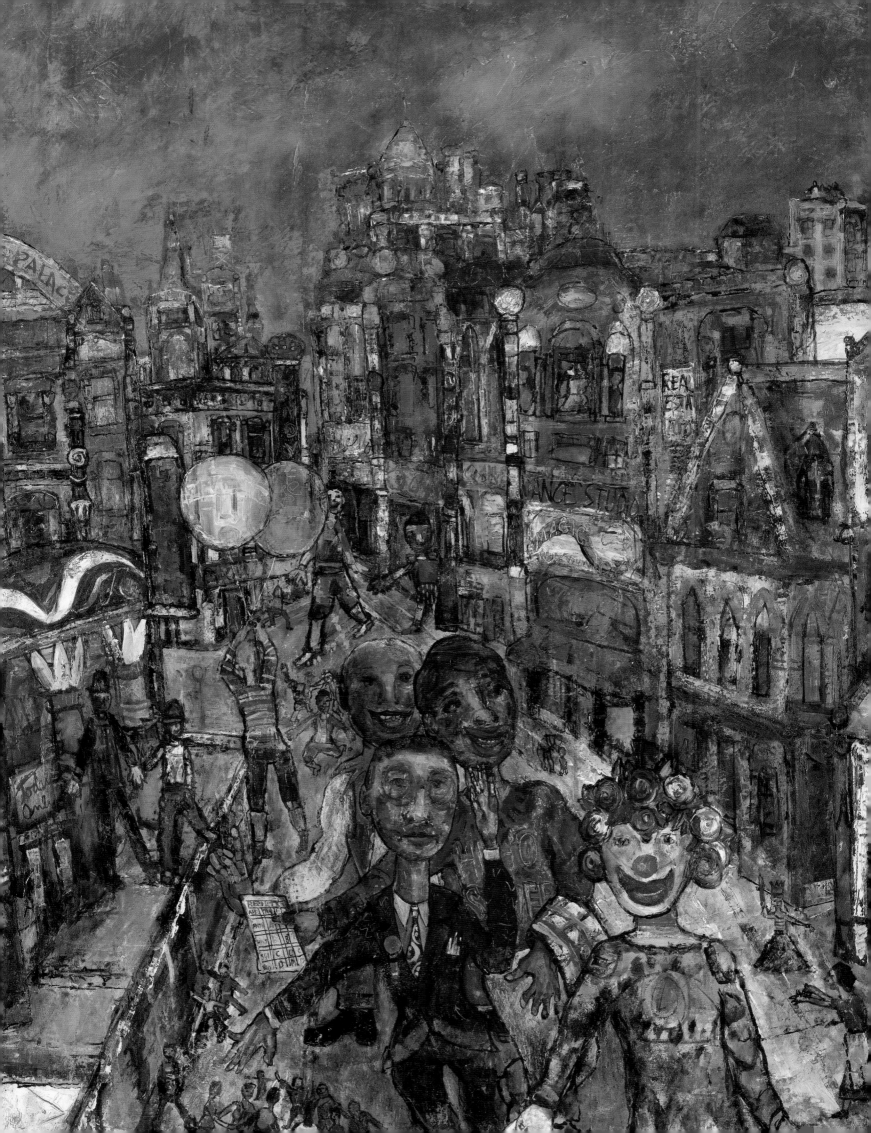

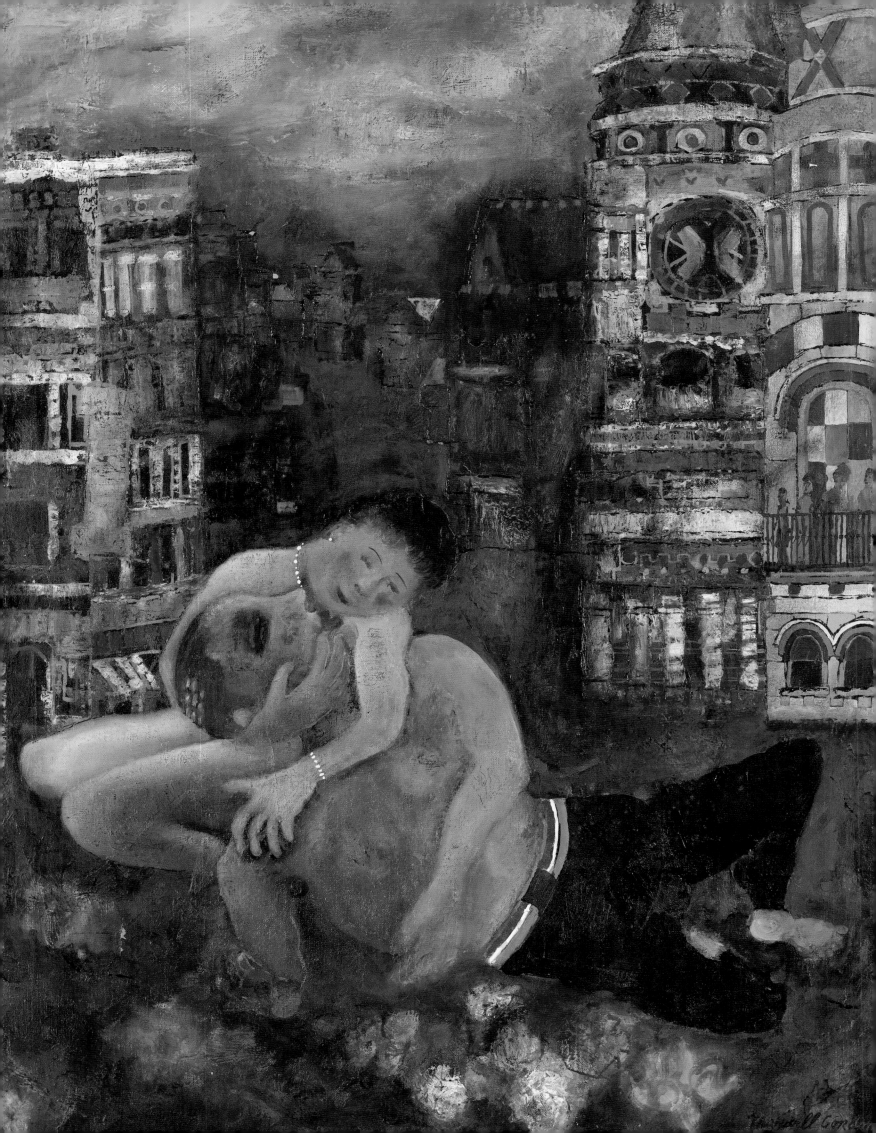

"ACTO II - LA PIÑATA TOMA VIDA"
"ACT II - The PIÑATA Comes To LIFE"
1.00 x 1.50 m.
(oleo sobre tela) (oil on canvas)
(finished 10/13/67)

Maxwell Gordon
Rio Hudson 28 - apt. 9
Mexico 5, D.F
tel - 5-11-05-00

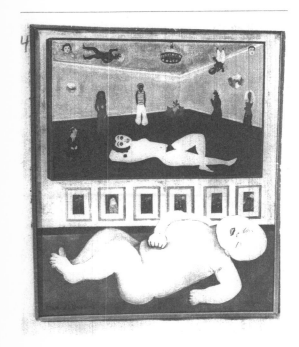

"EL CUARTO"
"THE ROOM"
.40 x .50 m.
(OLEO SOBRE TELA) (OIL ON CANVAS)

MAXWELL GORDON
RIO HUDSON - 28 - APT. 9
MEXICO CITY, S.D.F.
MEXICO
tel. 5-11-05-00

NINA

SERGIO CUA. FOTOS
LUIS ST. - 35 mm

MAXWELL GORDON
RIO HUDSON 28 - APT. 9
MEXICO 5. D.F

"RESTING" - DRAWING - 48 x 62 cms.
"DESCANSANDO" - DIBUJO - 48 x 62 cms.

• "The END of the world?" - or the World
 alive"
 "such painting"
 — 150 x 200 or my last
∆ "The Way I would love"

"ACT IV OR, MY CARNIVAl Seymour worth
ACT V OR; ACT III ORgy;" TODAY orgymal
MY CARNIVAL TODAY
AT NIGHT - only made in colors - faces that
show end - emerge - 2 or 3 good people.

Best painting to date.

" ACT IV - OR, - MY CARNIVAl"

"ACTO V - EL GUERRERO DESPIERTA" 050
 "ACT V - THE WARRIO AWAKENS"
1440/ 100 ct x 150 ct - finished 5/23/67. check
 10/24/77
4 coats of vinelica premium + plastileter.
all oil paints - laid in loosely landscape
to be happy then added in detail
and when parity dry - Put a
glaze over of raw sienna + blacks
& burnt siennes.

" finished - 6/20/67 Sous St
Contemplation
Contemplación " 1 mt. x 1½ mt

Painted with oils
over vinelica
primed canvas.

 9/14/78 - Chuck
 finished 1 mt x 1½ mt
 If possible 9/16/67.
 "The Painted Wedding"
" La BODA Pintada
 painted with oil over vinelica primed
 canvas

" THEY ARE only PEOPLE & They
have to respond to The TRUTH
WELL TOLD "

" There are only the Truths & the
utter's can only Tell it Truthfully "
in a plesh manner " —

"IT'S A STUPID WORLD"

ALL IS SYMBOLS - "MA" CAN BE AN INDIAN GIRL OR
A TREE TRUNK - ALL INSTRUMENTS for MY own
PERSONAL SPIRIT. - WHAT THE OTHER PERSON sees
is his business. - I use the graphic forms I
wish.

"ON BLACKNESS, THE COLOR IS FOUGHT"

"LA FAMILIA" #1
"The Family" #1
.75 × 1.00 m.
finished 11/26/69 .75

1.00

50
"The Sermon"
"EL SERMÓN" 40

40

marian
STEVENS
TO KEY WEST
50

finished Jan 1970
"The Fortune
LADY FORTUNE"
"DAMA DE FORTUNA"

LAST PAINTING FOR B/YEAR

finished DEC 1969
Lady Fortune
"DAMA DE FORTO

1931

! $1 after B.A. show

720 100 ct

75

finished march 11, 1970
"The Unwelcome Guest"
"LA VISITANTE DESAVENIDA"

JIMMY & PRISCILLA - July 4 - 78

2.00 finished May 30, 1970.

1.50

flowers she dropped in
her love for this tough man

"LA ESCENA" - THE SCENE"
2 masks + tiny Birds
Totem of 2 people.

2 death masks -
they're alive & later they
are dead.

• The Phoney Forger - Honest Tomorrow
• Honest today - Forger Tomorrow.
• Little Birds are sweet - Forger Keep them for
 sweet atmosphere - for themselves & their
 customers.
• They are bad - but so are many others - Lets'
 dramatize it - & Create a theatre of paint. OLLA!

T.S. ELIOT:	• A white man disguised as
Between the Conception	a black, handing a false
And the Creation	document to a genuine
Between the Emotion	black girl.
And the Response	• "The Forger & the Good Girl"
Falls the Shadow.	• "It's the Balloons that count"

1. Drew + painted Broadly with Acrilica only.
2. When dry, impratura of oil paint ochres, grey,
 green, etc with my Regular medium.
3. Wiped off sensitively, excess with a cloth.
 Uniformly dull, not to have a gloss.
4. Can work over when impratura wet or dry
 with Acrilica or oil paints.
5. ETC.

Registering the Color Blocks. Instead of gluing print from Key Block onto subsequent blocks we simply offset the print on them.

PRINT

THUMB TACKS

WOOD BLOCK

TABLE

REGISTERING COLOR WOODCUT

Nail mitered corner of 1×2 or 1×3 on table or special Board. Put Key Block in corner + attach paper to strip forming corner, making print on not too absorbent paper with exceptionally heavy inking. After Key Block print finish replace with 2nd Block. All Blocks should be same size & square to have a good register. Wet print folded back on top of 2nd Block + Rubbed. So transferred from paper to wood to serve as guide for register.

Old timers who did not make enormous print cut register mark on block that

was larger than dimensions of print.

One of great interests in col. prints is rich & exciting effects produced with few colors exploited. In contemporary col. prints try to exploit overlapping transparent cols, something Japs used little. When work on large col. print where defined colors far from each other to permit a controlled rolling, any no. of colors can be used on same Block.

In smaller ~~movable blocks~~ areas some use brushes to apply col. (altho Peterdi doesn't like painted quality of col. brushed. Area should be defined by woodcut. Otherwise in monoprint category).

moveable Small Blocks used today.
Practicable, sometimes involves planning in order to print in register with large blocks. Easiest way to put a light cardboard exactly size of Key Block in position. Once small Block are placed in correct position to register, can be marked on cardboard, then the small Block glued down to avoid shifting.

Cardboard Cuts.
Mo. of print makers use cardboard cuts in combination with wood cuts for simple col. areas. For few flat col. areas on complex print, would be senseless to cut large wood. Cardboard shapes can be put in position as movable small blocks are. Or can be temporarily mounted on surface of larger wood block. When printed cardboard has to be shellaced or sprayed with plaster to harden surface & prevent absorption of color.

I Paint my pictures as I feel —
(and they paint for me?) When they
are finished I hope that they
communicate and the touch the
sensitivity to Beauty that is always
dormant in a different degrees in
every person.

A procedure for Painting
Delacroix — etc Cézanne Dubuffet, Dali,
Picasso, Francis Bacon, & many Ed. munch
other good artists work openly etc
from photographs, Postcards, etc
other artists Painting, etc, etc . —
& they feel no need to be
secretive. but do so publically.
Francis Bacon hangs all the above
references on his walls & the
reporter from the Art magazines
photographs & reproduces them.
So does Dali — Picasso — the Women of Algiers" etc
 from Delacroix — & " LAS MENINAS"
 from Velasquez
Salvador Dali — Enlarged photo
of a painting & painted from it.
works from Photos

My resistance to art success to include money & popularity, even to good connoisieurs: — am I against success. — With success can come happiness — freedom from Edith's legal position & a better relation with my children.

Construct a show *& also*!!! for success as art & money. — must be New York. First Resolution — must be — NO BUCKEYES — ever again in my life. NO PARK. — MAKE 15 MAJOR PAINTINTING FOR N.Y. EXHIBIT. & SELLOUT IN MAJOR GALLERY. — PRIZES, MUSEUMS, ETC. & 10 MAJOR WOOD CUTS. FOR N.Y. SELLOUT — EXPLOIT ETC.

1 GOOD WORK = 1000 BAD ONES.

LET THE SUBJECTS & ART PICK YOU.

LIBRARY
BRITISH BOOK STORE
AMERICAN " ".

IN MEXICO THERE ARE NO FELLOW ARTISTS FOR INSPIRATION. — I MUST DEPEND & SEARCH FOR MYSELF.

"RESORT COUNTRY LEFT OVER" ["LUGAR DE VERANEO, DESOLADO"]

6/6/79
Guess
140

1:50 mm

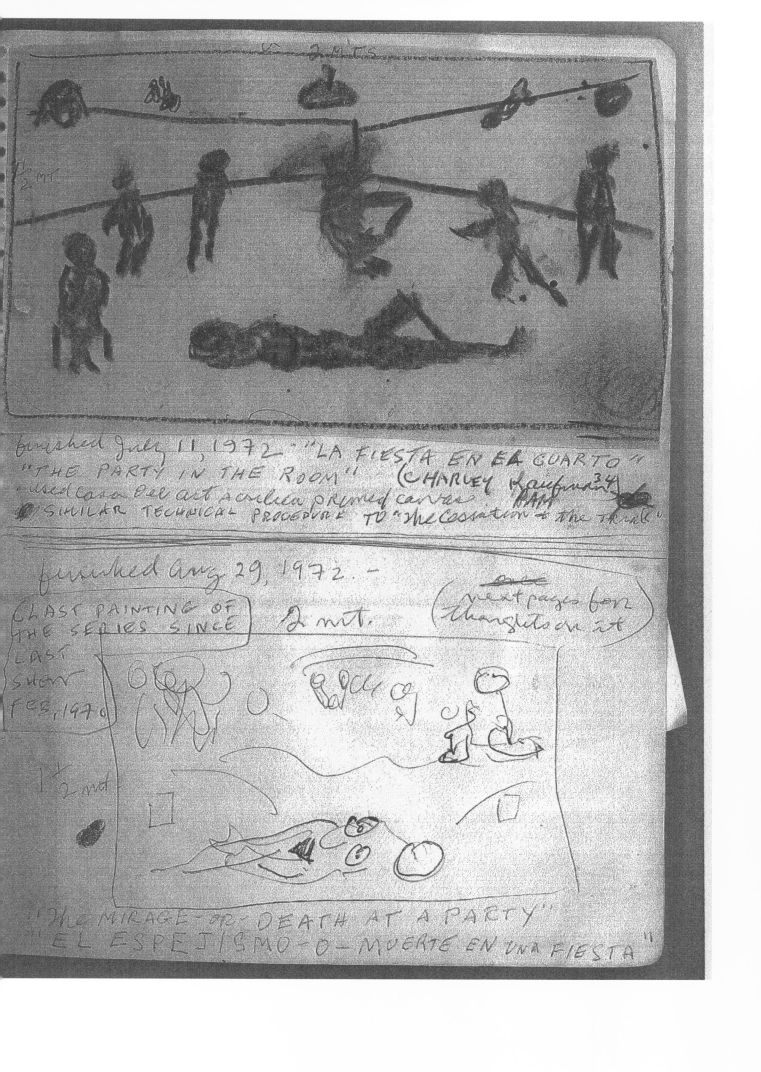

finished July 11, 1972 · "LA FIESTA EN EL CUARTO"
"THE PARTY IN THE ROOM" (CHARLEY Kaufman³⁴)
· used Casa del arte acrílica primed canvas · DAM
· SIMILAR TECHNICAL PROCEDURE TO "the Cessation + the Trial"

finished Aug 29, 1972. -

(LAST PAINTING OF
THE SERIES SINCE
LAST
SHOW
FEB, 1970)

2 mt.

(next pages for
thoughts on it)

1½ mt

"The MIRAGE - or - DEATH AT A PARTY"
"EL ESPEJISMO - O - MUERTE EN UNA FIESTA"

II) KEEP THIS CARDBOARD, I LIKE WHATS [MARK]
WRITTEN ON IT

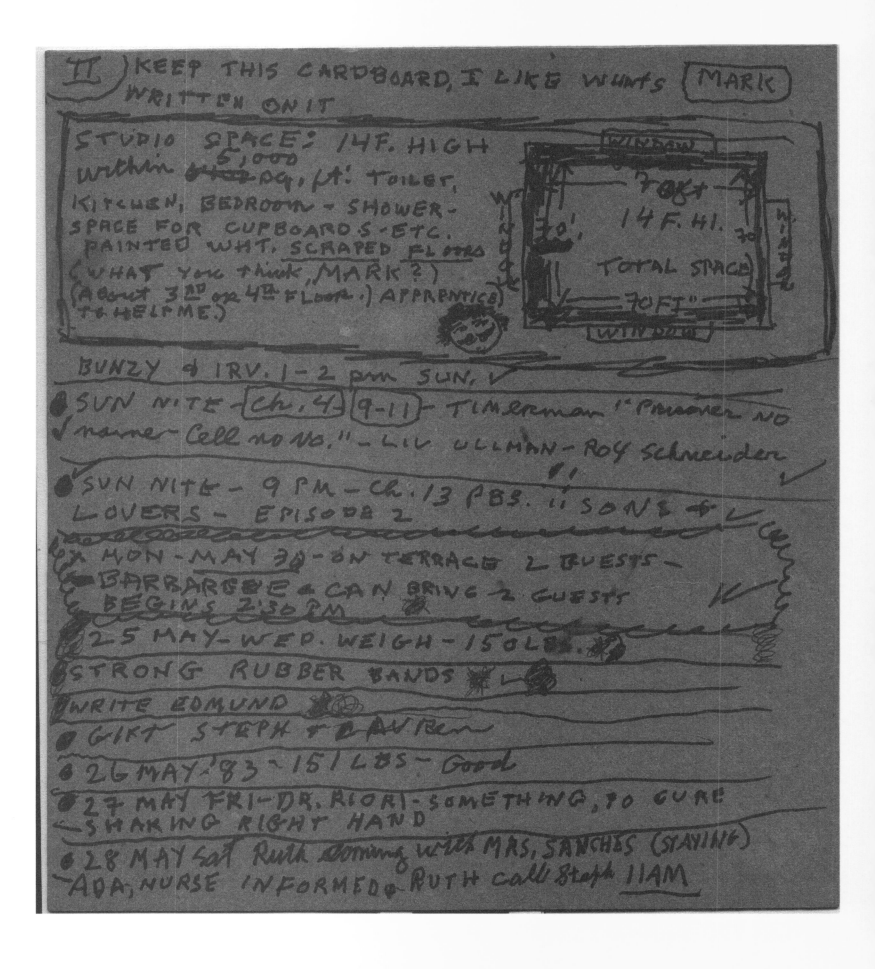

STUDIO SPACE: 14 F. HIGH
within ~~abt~~ 5,000 sq. ft: TOILET,
KITCHEN, BEDROOM - SHOWER -
SPACE FOR CUPBOARDS - ETC.
PAINTED WHT. SCRAPED FLOORS
(WHAT YOU think, MARK ?)
(About 3RD or 4TH FLOOR .) APPRENTICE)
TO HELP ME.)

WINDOW
70 ft.
14 F. HI.
TOTAL SPACE
70 FT"

WINDOW

BUNZY & IRV. 1 - 2 pm SUN. ✓

● SUN NITE - [Ch. 4] [9-11] - TIMERMAN 1st Prisoner NO
✓ name - Cell no No." - LIV ULLMAN - ROY Schneider ✓

● SUN NITE - 9 PM - Ch. 13 PBS. "SONS & ✓
LOVERS - EPISODE 2

● MON - MAY 30 - ON TERRACE 2 GUESTS -
BARBARUE & CAN BRING 2 GUESTS
BEGINS 2:30 PM ✓

● 25 MAY - WED. WEIGH - 150 LB. ※

● STRONG RUBBER BANDS ※ ✓

● WRITE EDMUND ✗

● GIFT STEPH & LAUREN

● 26 MAY '83 - 151 LBS - Good

● 27 MAY FRI - DR. RIORI - SOMETHING, TO CURE
SHAKING RIGHT HAND

● 28 MAY Sat Ruth coming with MRS. SANCHES (STAYING)
AOA, NURSE INFORMED ● RUTH call Steph 11AM

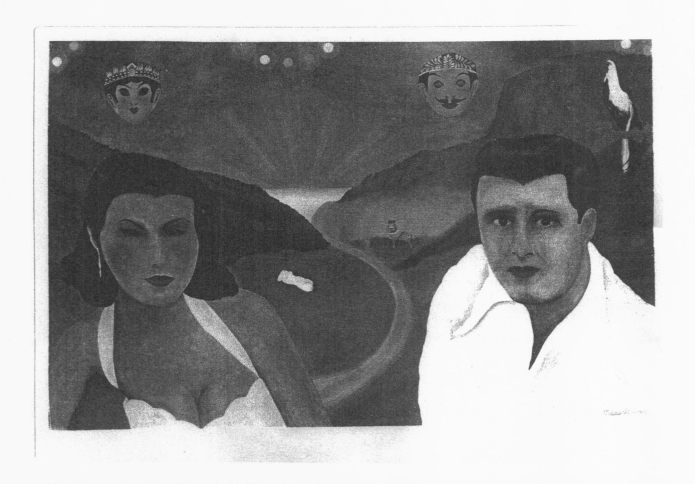

MAXWELL GORDON

"EL ARTISTA EN SU ESTUDIO" 1964

Oleo s/tela

75 x 100 cms.

COL. DEL AUTOR.

Israel Museum Jerusalem

July 31, 1981-

Dear Steph, Lauren & John

Like the note I sent you says, it'll be too late to answer me in San Miguel. I am catching a plane Aug 18. from Mexico City to Tel aviv with an hour stop over in New Orleans then to London. One day there where I hope to meet a friend of mine then I will arrive Tel. Aviv. Aug 20 6 PM - via British airways from mexico to tel aviv

I am sending this as a personal Goodbye to my daughter & grandaughter who I am happy we spent the week together. I feel inside, altho tears don't enter my eyes anymore. - I kiss you both - and - hope we shall see each again & embrace. I am enclosing a copy of a letter from

she was with Katy + me at your house) (and Lauren was at their house for Dinner, daughter Gabriela, and saw many of my paintings there) sent me to say "Goodbye," because they leave for States before I leave. - It is beautiful so I wanted you to see it.

I am not giving out address of people in Israel who are meeting me & I stay at their house until I find a place of my own, but I make a very few exceptions. - & I want to give it to you & Lauren

MAXWELL GORDON
c/o AMALIA and AKIVA GOFFER
5 - HANOF ST.
SAVYON, ISRAEL

So, my small family - Goodbye and emotion is strong as I prepare every day till I leave, - and my combination of LONE WOLF & sociable creature, handles all well. -
Your strong and spiritual father & Grandfather. - sees you inside of him and kisses once more - I LOVE - Dad &

MAXWELL GORDON
RIO HUDSON-28-APT.9.
MEXICO. 5, D.F.

NOV. 14, 1968.

Dear Edith,

This letter may come as a surprise to you, but I must make the attempt to appeal to your generosity.

I have now been in Mexico * for about * seven years, away from the city which was my home, without my family, and terribly lonesome most of the time.

I have lived in Mexico all these years because of your judgement against me under our separation agreement, and my lack of money. I am sure that your rights in the agreement are unquestionable. But the only way I can earn money is through my painting, and if I tried to paint and exhibit in New York all my work could be taken by the sheriff, like the last time. I am financially incapable of paying even your old judgement against me, much less the arrears I may owe you since then.

We were young when we first met and planned a life. Now, my bones are getting stiffer and I've had to see doctors about my blood pressure, liver, and bad pains in my knees

We once loved each other and you were a devoted and faithful wife. I know you have made a success of your career, and I have always had belief in your intelligence,

talent, creativity, and (2) capability to succeed in anything you try. Yet I also know what suffering you may have gone through. Since we have separated I have talked to divorced women and I am well aware how such a woman alone has it difficult. Yet a man alone suffers also.

After all these years mexico is still not my home town. Our children, my past, and my memories are all of New York and I would like to be able to ~~to~~ be there.

Would you consider making a new "Agreement" of some sort which would permit me to come back to New York. If you would be willing we could get together to talk personally or whatever you suggest.

Perhaps I should have written this kind of letter ~~earlier~~ but I probably was too proud to do it but now I realize I can't continue to live on pride only.

I remember the parts of your personality that were ~~part~~ and good hearted, and I hope that that part of you will now create some ideas for a solution which I know will have no practical gain for you but will take away the unhappiness I live under.

Please let me hear from you soon,

Max.

Poem Inspired by "TRYST" (Painting by Maxwell Gordon)

Miss Pettigrew

"I'm an artist--so don't bet
on me."
-- Maxwell Gordon

We learn, we learn that the lady in the picture
That we saw as children, may be real.
Do you remember how she looked--the unbound
Chestnut hair tossed in the wind; her robes
Flowing, and a distant lark high
Upon the horizon; flowers in
Her hand, the tallest meadow grasses waving
At her feet, and the sky, indulgent to
The gamboling of clouds above her head.
How could we help but love her? She was lovely,
Lovely and she lived inside the gold
Imagination of the picture frame,
Gone rapt and beautiful -- without a name.

But she is real; she's Margaret Pettigrew.
Yesterday, we saw her stand against
The sun upon that hill, her chestnut hair
Tossing in the wind, her summer gown
Rustling in the breeze and pale grey eyes
Fixed on the far horizon. In her hand,
Wild flowers, wild flowers in a cluster shone.
This time, the indulgent lark sang
A melody among the clouds in praise
Of Margaret whom we loved and called, but she
Turned her back on us and ran to meet
The gentleman she waited for whose name
Escaped us in a rush of blood and blame.

by

Leonard Wolf

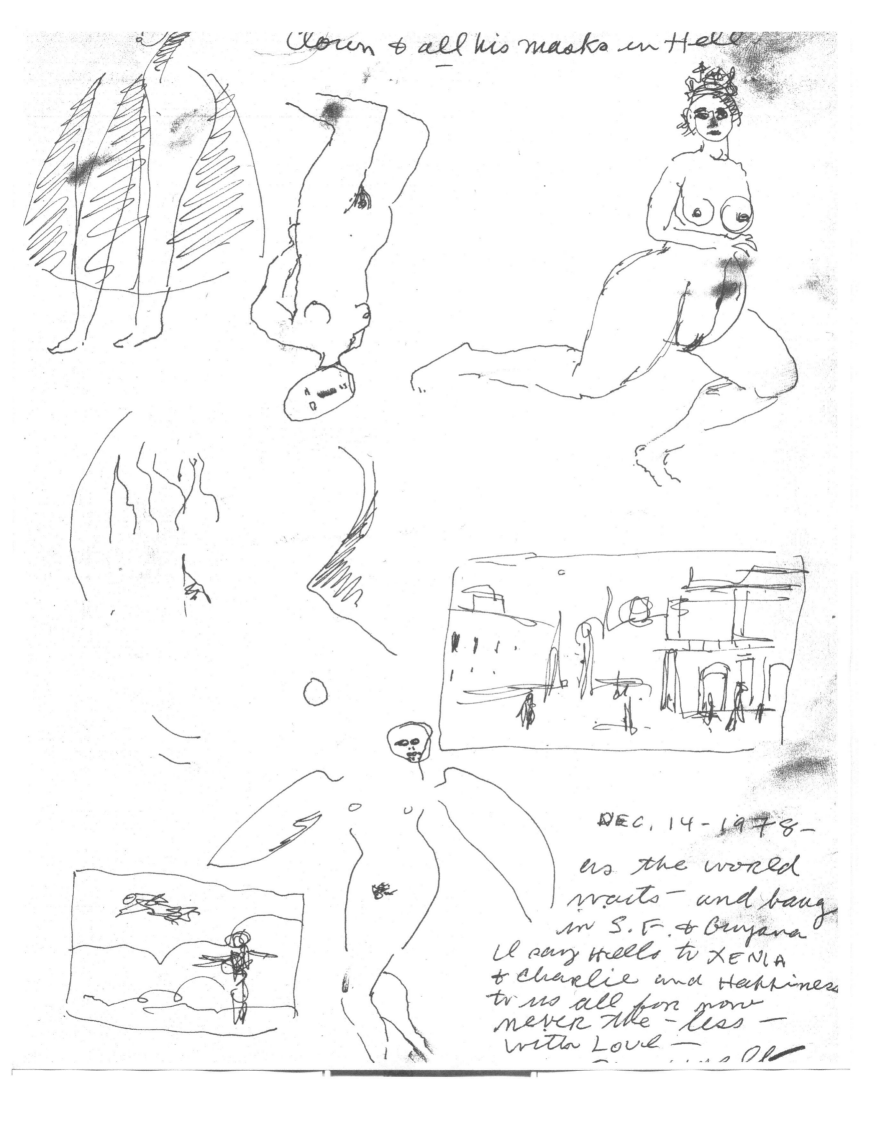

Clown & all his masks in Hell

DEC. 14 - 1978 -

as the world
waits — and bang
in S.F. & Guyana
I say Hello to XENIA
& Charlie and Happiness
to us all for now
never the - less —
with Love —

SESSION 1

1. In the Beginning

2. CAVEMAN

3. EL GRECO

4. Jackson Pollack, Wm. DeKooning, Hans Hoffman

5. (1.) View (2) Holiday (3) Next Day (4) Somewhere in China
 (5) 2 Shores - all in 1943 Show - show slides

All people of all cultures and stages of civilization have an interest
to different degrees in other people, objects, trees, oceans, animals.
Some of the conceptions are seen imaginatively, some realistically, etc.
Some keep it to themselves, others wish to make it clearer to their
own selves or dreams. Some feel the urge to let other people know how
they see, know, or feel about what is around them. To others, even
today to a civilized person some things can't be touched, their outlook
appears to be magic, and some tell all this to us in words - and we hear
a story -, a sad one, a gay one, mysterious, etc.-. Those that have a
beautiful voice will sing to us and others will draw about what they
feel and know- and there is a picture. In all this, the imagination
indicates the creative interpretations we all are capable of.

The Ink Blots used by psychologists will seem to suggest different
things to each person.(Max Ernst and blot on floor).

CAVEMAN

STONE AGE - 15000 years ago - first known pictures made - lived in caves.
HUNTING primary. No knowledge of farming or cattle raising. Deer and
Buffalo very important because of food and difficult to hunt. Had tools
of wood, bone or stone - knew nothing of metal. Hunted on foot. No
knowledge of riding horses.
Probably imagination suggested to more sensitive with latent talent
pictures of Buffalo or deer on sides of cave - as in ink blot. Drawn
on sides of cave with burnt stick from fire. Drawings were done one on

1

top of the other without any order. The bottom drawings were spoiled by those on top. In dark and difficult sections of cave not near the light. Cavemen did not want them for decorations as we know about pictures. Some caves discovered rectently & by chance.

Probably - a hunting magic or symbol to practice hopeful killing.

So, even 15000 years ago the painter was a special kind of person; others went hunting while he stayed home to draw the animals. He was probably considered a magician. Primitive man probably confused between pics and real thing. As modern person angrily might tear up a foto of one he has fought with.

ART- concerned with feelings as well as with things as they really are. Pictures combine intellect & emotion so paintings are different from one another, depending on whether artists are more interested in feeling or knowing, or in what he felt, also HOW MUCH he { SAW KNEW FELT

el greco

1577- Assumption of the Virgin - 1st great success. Came from Crete to Toledo, Spain as a mature artist influenced by the Italian Artists, mostly Tintoretto. Uses of Space in a personal way for that period of time. He used foreshortening but wit out perspective. Used reality in his paintings combined with strong feeling.

1. View of Toledo (Metrop.)

2. New painting Metrop.

3. My first essay

4. Lived in Ghetto

5. Theory of Eyes

6. Picasso - Blue Period

7. Concerend Modern- (distortion & lack of perspective

8. Had a school

TECHNICAL PROCEDURE of Canvass of EL GRECO

Primed semi-absorbent, possibly - grey background - impratrura -
drew - mixed wht & scumbled - isolated with varnish - glazed - corrected
with wht - glazed under painting & over painting. Had followers in
school - but alla prima is the mark of the master. Analyze a particular
painting spontaneously or his paintings in general - as to:

1. COLOR - glazed - rich blue & reds but blacks

2. FORM - mystical & Supernatural of Religion

3. MASSES

4. SPACE- foreshortening, no perspective

5. DRAMA - to move psychologically

6. SUBJECT -Religion

7. MOOD

8. PARTICIPATION - hand of master

9. HONESTY "

10.

JACKSON POLLACK
HANS HOFFMAN 1940-1960
WM. DEKOONING

POLLACK HOFFMAN DEKOONING

raw canvass School on 8 St. Woman
 & Provinsetown
Picasso Abst. Landscapes
 84 yrs.old today
Balthus Show early drawings
 great influence
Action Painting Guggenheim

Critics

Cedar Bar

Show 1st of my color slide & talk about generally & technically

1. View 18 by 28 1943 Show
2. Holiday 16 by 20 "
3. Next Day " "
4. Somewhere in China 16 by 20 '43 Show
5. 2 Shores 18 by 26 "

INK BLOT

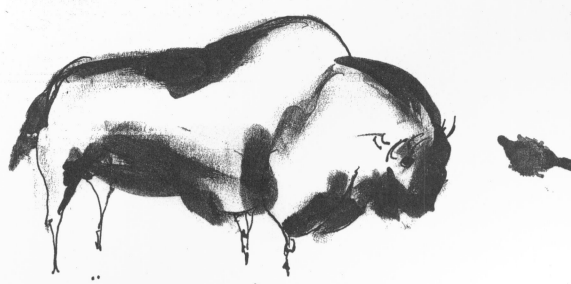

OLD "STONE AGE" CAVE PAINTING
"STANDING BUFFALO - ABOUT 15,000 B.C.
FONT-DE-GAUME, FRANCE

OLD STONE AGE CAVE PAINTING
"ANIMALS" 15,000 - 10,000 B.C.
LASCAUX, FRANCE

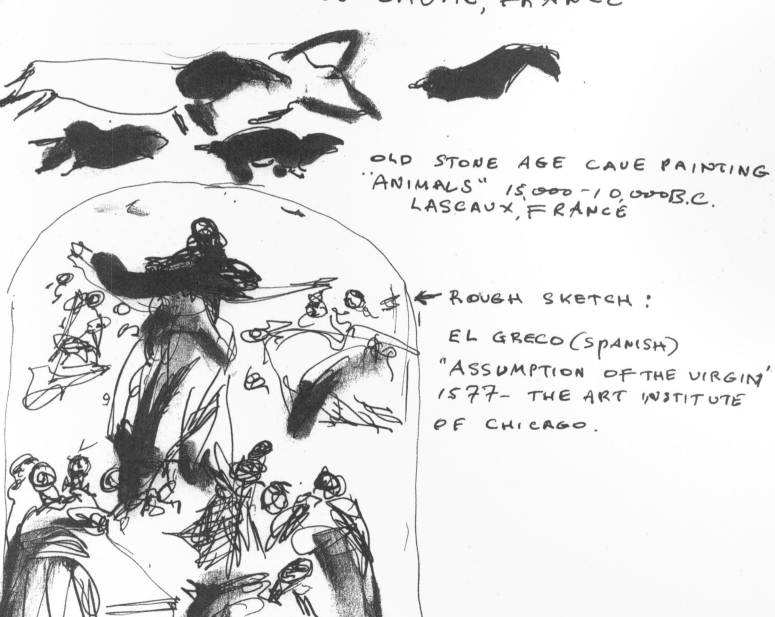

← ROUGH SKETCH:

EL GRECO (SPANISH)
"ASSUMPTION OF THE VIRGIN"
1577 - THE ART INSTITUTE
OF CHICAGO.

Soup. 2.00 m

finished
5/8/71
May

"THE LAST VOYAGE"

"EL ÚLTIMO VIAJE"

1.50 m

(LVIS)

Over a pretty picture, this is happening

Primed raw-canvas with 2 coats acrylic
after — then primed 1st coat Dutch Boy pure. then
2nd coat Dutch Boy mixed with Olb. blue, Red.
plus a little linseed oil — used big palette
knife & scraped thin to make a smooth plastic
finish.

Possible TITLES 1. The Voyage
1. The Twist 2. The Last Voyage
2. The Path 3. While the Angels Sing
3. Tidal Wave 4. The Tragedy
4. Deluge 5. The Last of the Masks
5. The Voyage
6. Maelstrom
7. White Horses
8. Coming Storm
9. The Close Gate
10. The Last Voyage
11. The Boat
12. The Ship
13. While the Angels Sing
14. The Ship that goes you know where
15. Peace o no Peace
16. The Tragedy
17. The Competition
18. The Last of the masks
19. The Queen
20. The Masks
21. The Funeral Pyre
22. The Birth

EGYPT -

LOTUS BLOSSOMS

capitols - Reds
Blue
Ochres

metropolitan museums - (mummies)
no perspective / ~~shown from~~

HIEROGLYPHICS - (PICTURE WRITING)

GODS - (IDOLS) SUN, moon, water etc.
animals - etc.

ART OBJECTS IN TOMBS.
Preserved the dead - drying them & wrapping
them up & putting them in strong Tombs.
Kings, had statues in tombs in case
something happened to real Body.

Egyptian Wall Painting about 3000 B.C. (earliest)
made Pictures on walls of Tomb of life of
the dead man so spirit could feel at home.

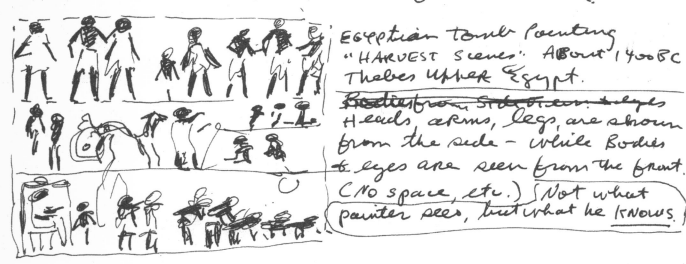

Egyptian tomb Painting
"HARVEST Scenes". About 1400 BC
Thebes Upper Egypt.
~~Bodies from side, from eyes~~
Heads, arms, legs, are shown
from the side - while Bodies
& eyes are seen from the front.
(No space, etc.) Not what
painter sees, but what he KNOWS.

?BETE — ROCKY ISLAND - near GREECE
• Between 2500 & 1000 B.C. — SAILORS, art because
• LITTLE known about them

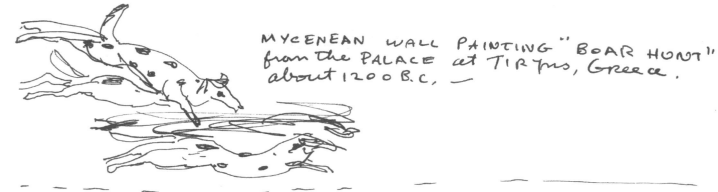

MYCENEAN WALL PAINTING "BOAR HUNT"
from the PALACE at TIRyns, Greece.
about 1200 B.C. —

TITIAN: Greatest of Venetian Painters — Knew something
of work of Michael Angelo & Raphael.

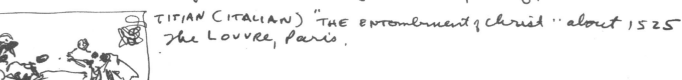

TITIAN (ITALIAN) "THE ENTOMBMENT of Christ" about 1525
the LOUVRE, Paris.

mood, action, color.
Titian's greatest fame as a portrait Painter:
• all important men of his day from Pope & Emperor.

<TITIAN "MAN WITH GLOVE" About 1520 The LOUVRE, Paris

Picasso — arrived Paris about 1900

Picasso — old guitarist 1903. — BLUE PERIOD.

About 1906 — began in manner of Cezanne & with
Braque farther Towards Cubism.

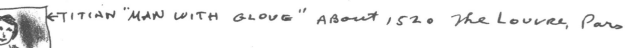

STILL LIFE with
chair caning - Picasso

BRAQUE:
- CUBism with Picasso – $
- Beautiful Taste
- one man show at museud. ART N.y

ROUALT:
 STRong christian faith.
CLOWNS – suggest sympathy & despair – symbols –
Prostitutes, etc. –
 Lithos – "miseres". – Paris, N.y. • Painted in
 cellar es production – bought up later.
- On cardboard sometimes
- STAINED Glass.

LEGER:
 MODER – TUBES – BICYCLE. – MUS. Mod. Art N.y. etc

lástima que no sea caro.

Es lamentable que todavía haya gente así, que juzga un whisky por su precio y que se deja influenciar por las etiquetas.

Sabemos que si estas mismas personas toman TORYS "a ciegas", dicen: "…Indudablemente es un whisky importado…! Inconfundible, whisky escocés!… Un whisky carísimo, ¿verdad?"

Whisky TORYS no le pide nada en sabor a los whiskies importados más famosos, pero tiene una gran diferencia… su precio. ! Cuesta menos de la mitad!

Sirva 4 jaiboles con whiskies importados y uno más con whisky TORYS. Pida a un amigo le vende los ojos. Ahora pruebe los whiskies. Verá que TORYS no le pide nada a los whiskies importados.

WHISKY **TORYS**

"SELECCIONES" (reader's Digest
Oct. 1967 – Maxwell Gordon

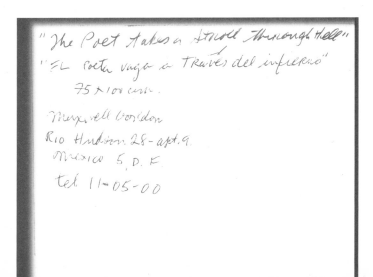

"The Poet takes a Stroll through Hell"
"EL poeta vaga a Través del infierno"
 75 × 100 cm.
Maxwell Gordon
Rio Hudson 28 – apt. 9.
mexico 5, D.F.
tel. 11-05-00